the americans. new art. the americans. new art. the americans. new art. the americans. new art. the americans. new art. the americans. new art.
the americans. new art. the americans. new art. the americans. new art. the americans. new art. the americans. new art. the americans. new art.
the americans. new art. the americans. new art. the americans. new art. the americans. new art. the americans. new art. the americans. new art.
the americans. new art. the americans. new art. the americans. new art. the americans. new art. the americans. new art. the americans. new art.
the americans. new art. the americans. new art. the americans. new art. the americans. new art. the americans. new art. the americans. new art.
the americans. new art. the americans. new art. the americans. new art. the americans. new art. the americans. new art. the americans. new art.
the americans. new art. the americans. new art. the americans. new art. the americans. new art. the americans. new art. the americans. new art.
the americans. new art. the americans. new art. the americans. new art. the americans. new art. the americans. new art. the americans. new art.
the americans. new art. the americans. new art. the americans. new art. the americans. new art. the americans. new art. the americans. new art.
the americans. new art. the americans. new art. the americans. new art. the americans. new art. the americans. new art. the americans. new art.
the americans. new art. the americans. new art. the americans. new art. the americans. new art. the americans. new art. the americans. new art.
the americans. new art. the americans. new art. the americans. new art. the americans. new art. the americans. new art. the americans. new art.
the americans. new art. the americans. new art. the americans. new art. the americans. new art. the americans. new art. the americans. new art.
the americans. new art. the americans. new art. the americans. new art. the americans. new art. the americans. new art. the americans. new art.
the americans. new art. the americans. new art. the americans. new art. the americans. new art. the americans. new art. the americans. new art.
the americans. new art. the americans. new art. the americans. new art. the americans. new art. the americans. new art. the americans. new art.
the americans. new art. the americans. new art. the americans. new art. the americans. new art. the americans. new art. the americans. new art.
the americans. new art. the americans. new art. the americans. new art. the americans. new art. the americans. new art. the americans. new art.
the americans. new art. the americans. new art. the americans. new art. the americans. new art. the americans. new art. the americans. new art.
the americans. new art. the americans. new art. the americans. new art. the americans. new art. the americans. new art. the americans. new art.
the americans. new art. the americans. new art. the americans. new art. the americans. new art. the americans. new art. the americans. new art.
the americans. new art. the americans. new art. the americans. new art. the americans. new art. the americans. new art. the americans. new art.
the americans. new art. the americans. new art. the americans. new art. the americans. new art. the americans. new art. the americans. new art.
the americans. new art. the americans. new art. the americans. new art. the americans. new art. the americans. new art. the americans. new art.
the americans. new art. the americans. new art. the americans. new art. the americans. new art. the americans. new art. the americans. new art.

the americ ans. new art.

Published on the occasion of the exhibition:
the americans. new art.
25 October – 23 December 2001
Barbican Gallery, London.

Curator: Mark Sladen.
Exhibition organiser: Julia Bunnage/Philippa Alden.
Curatorial assistant: Sophie Persson.

Barbican Gallery. Barbican Centre,
Silk Street, London EC2Y 8DS.
www.barbican.org.uk

The Barbican Centre is owned, funded and
managed by the Corporation of London.

First published in 2001 by
Booth-Clibborn Editions.
12 Percy Street, London W1T 1DW.
www.booth-clibborn.com

Designed by Big Corporate Disco
www.bigcorporatedisco.com

The cover and contents of this book include
text set in a font (Albenda Bold) and colour system
(from the project COLOR-I-ME-TRY) designed
by Ricci Albenda. All rights reserved.

Printed and bound in Hong Kong by DNP.

ISBN > 1 86154 222 4.

the americans. new art.

Organised by Barbican art.
Curated by Mark Sladen.
With texts by Bruce Hainley, Katy Siegel,
Bennett Simpson, Mark Sladen
and John Slyce.

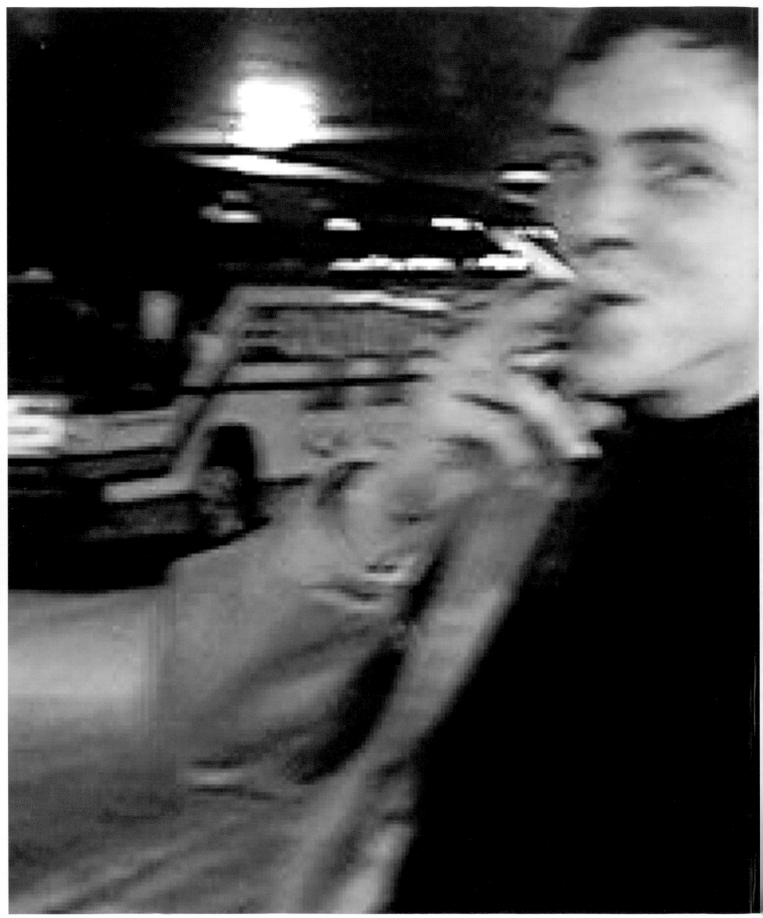

mark sladen.
TOO MUCH INFORMATION.

The author arriving at JFK Airport
in New York for the first time.

Matthew Barney was one of the first artists about whom I got really excited. It was a summer's day some time in the early nineties and a group of us were driving out of London and into the countryside to go stay in this mill conversion. I had left college a few years before and had been doing various things. I had worked as a graphic designer for a while but had got bored with that and was looking around for something to do. So I'm sitting in the back of this car in the summertime, being driven into the country and it's warm and I'm kind of going into this other zone. It must have been a Sunday as the back of the car was all full of newspapers, including this colour magazine for **The Observer**. On this particular Sunday the cover story was on Matthew Barney and I just lapped it up.

↓

Here is this young American artist dressing up in all this fetishistic gear and climbing all over a gallery in New York in the middle of the night. He's filming it and then just exhibiting the gear and the film when the gallery opens. He's got this whole private language worked out which involves assuming the roles of these characters like divas and satyrs and using very particular media like petroleum jelly and surgical clamps. It's all kind of allegorical except he doesn't really tell you what the allegory is. I'm sitting in this car with these people who I went to college with and it feels like they're all really successful and English and posh and I don't know what the hell I'm doing with my life but I do know that this guy, this Barney guy, I think I have an idea what he's up to. I slip the magazine into my bag and don't talk about it to anyone. I just want to hang onto it like it's a key to what might be going on in my head somewhere. For me that has

always been the exciting thing about contemporary art – the call that occasionally comes from an artwork. That almost imperceptible sound and that moment of recognition.

↓

A few years later, sometime in the mid nineties, I'm sitting in a bar in New York's Lower East Side drinking with Richard Billingham. I had started writing about art for a few magazines and my friend Hilary had seen some of Richard's photographs and suggested I should write about him. I wrote this piece for **Frieze** before many other people in the art world had really caught onto him. Richard liked it and I think a lot of people liked it and it got re-printed and I think it launched me in the art world. So I'm in this bar in New York and the whole of the Lower East Side is still a little bit scary at that point – not tidied up so much as it's getting now. It's my first trip to New York and here I am bumping into Richard in a bar with all these artists and I feel like I've arrived.

↓

New York had always been an idea I aspired to. My parents lived there for a bit before I was born and my Mum used to tell stories about living in the Lower East Side and buying cheesecake from the deli and it all being this amazingly exotic thing. I always kind of wished my parents had stayed there but they moved back to England a couple of years before I was born, I don't really know why. As a result I spent the seventies reading **Spiderman** comics and watching **Starsky and Hutch** and dreaming about New York. I guess I shared that image of America that a lot of people had at mid century. That image of sunshine and Gotham and classlessness and abundance and aggression and glamour. The idea that you

could reinvent yourself there. And here I am sitting in a bar drinking with Richard and my tiny mind is blown like I made it into Studio 54 or something.

↓

And of course I still believe all that stuff. Even if it's rubbish it's still an enabling fiction. I have always felt freer in America and I have always felt more effective in the American art world. I didn't go to art school and I've never really hung out that much with artists in Britain but somehow in America it's different. I feel braver and I can just ring up a gallery and go and meet an artist and go out for a drink with them and it isn't so complicated. In the later nineties I worked for a commercial gallery in London and I got to travel a lot in the States and meet a lot of people. Doing the research for this show I got to meet a whole lot more. I hope this show conveys some of the excitement I have experienced while attempting to navigate the American art scene. And I hope it conveys some of the fascination I have with trying to negotiate an idea of American-ness. You shouldn't underestimate how important an idea America still is.

↓

At one point in my planning I thought about doing a best of American art of the nineties show. This would have sort of worked as a category because in America, as in Britain, the art world really was radically different in the nineties to how it had been in the previous decade. It is hard for me to generalise about American art of the eighties because I wasn't in any way a participant, but I do know the myth. This is based around the idea of a few young artists making big bombastic paintings and having a lot of success very quickly and embracing a celebrity lifestyle and a few dealers making a lot of money and paying people in cocaine and the whole thing coming crashing down with the economic recession at the end of the eighties. It appears that the American art world of the early nineties embraced this myth with a certain self-flagellating zeal. The new American art was going to be different. It was going to be theoretical. It was going to be political. It was going to be personal. It was going to be less commodified. It was going to be video. It was going to be performative. It was going to be less macho. Whatever it was it wasn't going to be what it was before. The kind of artists who began to be lauded in the early nineties included people like Matthew Barney and John Currin and Karen Kilimnik and Rirkrit Tiravanija and Jason Rhoades, all of whom seemed to satisfy at least some of these criteria. That's the history bit over.

↓

But while I was thinking about doing this best of the nineties show I realised a couple of things. The first was that I wasn't really interested in doing one of these supposedly objective exhibitions. I was inspired by seeing **Greater New York**, the exhibition at PS1 in which a whole load of curators gathered together a whole load of recent stuff by a whole load of artists living in the New York boroughs. **Greater New York** didn't try to be definitive, but did have a lot of chaotic energy and was really fun to go around. The second thing I realised was that although I think that Barney and Currin and Kilimnik and Tiravanija and Rhoades are all great it is really the wave that emerged in their wake that I have had firsthand experience of. In the end I've concentrated on artists who have emerged to

international prominence since about 1995 or who are currently emerging, and I've made the choice a personal one. The wave of artists that has emerged 'after Barney' represents an amazing surge of activity and one about which I feel I can speak. I also think I can recognise some of the things that characterise this art.

↓

IT'S INTO HYBRID SYSTEMS

In one work Tom Friedman develops a system for making a self-portrait out of sugar cubes. But then in another he develops a system for making a portrait of a dollar bill out of dollar bills. It seems like the system isn't the point — the point is the will to build the system. The will is the mysterious and interesting bit. Evan Holloway's systems are more obviously fucked-up. Why would anyone take a tree and set all the branches at 90° angles to each other? Holloway often seems to be mapping one system onto another and manages to get you into an odd headspace as a result. These artists make work that bears a resemblance to conceptual art from the seventies, except that there's so much more random weird stuff in what they make. Which is only appropriate, since our cultural appreciation of the complexity of experience and the difficulty of making a simple statement about it have both increased exponentially since that time.

↓

IT CREATES A HYPOTHETICAL SPACE

'Welcome to the third place' is what they say on the adverts for the Playstation III and it seems kind of appropriate in this instance. A lot of artists I like (perhaps following on from people like Cindy Sherman and Charles Ray and Matthew Barney) mix together elements of fantasy and narrative and their own lives and the real world. They create this hybrid zone and the works are like bits of evidence of this parallel space. Keith Edmier is like that. His work **Beverly Edmier, 1967** is a representation of his own mother carrying him as a child, but it's also a picture of Jackie O and the mother-son bond and the sixties and of our endless attempt to get back to some sort of point of origin (which I think is also the theme of Bruce Hainley's essay in this book).

↓

IT'S POST–IRONIC

I guess irony was the big thing in the eighties and early nineties but it doesn't seem so any more. I like the photographic works of Piotr Uklanski. These employ naïve and clichéd elements of beauty and spectacle and allegory without ever being naïve or clichéd. But then neither are they ironic. It seems like we've reached a point of cultural sophistication where we can have a simultaneous appreciation of authenticity and inauthenticity within the same utterance. That seems to me one of the characteristics of some of the artists that Gavin Brown shows: you could say the same of Laura Owens or Elizabeth Peyton or even Rob Pruitt maybe.

↓

IT'S DECADENT

Pruitt's art is nothing if not decadent. It's not just the idea of making a work that consists of a twenty-foot line of cocaine to be consumed by the visitors at its launch. The panda paintings are wonderfully decadent too. In an obvious way, since they are dumb images of dumb animals made from the dumbest of materials — glitter. But also because they are beautiful and heartbreaking and funny and political too. Pandas have always been subject

to anthropomorphism and diplomacy and ecological propaganda. Pruitt appropriates the symbol and makes it personal. This combination of politics and decadence is pretty fabulous.

IT'S GIRLY

Some of the work in this show is playful and dreamy and offhand and even downright girly. That was something that American artists won in the nineties: permission to be girly. The painter Karen Kilimnik beat a path here, and has been followed by quite a few people, including the sculptor Rachel Feinstein. (I don't think Feinstein would mind me calling her girly; I'd like to think that the derogatory overtones of the word have been undermined sufficiently for it to be reclaimed.) Being girly in sculpture is a very useful thing, as people often struggle to make sculpture that isn't macho. Feinstein's **Yesterday** is a brave attempt to make a girly public sculpture. It kind of fails but that's OK because her art leaves space for failure. Some of the men in the show also make work that's girly, and not just the gay boys.

IT USES FICTION AND NARRATIVE

I guess you could call Brian Calvin's paintings a bit girly. Well they're brightly coloured and figurative and they sort of tell stories. (Am I digging myself a hole here?) Narrative was another big no-no for a long time, but it's back with a vengeance now. Often the narrative isn't entirely given its head, and instead is presented in fragmentary form or in contradiction to other formats. Like in the earlier works of T.J. Wilcox, which mix footage from feature films and documentaries as well as staged footage and the artist's animations.

In her essay Katy Siegel talks about how American artists use all these different modes of address, and I think she's onto something.

IT'S NOT DIGITAL

A lot of the work in this show has an engagement with manual labour and craft that could be construed as positively anti-technological. But even the work that deploys new technologies does not promote these technologies. There has been a rash of recent exhibitions in America on the theme of the digital but I don't feel that the new American art is really invested in the digital at all. Paul Pfeiffer has been in several of these shows but they are in danger of doing him a disservice. Pfeiffer's photographs and sculptures and videos may be constructed with the help of cutting-edge technology but what they seem to be about are the odd human traces that survive at the edges of the media realm: the stuff about desire and aspiration and frustration that doesn't quite get assimilated.

IT'S IMMERSED IN THE MEDIA ZONE

I got into Jonathan Horowitz's work when I saw a work of his in which he appropriates a Michael Jackson video. At the start of Jackson's video you see the destruction to the eco-realm and then, as Michael's cathartic rage kicks in, all the fallen trees rise from the forest floor and the slaughtered elephant regains its tusks. All Horowitz does is play the thing backwards, so everything is messed up but then again not – the elephant still ends up intact. This simple intervention draws attention to video and nature and Jackson as completely pre-mediated sites of

cultural fantasy. A lot of the art in this show exists in this kind of no-man's-land. Amy Adler's work does, with its variously appropriated images of teen idols.

↓
IT'S ABOUT NETWORKS OF PEOPLE AND IDEAS
Katy and I went for lunch and she asked me an interesting question: in what way do you think this show will be criticised? My immediate response was that people would say it wasn't political enough. I said that because that is what the opinion-formers in the British art world seem to want at the moment. American art of the early nineties was political in a more obvious way, with lots of stuff about race and gender and sexuality and so on. This is still a strand that bubbles along, but on the whole American artists seem to have assimilated politics into their work rather than needing to express it directly. Tiravanija has been a guiding light in this regard: with his participatory events (such as his food happenings) that create and mobilise a network of people. Erik Parker is like this. His paintings contain whole networks of people and ideas, operating within an expanded notion of the political.

↓
IT'S BEAUTIFUL
You won't really get an idea of what one of Ellen Gallagher's black paintings looks like from this book, so I hope you see the show or see one someplace else. They're built up from enamel paint and little bits of rubber, and they're resistant to photography in a way that verges on passive aggression. But like all of Ellen Gallagher's works they're also incredibly beautiful. Beauty has been a big story in the nineties, and it's great that artists don't feel

guilty any more about making beautiful work. Maybe this thread wasn't broken in the States in the same way it was in Europe – certainly the discourse of abstract painting seemed to survive better there. But perhaps there is still guilt attached to beauty. Gallagher's work seems to suggest so.

↓
IT'S GOTHIC
I guess Tim Hawkinson is the most obviously gothic artist in the show. Gothic in content: his preoccupation with the body and with opening up its workings. And gothic in style: his use of traceries and accumulations of detail. Of course, it's a contemporary variant, in which bodily mapping is a metaphor for other types of information flow. But it retains some of the outsider qualities that we associate with other versions of the gothic. Fred Tomaselli is an obvious parallel, and in his work the streak of Americana is even more obvious. Like an art that might have been developed by a breakaway religious sect holed up somewhere in the Mid-West. These guys make some of the most un-British work in the show.

↓
IT'S NOT BRITISH
Even something that looks like yBa work isn't yBa work: for example, Tony Matelli's **Lost and Sick: Winter Version**. This piece features a trio of boys, their wilderness trek rapidly turning to the bad through the agency of poisonous berries or some such. It's like a dysfunctional version of the **Three Graces**, and as a life-size realist sculpture with an obvious socio-political edge it invites comparisons to the work of the Chapman brothers. And yet if the Chapmans made it the boys wouldn't simply be ailing – they would be past the point of no return and probably already mutating into

flesh-eating zombies. Contemporary American art is not so invested in shock as its British counterpart and Matelli keeps his work in a more subtle state of suspension. Instead of the dynamics of satire, his art deploys the creeping insight of a slowly unravelling joke.

↓

IT HAS THE LIMINAL QUALITY OF LIVED EXPERIENCE

I'm thinking of Dara Friedman's truly glorious video, **Government Cut Freestyle**. Shots of boys jumping off a pier somewhere in Florida. All the shots spliced together with jump-cuts. A bit of radio noise seeping into the otherwise silent soundtrack. This seems to draw on our dreams of America, all those coming of age films set in nowheresville in the summertime. But in another way it's completely unsentimental and simply a self-reflexive piece of filmmaking about those things that films usually leave out. In this analytical framework it somehow manages to capture the liminal quality of lived experience. There, I said it again, and now I guess I have to justify it. But I don't think I can. You'll just have to watch it. Paul Sietsema's **Untitled (Beautiful Place)** is equally good.

↓

IT'S ABOUT INFORMATION FLOW

The cover and contents of this book feature a font and colour system developed by Ricci Albenda. It's related to Times Roman but the artist has re-cut it. And he's also developed this system where each letter of the alphabet has a different colour, so that when you compose a word the colours jump about through this spectrum and you have this nice randomising thing going on. Using a randomised prismatic system seems like a very contemporary gesture. It seems to say something about all the information that we have to process these days, and how it is banal and beautiful and sublime and how you just have to make a leap of faith that there is an order that underlies it somewhere. Processing information seems to me to be the main challenge today and a lot of American artists use metaphors of information flow in their work. Sarah Sze and Julie Mehretu are good examples.

↓

IT CONTAINS AN IDEA OF AMERICA

Or rather, it contains lots of ideas of America. Of course, this isn't particular to this wave of American artists. America has been one of the main subjects of American art since its inception. (People will tell you that this has something to do with America being a pioneer country or an immigrant country or a young country or whatever.) The ideas of America embodied in the work of the artists in this show are various. From the imagery of the colonial era that Kara Walker plays with in her silhouettes. To the dream of Hollywood that permeates Jeff Burton's photographs. America is still contested territory. And it will always be a fantastical construction. I love America. Is that too much information?

the artists.

With introductory texts by
John Slyce.

EDUCATION
↓
1991 BA, Yale University, CT.
1997 MFA, School of Visual Arts, New York.
↓
SELECTED SOLO EXHIBITIONS
↓
1997 **White Room**, White Columns, New York.
1998 Institute of Contemporary Arts, London.*
1999 Museum of Contemporary Art, Chicago.*
 Galerie für Zeitgenössische Kunst, Leipzig.*
 Fondation Cartier pour l'Art
 Contemporain, Paris.*
2000 Marianne Boesky Gallery, New York.
2001 Bard College, Center for Curatorial Studies,
 Annandale-on-Hudson, NY.
 Museum of Contemporary Art, San Diego.
 Israel Museum, Jerusalem.
↓
SELECTED GROUP EXHIBITIONS
↓
1996 **SoHo Annual**, New York
1997 **Migrateurs**, Musée d'Art Moderne de la Ville
 de Paris, Paris.
 Cities on the Move, Vienna Secession, Vienna
 (and tour).*
 Some Young New Yorkers, PS1/MoMA, New York.
1998 **Berlin Biennial**, Berlin.*
 Where: Allegories of Site in Contemporary Art,
 Whitney Museum of American Art at Champion,
 Stamford, CT.
 Manifesta 2, Luxembourg.*
 Construction Drawing, PS1/MoMA, New York.
1999 **Venice Biennale**, Venice.*
 The Carnegie International, Carnegie Institute,
 Pittsburgh, PA.*
2000 **Whitney Biennial**, The Whitney Museum of
 American Art, New York.
 Mission pour la célébration de l'an 2000,
 La Beauté, Avignon, France.
2001 **010101: Art in Technological Times**, San Francisco
 Museum of Modern Art, San Francisco, CA.
 Bo01 City of Tomorrow, European Housing
 Expo, Malmo.
↓

SELECTED BIBLIOGRAPHY
↓
1999 Birnbaum, Daniel, 'Just So', **Frieze**, London,
 September-October 1999, pp 90-93.
 Gingeras, Alison, 'Sarah Sze: La Poesie
 du Meddano', **BeauxArts**, Paris, December
 1999, pp 58-61.
2001 Israel, Nico, 'Sarah Sze', **Artforum**, New York,
 January, 2001, p 138.
 Rottner, Nadja, 'Sarah Sze', **Flash Art**, Milan,
 January-February 2001, np.

 * Exhibition publication produced

sarah sze.

BORN IN BOSTON MA, 1969.
LIVES IN NEW YORK.

↓

Sarah Sze's site-specific installations are as near as one gets to a total artwork. They incorporate elements of colour and form that are native to painting, the movement and light of cinema, the tilted planes of architecture and the intimacies of drawing. Her imaginative worlds reflect informational systems encompassing the bite, the byte, the molecule and atom and are constructed from items that pass through our hands and pockets during everyday patterns of consumption. Working on-site and often reconfiguring materials from previous pieces, her labours are obsessive, condensed and ultimately temporary, which adds a crucial time-based element to her site-specific practice.

↓

To experience a Sze installation is to enter a space that is rigorously ordered and yet perplexingly chaotic; fragmentary and yet still connected at multiple levels; monumental and yet ephemeral and scaled to the human hand. There is a poetry to the artist's work that accrues during quietly fascinating moments when one discovers one detail perched precariously atop another. **Strange Attractor** (2000), which colonised a giant bay window at the Whitney, draws on a term from chaos theory that designates processes that are stable, confined and yet never do the same thing twice: like the patterns that water assumes when you turn the kitchen tap on. Sze's works produce similar trajectories and distortions as the shell of a gallery is split and the outside world appears to spill in.

↓

Things Fall Apart (2001) and **Everything that Rises Must Converge** (1999) draw, respectively, on a line in a poem by W.B. Yeats and the title of a short-story by Flannery O'Connor. Both point to Sze's ability to call our attention to the easily overlooked details of a site, and to create by deconstructing the fragmentary nature of that which surrounds us.

sarah sze.
Still Life with Flowers, 1999 (detail).
Mixed media, dimensions variable.
Installation at Galerie für Zeitgenössische Kunst,
Leipzig.

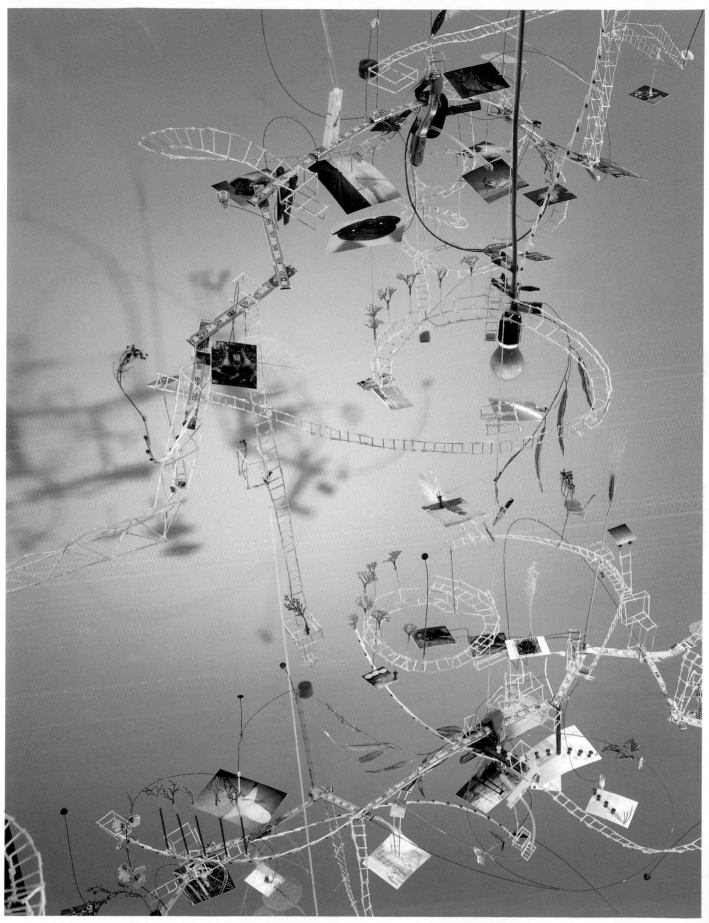

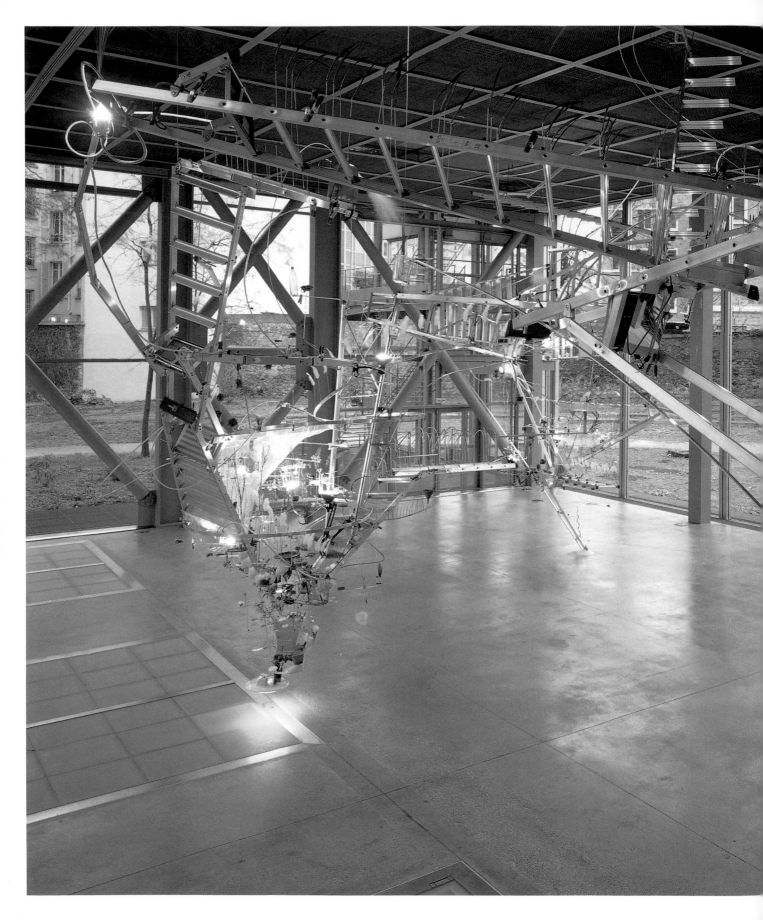

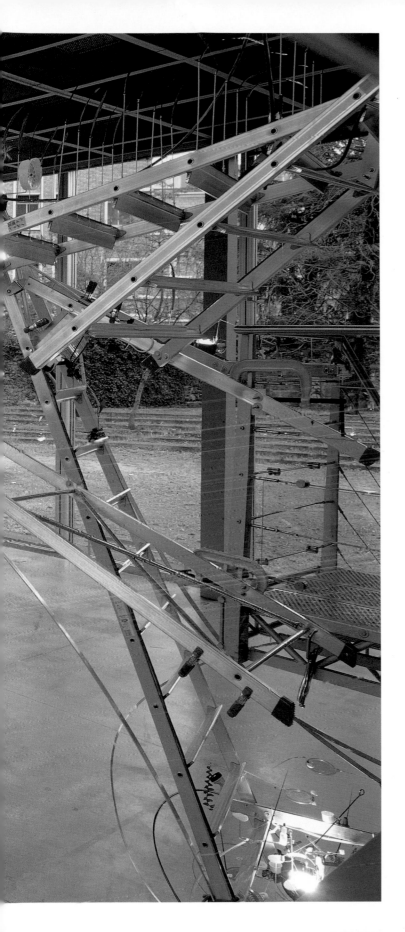

sarah sze.
Everything That Rises Must Converge, 1999 (details).
Mixed media, dimensions variable.
Installation at Fondation Cartier pour l'Art.
Contemporain, Paris.

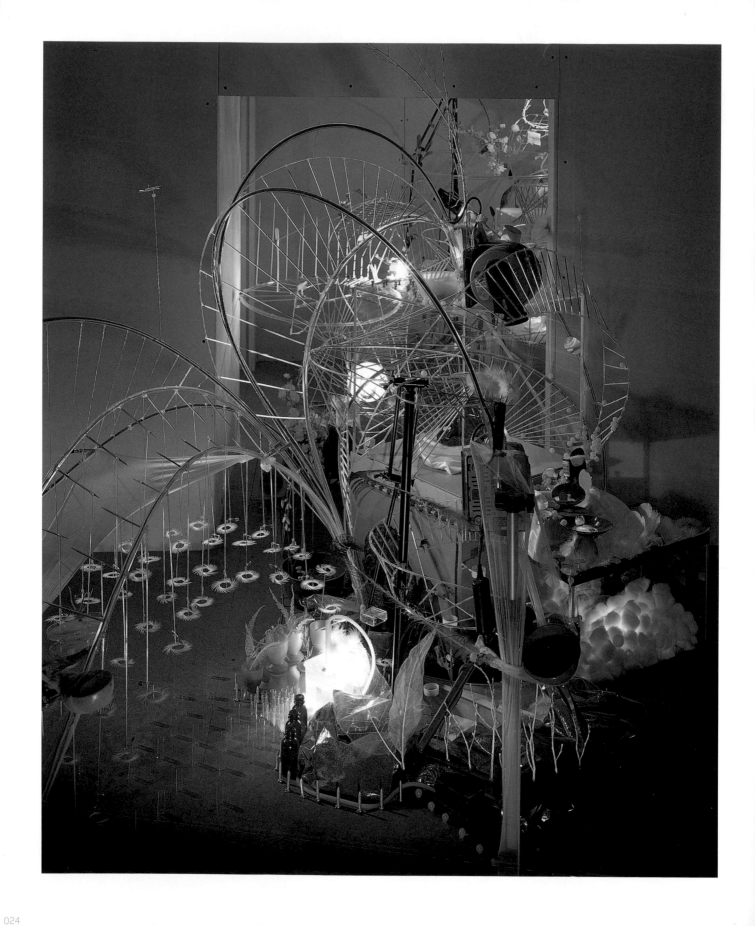

sarah sze.
Lower Treasury, 2000 (detail).
Mixed media, dimensions variable.
Installation at Palais des Papes,
Avignon, France.

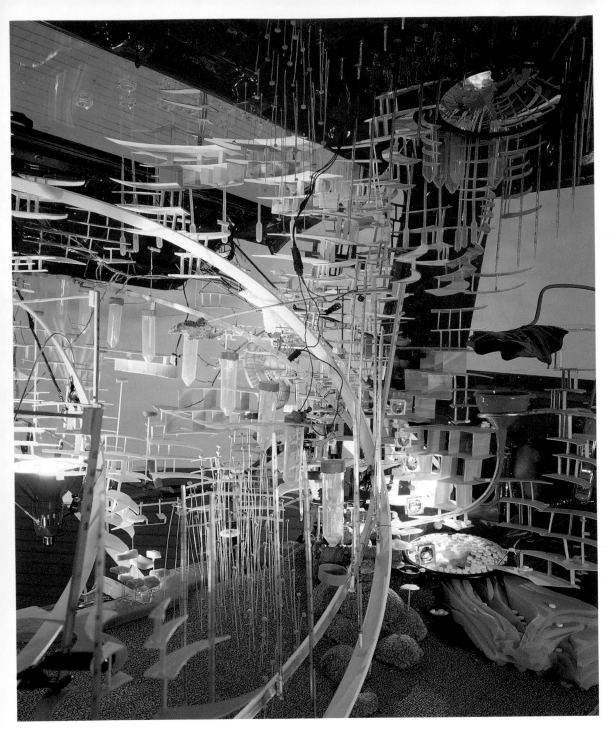

sarah sze.
Things Fall Apart, 2000 (details).
Mixed media, dimensions variable.
Installation at San Francisco Museum of Modern Art,
San Francisco, CA.

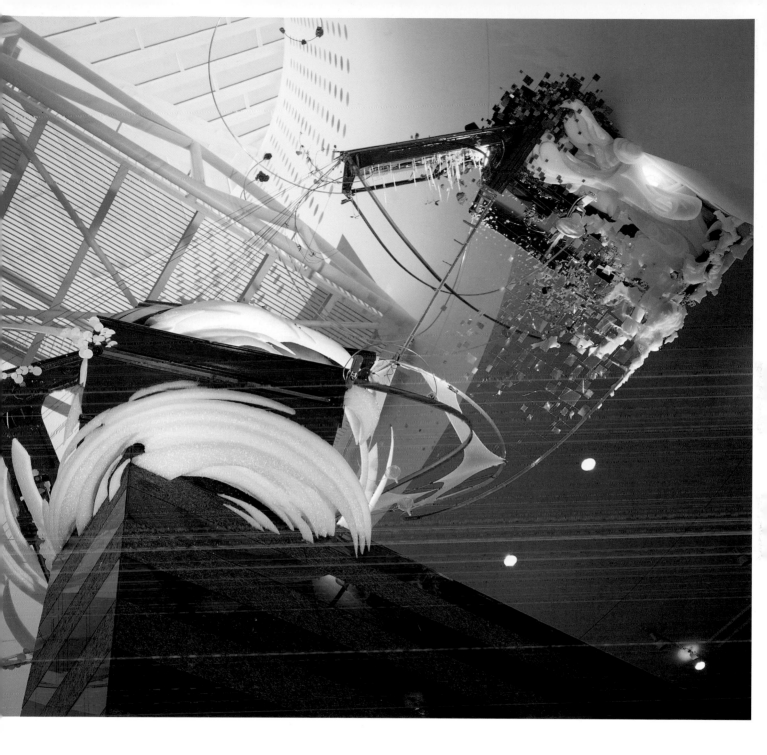

EDUCATION
↓
1994 BA, Otis Parsons, Los Angeles.
1997 MFA, University of California, Los Angeles.
↓
SOLO EXHIBITIONS
↓
1998 Richard Telles Fine Art, Los Angeles.
2001 Richard Telles Fine Art, Los Angeles.
↓
SELECTED GROUP EXHIBITIONS
↓
1999 **Happy Trails**, College of Creative Studies,
University of Santa Barbara, CA.
Hot Spots, Weatherspoon Gallery, University
of North Carolina, Greensboro, NC (and tour).
Drive-By: New Art from LA, South London
Gallery, London (and tour).
Profane Gardens, Guggenheim Gallery,
Chapman University, Orange, CA.
Liz Craft and Penti Monkkonen, Sadie Coles HQ,
London.
2000 **Good Luck For You**, Transmission Gallery,
Edinburgh.
California Dreamin, Gallery of Art, Carlsen Center,
Johnson County Community College, KS.
Small Worlds: Dioramas in Contemporary Art,
Museum of Contemporary Art, San Diego, CA.
Mise en Scène: New LA Sculpture, Santa Monica
Museum of Art, Santa Monica, CA (and tour).∗
↓
SELECTED BIBLIOGRAPHY
↓
1998 Pagel, David, 'Liz Craft', **Los Angeles Times**,
Los Angeles, 5 June 1998, pp 24-25.
Hainley, Bruce, 'Self Portrait as the Garden',
Frieze, London, September-October 1998,
pp 70-71.
Duncan, Michael, 'Liz Craft', **Art in America**,
New York, December 1998, p 103.
2000 Miles, Christopher, 'The Windmills of Her Mind',
Flaunt, Los Angeles, March 2000, pp 170-174.
Hainley, Bruce, 'Towards a Funner Laocoön',
Artforum, New York, Summer 2000, pp 166-173.

∗ Exhibition publication produced

liz craft.

BORN IN LOS ANGELES, 1970.
LIVES IN LOS ANGELES.

Look at all the objects that surround you right now—
what would happen if the textures on these things
suddenly shifted from one thing to the next? These are
the kind of stream-of-consciousness speculations
that drive the work of Liz Craft. Craft is a sculptor of
imposing scale and imagination. Her objects are at once
both referential and abstract—in fact, they are most
suggestively referential when most clearly abstract.

Take **Bullet Proof Snake** (1999). This certainly
represents a snake—some fourteen feet of which rise
from its coiled base—but a snake with a difference.
On the way up, Craft's diverse materials rub up against
each other while retaining their individual associations.
Suede mixes with vinyl, Astroturf with simulated
leather. At about head height a pinkish section curves
to form a C. This segment is also charged with digesting
(along with a few doughnuts) the remaining letters of
the artist's signature: R-A-F-T. A long index finger with
a red polished nail emerges in place of the serpent's
tongue. Craft has tied a piece of string around this
finger in a neat bow as if to remind her—and us—to
take pleasure in materials and things.

Lazy Daze (1999) is a delirious example of Craft's ability
to cast abstraction in the least obvious roles. Here a
Pac Man figure runs wild in a multi-coloured daydream
that could be situated in the abstract systems of a high
school chemistry class. Finally, **Black Widow** (2000),
which features a kind of mutated spider, is among
Craft's most direct efforts to re-enchant the world
of sculpture—through the shape both of what is known
and what is only imagined.

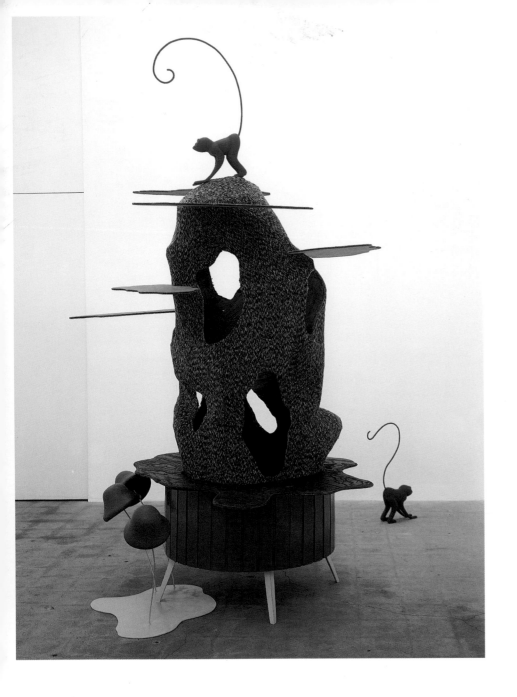

liz craft.
Monkey Puzzle, 1998.
Mixed media,
120 x 48 x 48"/ 305 x 122 x 122cm.

Right: Bullet Proof Snake, 1999.
Mixed media,
168 x 48 x 60"/ 428 x 122 x 152cm.

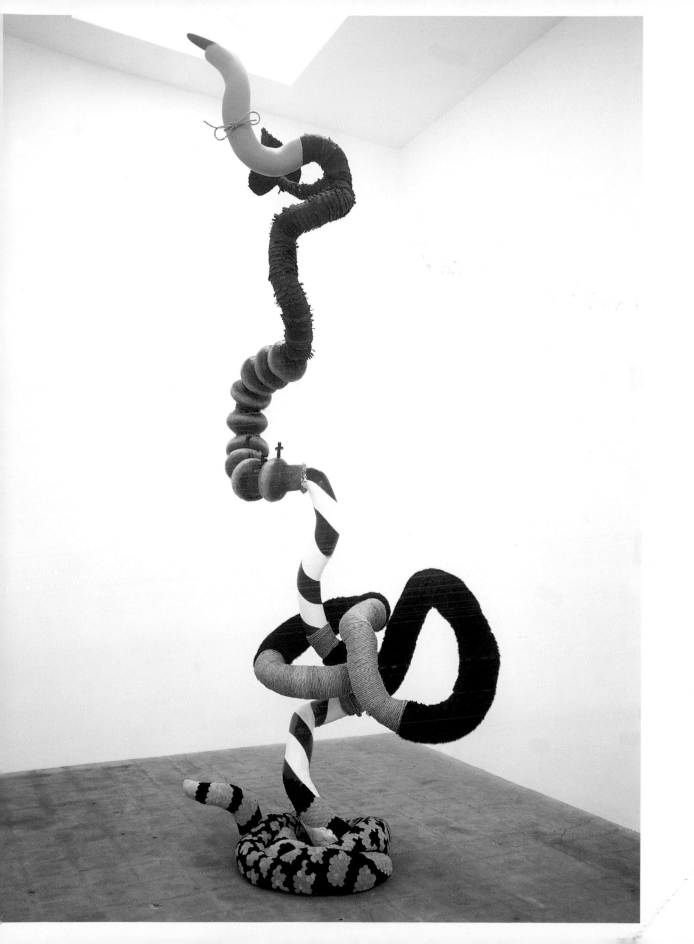

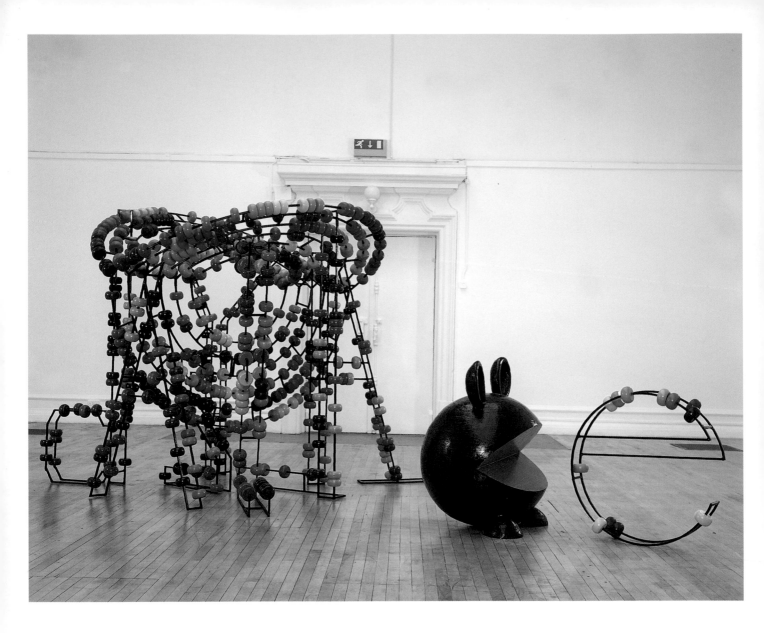

liz craft.
Lazy Daze, 1999.
Metal, wood and enamel paint,
dimensions variable.

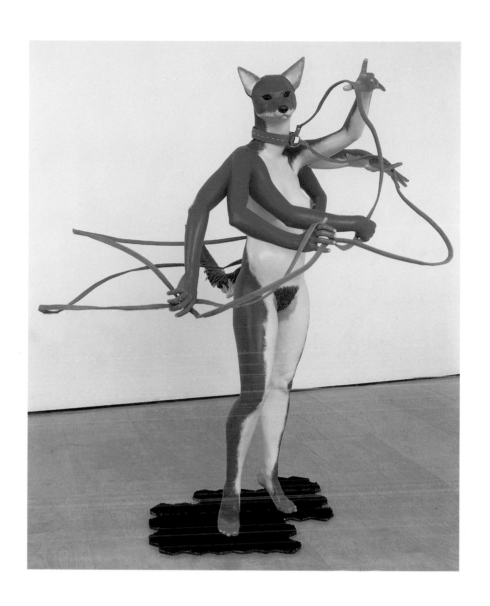

liz craft.
Foxy Lady, 1999.
Fibreglass, steel, carpet and enamel paint,
71 x 55 x 55" / 180 x 140 x 140 cm.

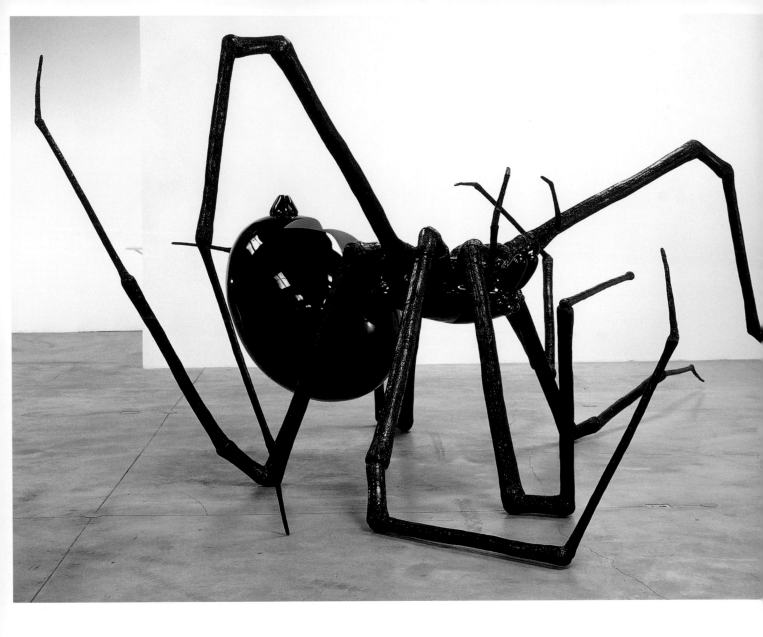

liz craft.
Black Widow, 2000.
Fibreglass and paint,
180 x 180 x 120" / 457 x 457 x 305cm.

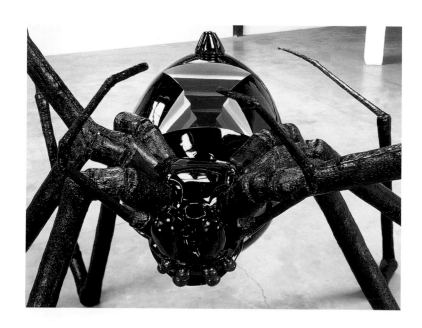

EDUCATION
↓
1982 BFA, University of Tulsa, OK.
1992 MFA, University of Illinois, Chicago.
↓
SELECTED SOLO EXHIBITIONS
↓
1995 Museum of Contemporary Art, Chicago.
1998 Art Institute of Chicago, Chicago.
Worcester Art Museum, Worcester, MA.
The Renaissance Society, University of
Chicago, Chicago.*
Wooster Gardens/Brent Sikkema, New York.
1999 Zeno X Gallery, Antwerp, Belgium.
2000 Centre d'Art Contemporain, Geneva.
ArtPace, San Antonio, TX.
Brent Sikkema Gallery, New York.
2001 UCLA Hammer Museum, Los Angeles.*
↓
SELECTED GROUP EXHIBITIONS
↓
1996 **Arturo Herrera and Carla Preiss**,
Thread Waxing Space, New York.
1998 **Arturo Herrera and Kara Walker**,
Stephen Friedman Gallery, London.
1999 **Life Cycles**, Galerie für Zeitgenössische
Kunst, Leipzig.
Color Me Blind!, Württembergischer Kunstverein,
Stuttgart (and tour).*
Istanbul Biennial, Istanbul.
TroubleSpot, Painting, MUHKA, Antwerp,
Belgium.*
2000 **Greater New York**, PS1/MoMA, New York.*
From a Distance: Approaching Landscape,
The Institute of Contemporary Art, Boston.
2001 **Painting at the Edge of the World**, Walker Art
Center, Minneapolis, MN (and tour).*
↓
SELECTED BIBLIOGRAPHY
↓
1998 Camper, Fred, 'Arturo Herrera', **Chicago Reader**,
Chicago, 13 February 1998, pp 28-29.
Morgan, Jessica, 'Arturo Herrrera', **Grand Street**,
New York, Fall 1998, p 229.
1999 Helguera, Pablo, 'Arturo Herrera, The Edges
of the Invisible', **Art Nexus**, Miami,
August-October 1999, pp 48-52.
2000 Cruz, Amada, 'Arturo Herrera', **Fresh Cream**,
Phaidon Press, London, 2000, p 328.
2001 Caniglia, Julie, 'Arturo Herrera', **Artforum**,
New York, January 2001, p 138.

* Exhibition publication produced.

arturo herrera.

BORN IN CARACAS, VENEZUELA, 1959.
LIVES IN NEW YORK.

↓

Artuto Herrera's practice is largely based on subtraction and effacement. What we see in his art is perhaps less significant than that which is missing — that which registers only in the imagination. In his work, which includes wall paintings, fabric pieces and works on paper, Herrera draws heavily on the past, merging the imagery of a twentieth-century childhood with strains of abstraction and Surrealism.

↓

The childhood that features in Herrera's art is one filtered through the entertainment industry, through cartoons and colouring books (his use of felt also has strong associations with children's art projects). His works are characterised by their use of negative space and these hollowed out forms — like the Abstract Expressionist paintings that they sometimes resemble — make unsettling demands, asking to be filled with a content that only the viewer can supply

↓

In Herrera's large monochromatic wall paintings, fragments of pop culture congeal and then just as suddenly disperse amongst a swimming overlay of latex paint. In **When Alone Again** (2001), the figure of Snow White is colonized by globs of the same dripping red paint from which her outline is formed. On the wall opposite, a tangle of dwarfs vie for autonomy with a similar configuration of post-painterly marks. The original source of these images is in film, and Herrera retains some of the scale and magic of the big screen, while investigating the implications of its projection onto an architectural site.

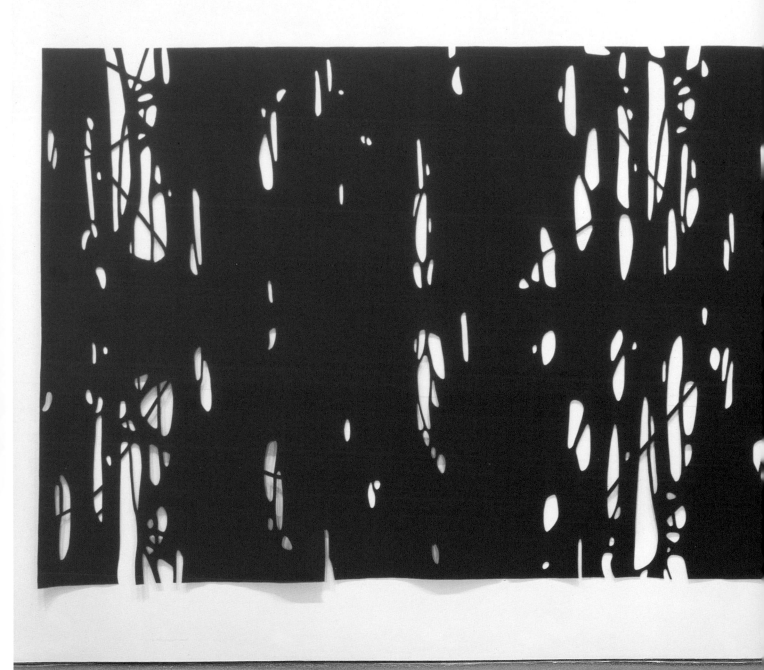

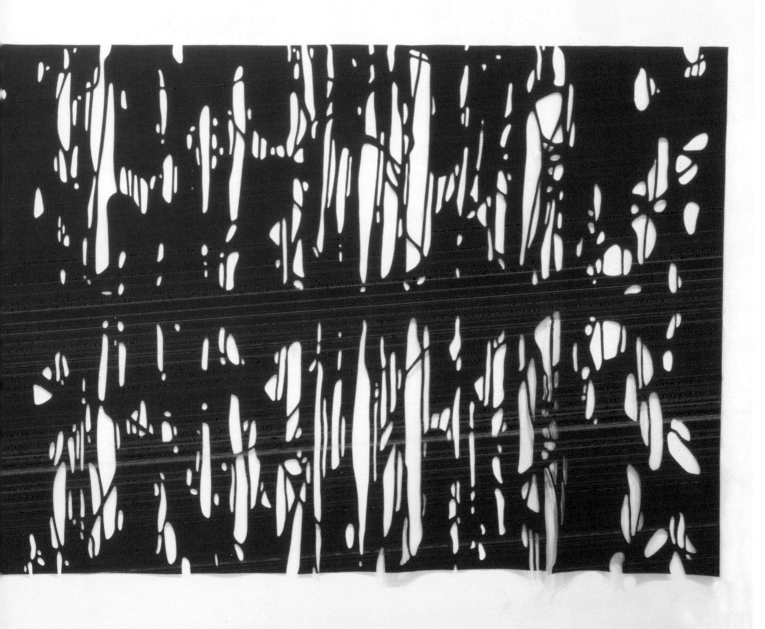

Previous page:
arturo herrera.
I Am Yours, 2000.
Wool felt, 64 x 192"/ 163 x 488cm.

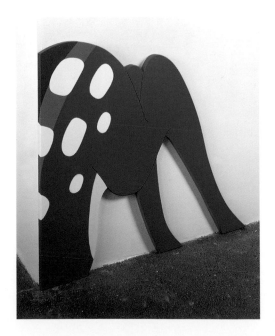

arturo herrera.
Still, 2000.
Urethane paint on MDF,
25 x 28"/ 64 x 71cm.

Right: Untitled, 2000.
Collage and watercolour on paper,
16 x 13"/ 41 x 33cm.

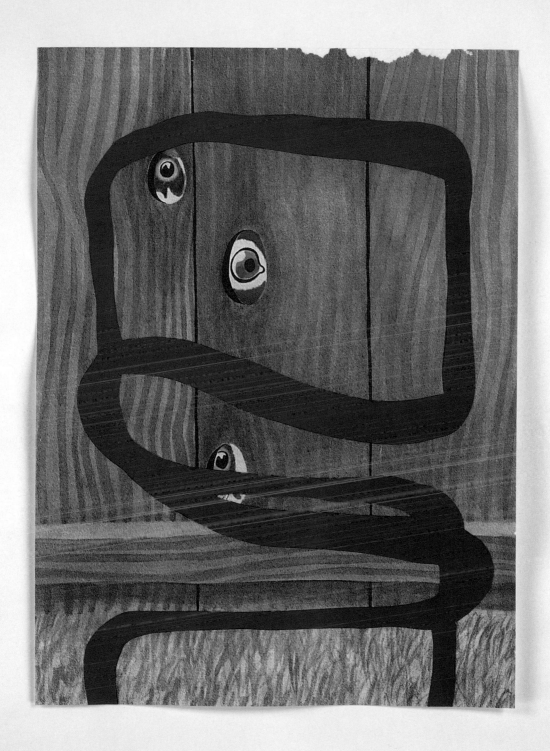

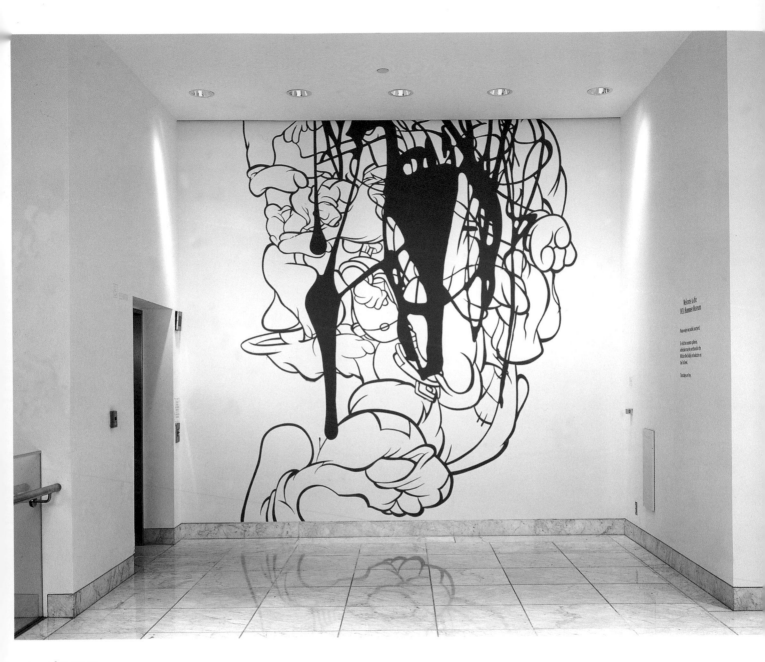

arturo herrera.
When Alone Again, 2001.
Latex on wall.
Installation at the UCLA Hammer Museum,
Los Angeles.

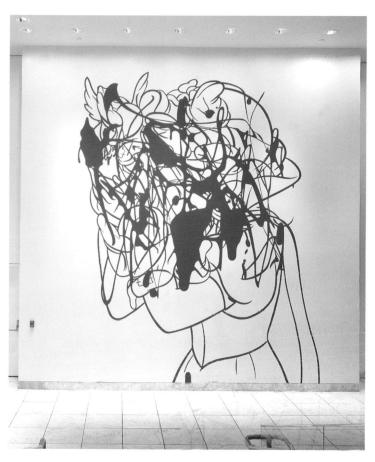

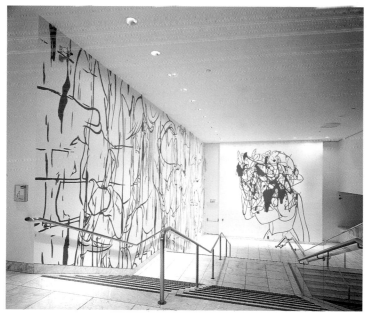

EDUCATION
↓

1984 BA, University of California, Los Angeles.
1995 MFA, University of California, Los Angeles.
↓

SOLO EXHIBITIONS
↓

1995 Dan Bernier Gallery, Santa Monica, CA.
1996 Jay Gorney Modern Art, New York.
1997 **Commotion: Martin Kersels**, Madison Art Center,
 Madison, WI.*
1998 Dan Bernier Gallery, Los Angeles.
 Theoretical Events, Th.e, Naples.
1999 Dan Bernier Gallery, Los Angeles.
 Galerie Georges-Philippe & Nathalie Vallois, Paris.
2000 Kunsthalle Bern, Bern.
 Deitch Projects, New York.
2001 ACME, Los Angeles.
 Tumble Room, Deitch Projects, New York.
↓

SELECTED GROUP EXHIBITIONS
↓

1994 **L.A.X. - The L.A. Biennial**, Otis Parsons Gallery,
 Los Angeles.
1995 **La Belle et La Béte**, Musée d'Art Moderne de la
 Ville de Paris, Paris.
1996 **Power of Suggestion: Narrative and Notation in
 Contemporary Drawing**, Museum of
 Contemporary Art, Los Angeles.
 **Defining the Nineties: Consensus-Making in
 New York, Miami, and Los Angeles**, Museum of
 Contemporary Art, Miami, FL .*
1997 **Cruising L.A.**, Soledad Lorenzo, Madrid.*
 Whitney Biennial, Whitney Museum of American
 Art, New York.*
1998 **Young Americans 2**, Saatchi Gallery, London.*
1999 **Melbourne Biennial**, Melbourne.*
2000 **Departures: 11 Artists at the Getty**, J. Paul Getty
 Museum, Los Angeles.
↓

SELECTED BIBLIOGRAPHY
↓

1998 Gerstler, Amy, 'Martin Kersels', **Artforum**,
 New York, May 1998, p 155.
1999 Knight, Christopher, 'That's Show Biz', **The Los
 Angeles Times**, Los Angeles, 16 September
 1999, p 24.
 Sanders, Mark, 'Totally Wired', **Dazed & Confused**,
 London, No 30, 1999, pp 51-53.
2000 Pagel, David, 'Inspiring Links between Art and
 Science', **The Los Angeles Times**, Los Angeles,
 18 August 2000, p F2 -3.
2001 Duncan, Michael, 'The Serious Slapstick of Martin
 Kersels', **Art in America**, New York, April 2001,
 pp 120-125.

* Exhibition publication produced

martin kersels.

BORN IN LOS ANGELES, 1960.
LIVES IN LOS ANGELES.

↓

Martin Kersels is one of the few artistic figures whose stature cannot be denied. Kersels is a big artist—clocking in at 6' 7" and 300 lbs. He has a background in performance, and bodies in space and motion —subject to the laws of gravity and slapstick—figure prominently in his boisterous but deceptively subtle art.

↓

Kersels combines aspects of performance, sound and kinetic art in a practice that exploits the chaos inherent in comedy. In **Tumble Room** (2001), he constructed a teenage girl's bedroom that rotated within a cylindrical frame. As the room spun, the contents crashed against the wastelands of suburbia and childhood. This piece was also used as the set for a video, **Pink Constellation** (2001). Here a camera rotates in sync with the room while Kersels and the performer Melinda Ring frolic on the shifting walls and ceiling. Comprised of twelve short alternating segments, the video is a study in contrasts. Ring is agile and deadpan as she pirouettes and bends with the illusion. Kersels and his mass jiggle and struggle to find a place in the room. Finally, the objects lose their moorings and begin to crash and chase him around the space, unleashing the gravity that fuels the levity in his work.

↓

Whirling (1999) is a series of photos for which Kersels supplied friends with cameras, instructing them to shoot while he spun them around by their feet. In **Kouros and Me** (2000) he wrestles with a Styrofoam double of the infamous grinning Getty sculpture as he bounces on a trampoline. Like the spinning rubber bands of **Zephyr** (2001), Kersels' art oscillates wildly—only to find its power along a sublimely simple conceptual axis.

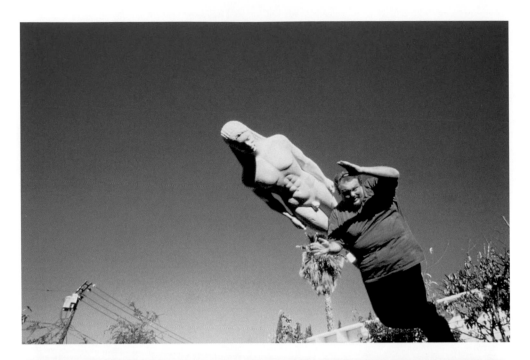

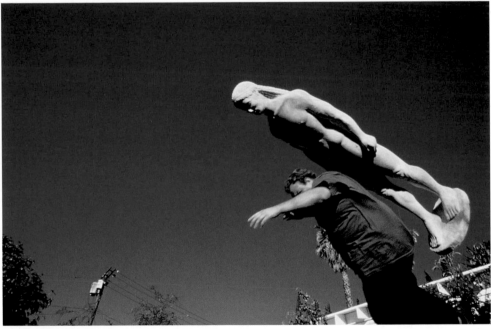

martin kersels.
Kouros and Me 1, 2000;
Kouros and Me 2, 2000; diptych.
Cibachrome prints,
each 48 x 71" / 122 x 180cm.

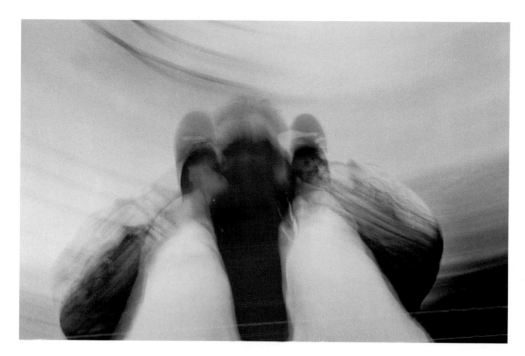

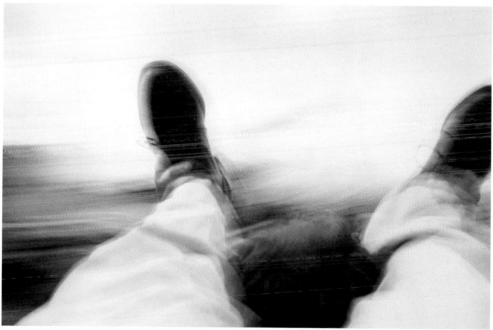

martin kersels.
Whirling Caryn, 1999;
Whirling Mr Keedy, 1999;
two parts from five-part series.
Cibachrome prints,
each 34 x 49" / 82 x 124cm.

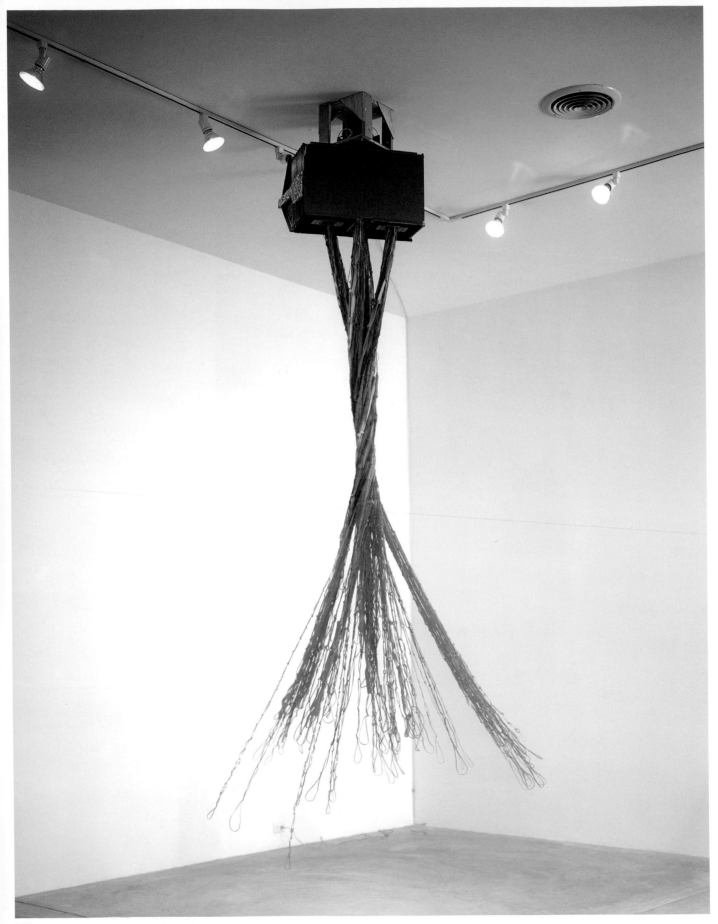

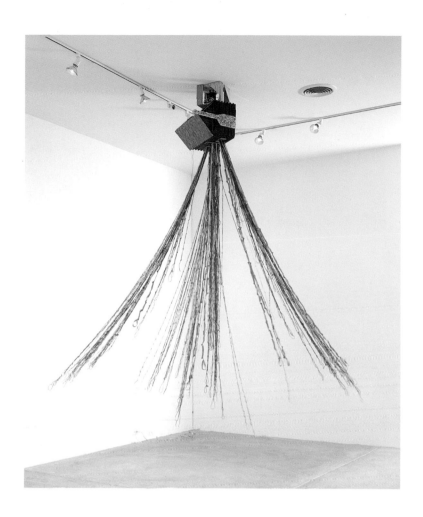

martin kersels.
Zephyr, 2001.
Rubber bands, wood and motor,
dimensions variable.

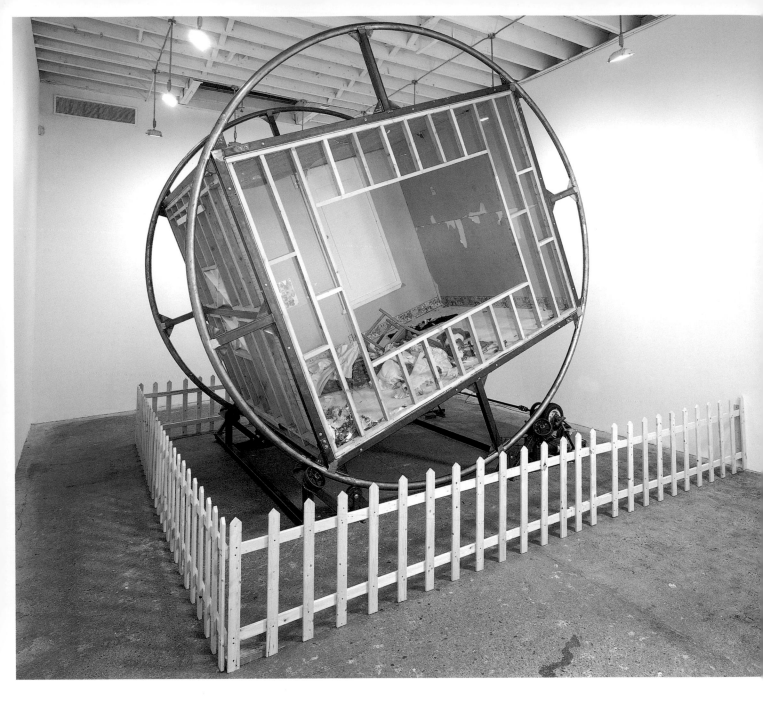

martin kersels.
Tumble Room, 2000
Mixed media. Dimensions of main piece:
diameter 180"/457cm, depth 120"/305cm.

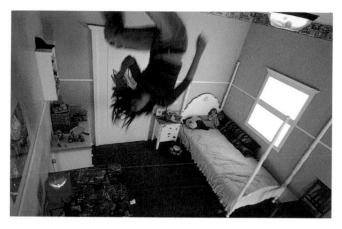

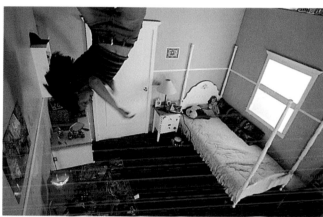

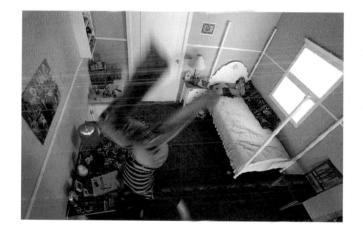

martin kersels.
Pink Constellation, 2001.
Single channel video on monitor, with sound,
20:16 minutes.

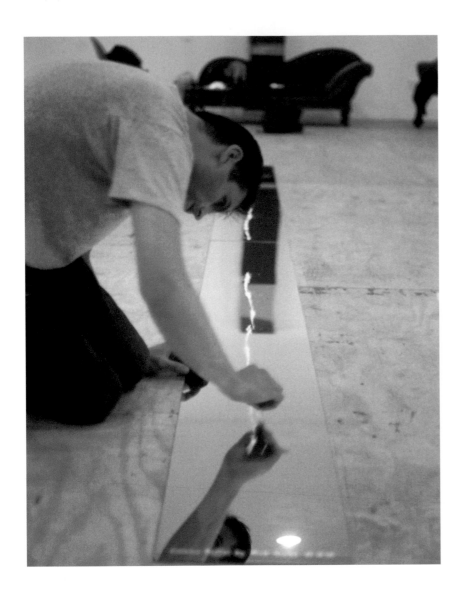

rob pruitt.
Cocaine Buffet, 1998.
Installation at Fifth International
(picture shows artist during set-up).

Right: **Eternal Bic,** 1999.
Bronze lighter, table and lighter fluid,
33 x 24" / 83 x 61cm.

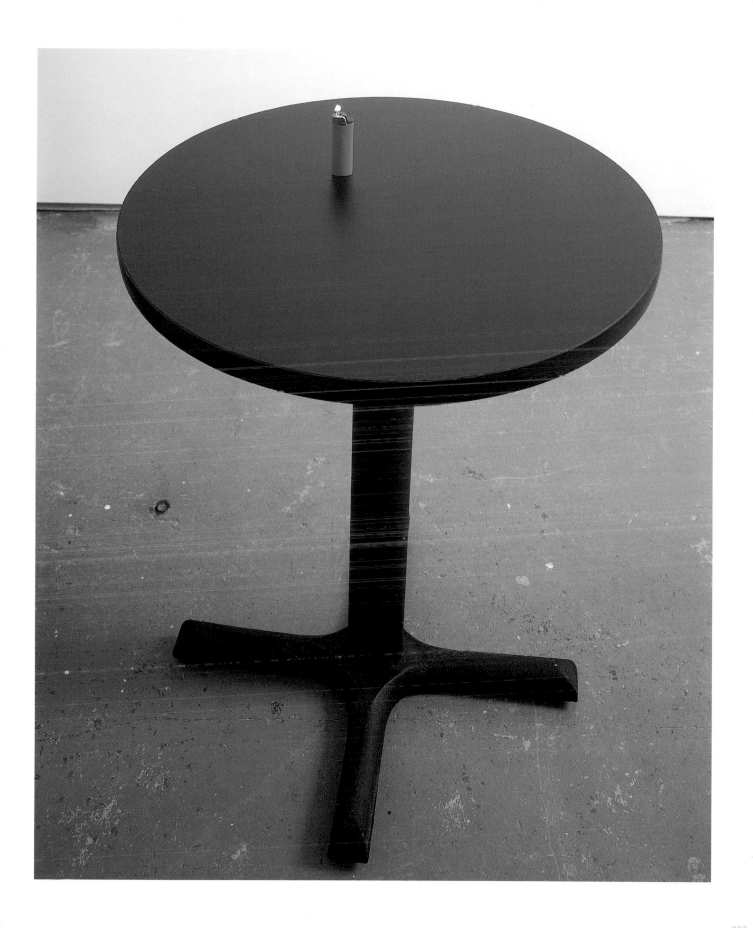

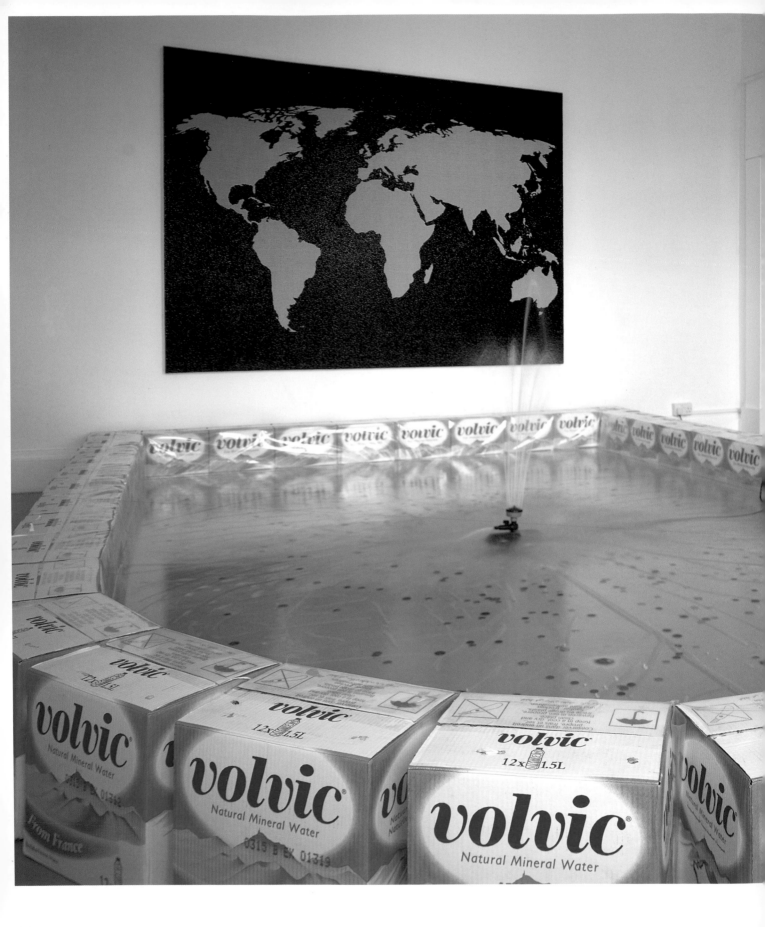

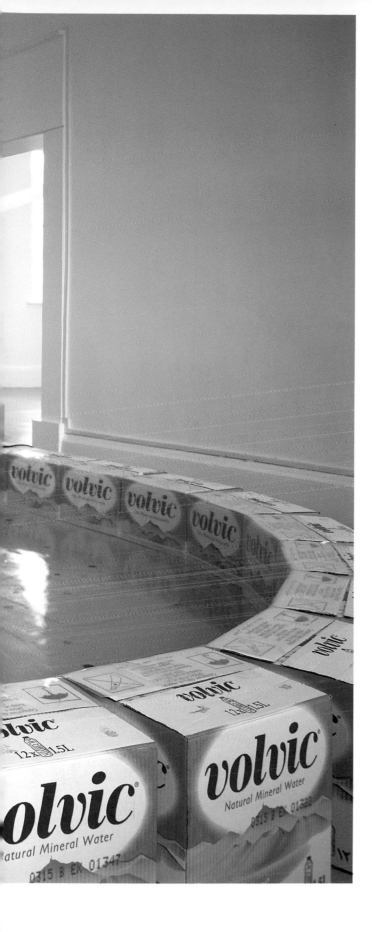

rob pruitt.
Background: **Black Glitter World**, 2001.
Enamel paint and glitter on canvas,
72 x 96" / 183 x 244cm.

Foreground: **Volvic Fountain**, 2001.
Electric pump, plastic sheeting and transformer,
dimensions variable.

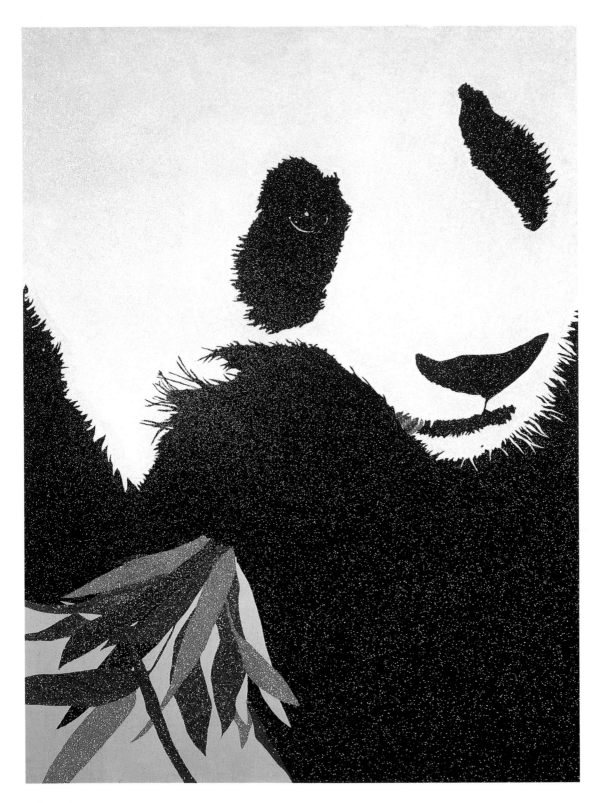

rob pruitt.
Panda and Bamboo, 2001.
Enamel paint and glitter on canvas,
98 x 72" / 249 x 183cm.

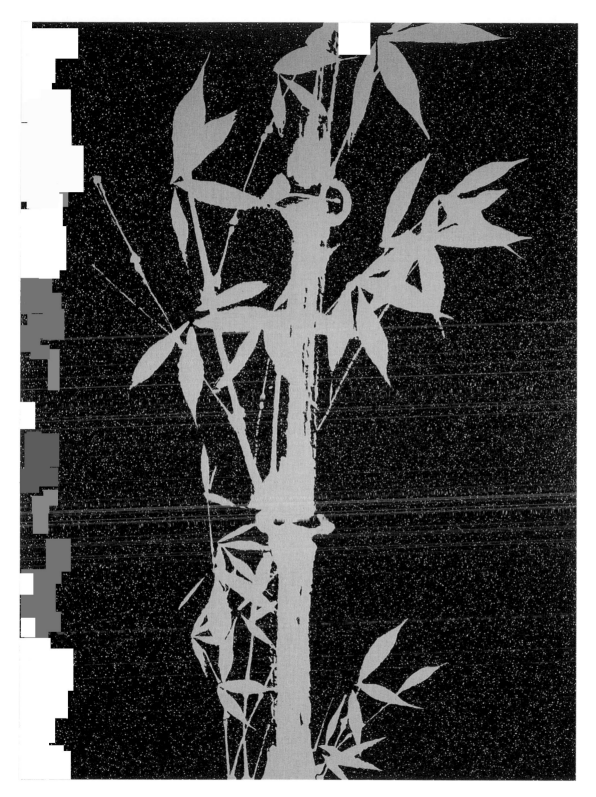

rob pruitt.
Moonlight Bamboo I, 2001.
Enamel paint and glitter on canvas,
98 x 72" / 249 x 183cm.

tony matelli.
Sleepwalker, 1997.
Polyester and paint,
65 x 20 x 30" / 165 x 51 x 76cm.

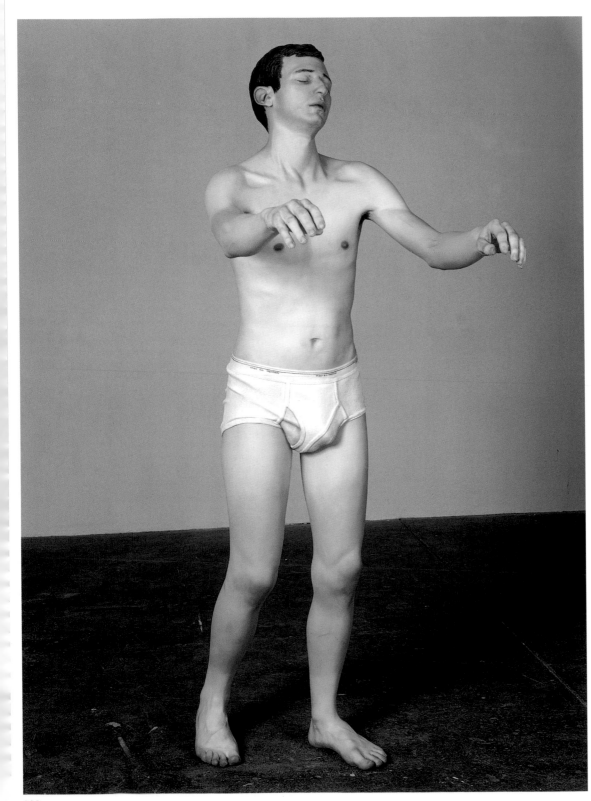

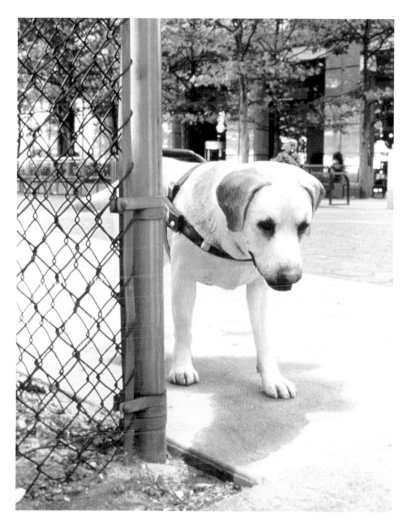

tony matelli.
Stray Dog, 1998.
Fiberglass and paint,
35 x 37 x 22" / 89 x 94 x 56cm.

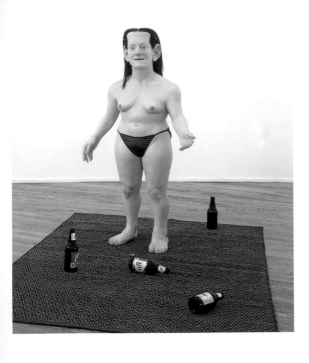

tony matelli.
Ideal Woman, 1998-99.
Polyvinyl acetate, human hair and paint,
46 x 24 x 32" / 117 x 61 x 81cm.

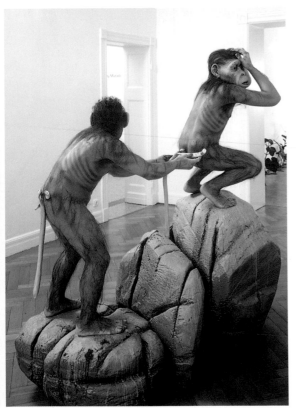

tony matelli.
Very, Very First Man:
Necessary Alterations, 1998-99.
Urethane, fibreglass and paint,
72 x 66 x 38" / 183 x 168 x 97cm.

Right: **Hopes and Dreams**, 1999.
Urethane, paint and printed money,
94 x 71 x 71" / 240 x 180 x 180cm.

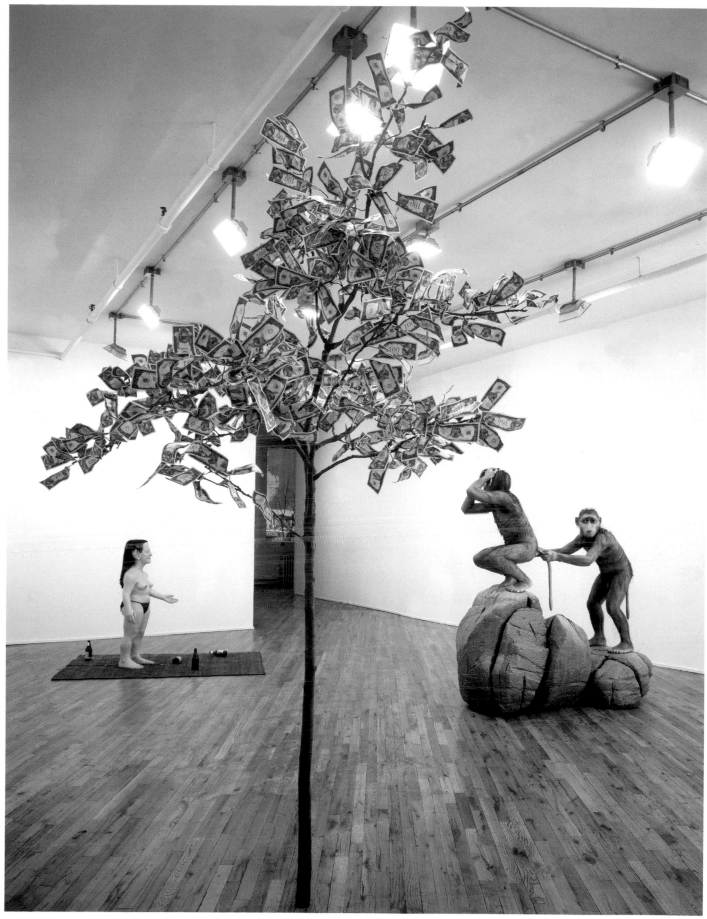

EDUCATION
↓
1992 BA, Kalamazoo College, Kalamazoo, MI.
1997 MFA, Rhode Island School of Design, RI.
↓
SELECTED SOLO EXHIBITIONS
↓
1996 **Paintings**, Sol Kofler Gallery, Providence, RI.
1998 Barbara Davis Gallery, Houston, TX.
1999 **Module**, Project Row Houses, Houston, TX.
2001 The Project, New York.
 Art Pace, San Antonio, TX.
↓
SELECTED GROUP EXHIBITIONS
↓
1998 **Text and Territory: Navigating through
 Immigration and Dislocation**, University Galleries,
 Illinois State University, Normal, IL.
 Core 1998, The Glassell School of Art,
 The Museum of Fine Arts Houston, Houston, TX.*
1999 **The Stroke**, Exit Art, New York.
 Texas Draws, Contemporary Arts Museum,
 Houston, TX.*
 Core 1999, The Glassell School of Art,
 The Museum of Fine Arts Houston, Houston, TX.*
2000 **Selections Fall 2000**, The Drawing Center,
 New York.
 Five Continents and One City, Museo de la
 Ciudad de Mexico, Mexcio City.
 Greater New York, PS1/MoMA, New York.
 Translations, Bard College Center for Curatorial
 Studies, Annandale-on-Hudson, NY.
2001 **Painting at the Edge of the World**, Walker Arts
 Center, Minneapolis, MN.
 Freestyle, Studio Museum in Harlem, New York.
 Casino 2001, Stedelijk Museum voor Actuele
 Kunst, Ghent, Belgium.
↓
SELECTED BIBLIOGRAPHY
↓
1998 Dewan, Shaila, 'Bugs to Beauty', **Houston Press**,
 Houston, TX, 30 July 1998, p 53.
1999 Dumbadze, Alexander, 'Julie Mehretu and Amy
 Brock', **New Art Examiner**, Chicago, September
 1999, np.
2000 Hoptman, Laura, 'Crosstown Traffic', **Frieze**,
 London, September-October 2000, pp 104-107.
 Anton, Saul, 'The Art World's Best-Kept Secret—
 Revealed!', **www.edificerex.com**, June 2000.

 * Exhibition publication produced

julie mehretu.

BORN IN ADDIS ABABA, ETHIOPIA, 1970.
LIVES IN NEW YORK.

↓

Julie Mehretu is a mapmaker who employs a complex of imaginary symbols, marks and tectonic fragments to generate macro and micro topographies in paint. Her paintings are fundamentally graphic, and have the look of schematic plans laid one upon the other. Mehretu in fact draws upon such sites as airports, arenas, schools, military installations, museums and government buildings, assembling a symbolic geography from these units that reveals an account of the formation of personal and communal identities.

↓

Back to Gondwanaland (2000) takes on the language of architecture and the city to confront aspects of globalisation. Three curvilinear structures based on the design of airport terminals ground the composition. These are contrasted with further architectural fragments that give way to layer upon layer of dots, coloured rectangles, personal symbols, scratches and innocent doodles. Mehretu builds up these fragments into a palimpsest of marks that appear to migrate, battle and socialise.

↓

By constructing such a cacophony of voices, claims, miscommunications and disconnections, Mehretu questions the claim of globalisation to bring us all nearer together in an electronic web of communication and exchange. In paintings like **Ringsite** (2000) much of the action takes place in a central pool. What is true of painting holds for political geography as well, where the limits on territorial expansion are defined by the edge.

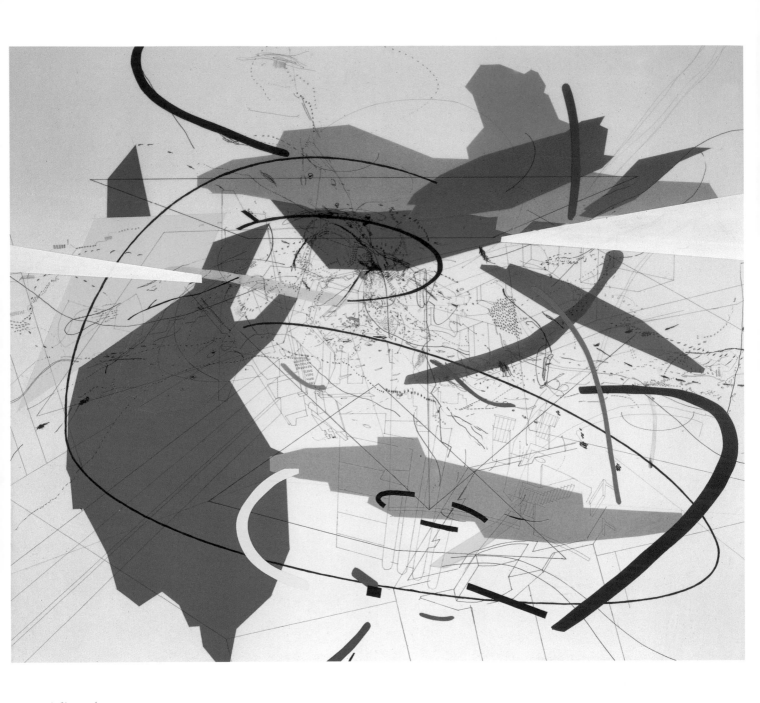

julie mehretu.
Untitled, 1999.
Ink and polymer on canvas,
60 x 72" / 152 x 182cm.

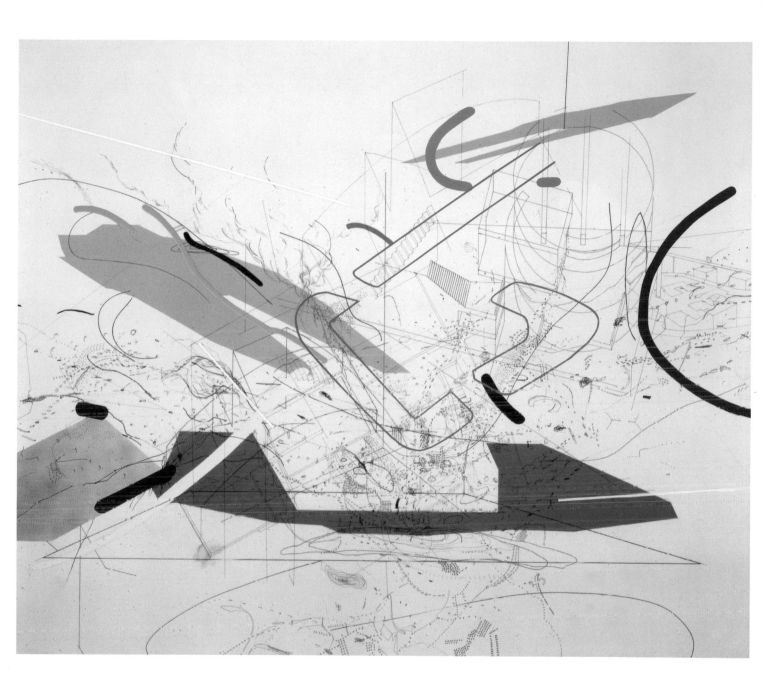

julie mehretu.
Untitled, 1999.
Ink and polymer on canvas,
60 x 72" / 152 x 182cm.

julie mehretu.
Ringsite, 2000.
Ink and polymer on canvas,
72 x 84" / 183 x 213cm.

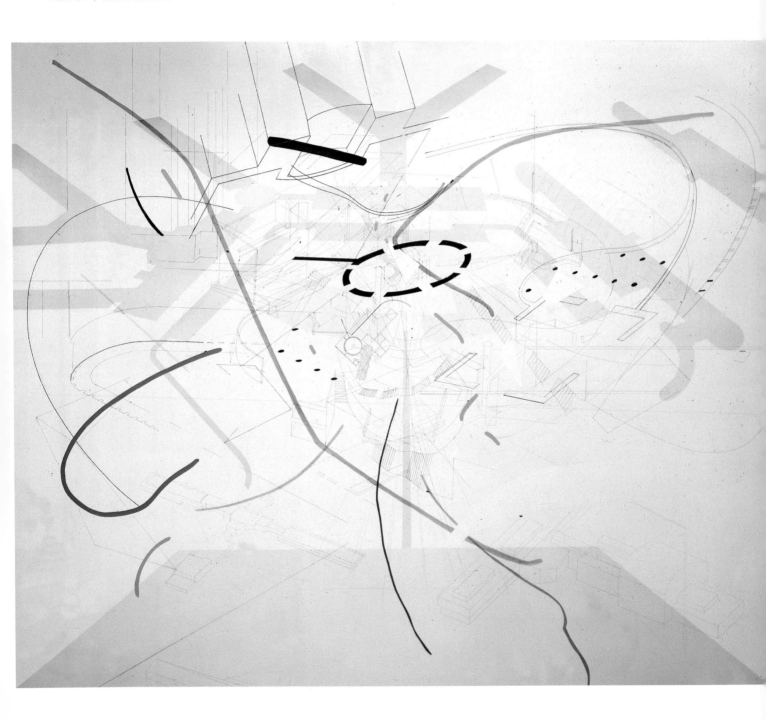

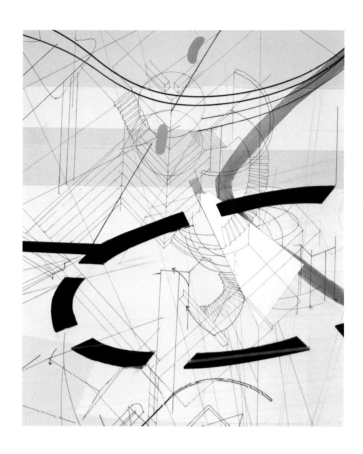

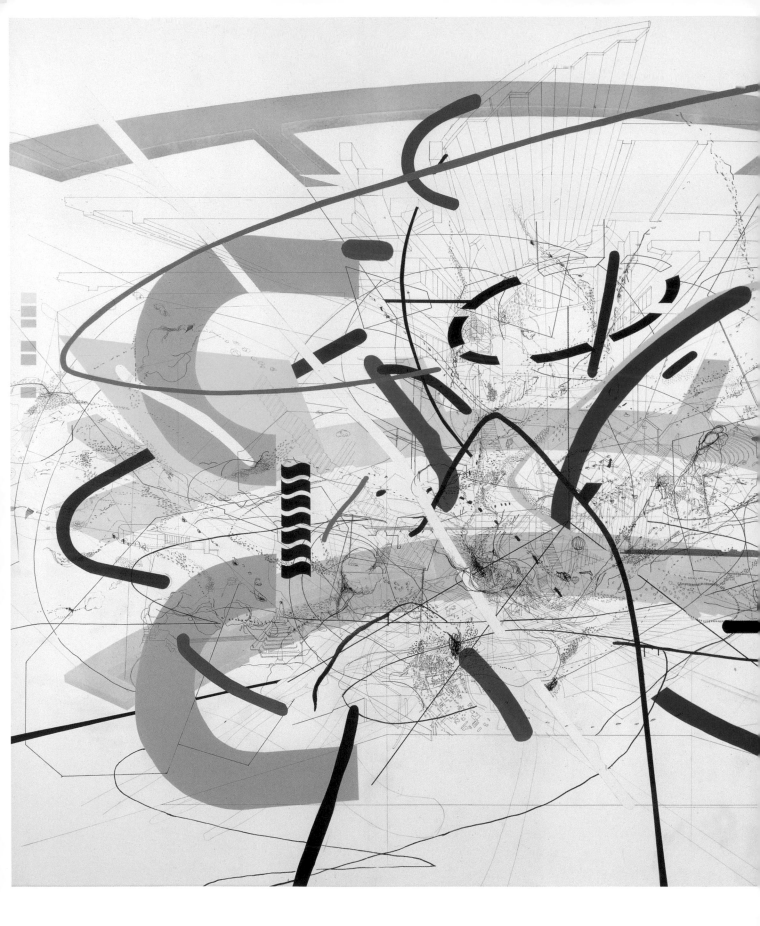

julie mehretu.
Back to Gondwanaland, 2000.
Ink and acrylic on canvas,
96 x 120" / 244 x 305cm.

EDUCATION
↓
1985 BA, Scripps College, Claremont, CA.
1990 Skowhegan School of Painting and Sculpture, Skowhegan, ME.
1991 MFA, Center College of Design, Pasadena , CA.
↓
SELECTED SOLO EXHIBITIONS
↓
1995 **Summer Work**, Shoshana Wayne Gallery, Santa Monica, CA.
1997 **Animal Flood**, I-20 Gallery, New York.
1998 Greengrassi, London.
1999 China Art Objects, Los Angeles.
2000 China Art Objects, Los Angeles.
2001 **Thoughts on Owls by Men of Letters**, Antiquariat Buchholz, Cologne.
 Galleria Francesca Kaufmann, Milan.
 Neugerriemschneider, Berlin.
↓
SELECTED GROUP EXHIBITIONS
↓
1995 **Filmcuts**, Neugerriemschneider, Berlin.
 Neotoma, Otis Art Gallery, Los Angeles.
1996 **Landscape Reclaimed**, The Aldrich Museum, Ridgefield, CT.★
 Open House, Williamson Gallery, Art Center College, Pasadena, CA.★
1997 **Enterprise**, Institute of Contemporary Art, Boston.★
 Elusive Paradise, Museum of Contemporary Art, Los Angeles.
 New Grounds, University of South Florida Contemporary Art Museum, Tampa, FL.
1998 **Abstract Painting, Once Removed**, Contemporary Arts Museum, Houston, TX.★
 LA Current Looking at the Light, UCLA Hammer Museum, Los Angeles.
 Hirsch Farm Project Now, Museum of Contemporary Art Chicago, Chicago.
1999 **What if**, Moderna Museet, Stockholm.
 Against Design, Institute of Contemporary Art, Philadelphia, PA.
2000 **circles °3 Silverlake Crossings**, Zentrum für Kunst und Medientechnologie, Karlsruhe, Germany.
 LA, Monika Sprüth Galerie, Cologne.
↓

SELECTED BIBLIOGRAPHY
↓
1999 McFarland, Dale, 'Pae White', **Frieze**, London, March-April 1999, pp 66-67.
 Intra, Giovanni, 'La struttura mobile', **Tema Celeste**, Milan, February 1999, pp 50-55.
 Tumlir, Jan, 'The Nouveau Objet', **Art/Text**, Los Angeles, May-July 1999, pp 40-43.
2000 Myers, Terry, 'Pae White', **Art/Text**, Los Angeles, May-July 2000, pp 85-86.

★ Exhibition publication produced

pae white.

BORN IN PASADENA, CA, 1963.
LIVES IN LOS ANGELES.

↓

For a decade now, Pae White has been designing books, catalogues, brochures, advertisements and posters – commissioned works that are indistinguishable in type from the projects of a jobbing graphic designer. What is different about these designs is that they are not meant as adjuncts to the artist's main work, but constitute a fundamental part of her practice – which absorbs content from graphic design, as well as from architecture, furniture design and digital media.

↓

White's work, both that conventionally considered design and what could be accepted as the contents of an art gallery, is characterised by a tendency towards overlapping compound shapes, crisp saturated colours and a diaphanous handling of space and light. These are largely straightforward aesthetic qualities, but the meaning in White's work is much more elusive – residing largely in its curious inter-disciplinary position.

↓

White's hanging paper pieces, sculptures, graphic prints, photos and installations are effortlessly simple. Yet their very unpretentiousness gives her work its edge. **Gemini** (2001) and **Libra** (2001) are two in a series of hanging paper constructions named after the signs of the zodiac. They could be taken for clocks, or for prototypes of some sort of cosmic calendar. **Birds and Ships** (2001) sums up White's amalgamated enterprise, where fugitive art content is mixed with equal parts design to create something that transcends each.

pae white.
Above: Aviary, 2000-2001.
Paper and thread, dimensions variable.

Below: Birds and Ships, 2001.
Plexiglass, 72 x 360" / 183 x 914cm.

pae white.
Storyboard for a Partial Peacock, 2000.
Paper, press-type and thread,
dimensions variable.

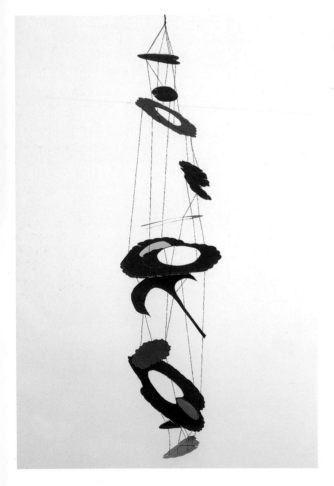

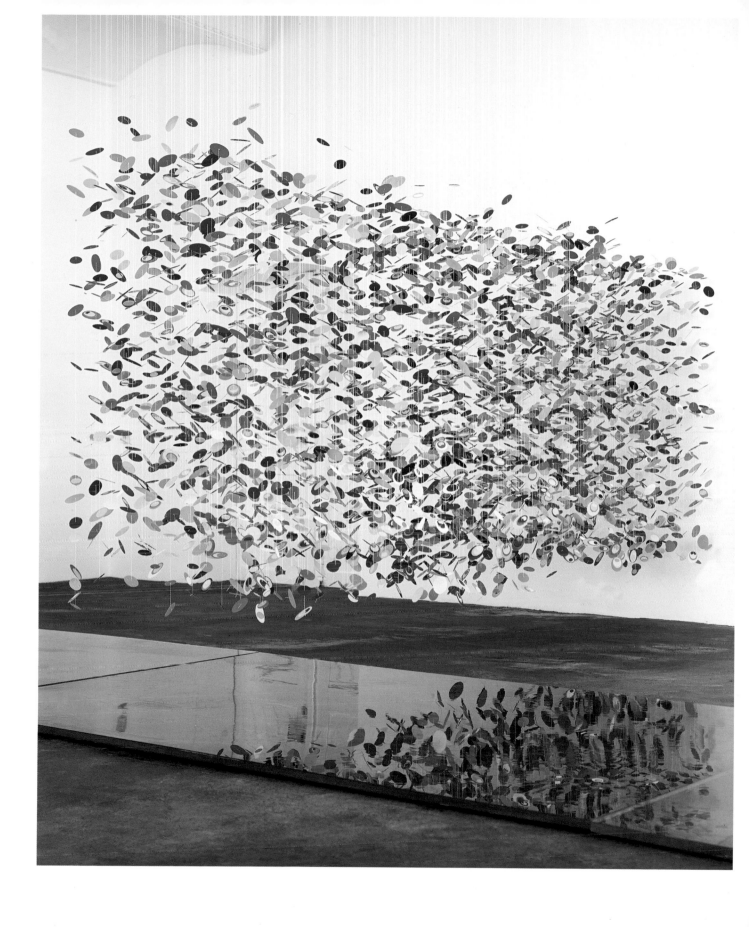

pae white.
Gemini, 2001.
Paper and thermometer,
16 x 9 x 8" / 40 x 24 x 20cm.

pae white.
Virgo, 2001.
Paper and clock mechanism,
14 x 9 x 9" / 35 x 23 x 24cm.

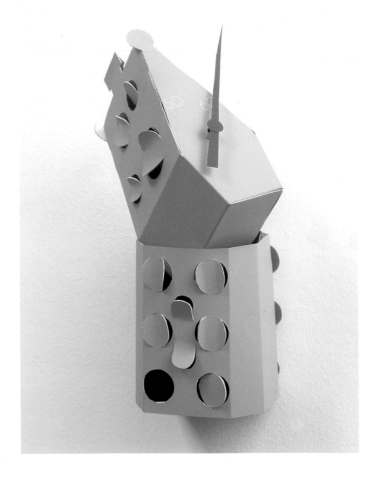

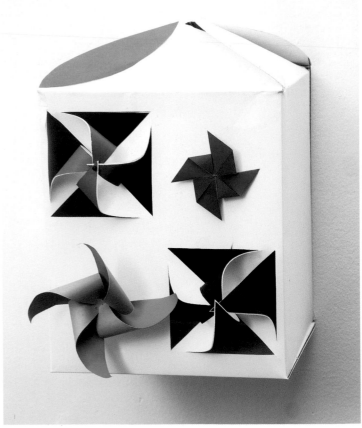

pae white.
Libra, 2001.
Paper and clock mechanism,
22 x 8 x 8" / 55 x 20 x 21cm.

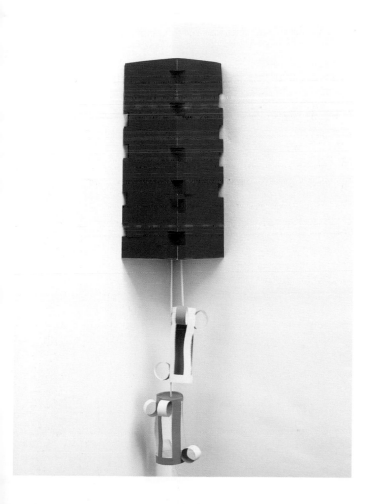

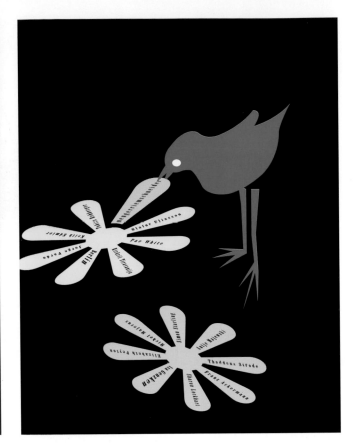

pae white.
Poster design;
part of catalogue for **What If**,
Moderna Museet, Stockholm,
2000-01.

pae white.
Advertisement design;
for Neugerriemschneider, Berlin,
published in **Frieze**,
London, 2001.

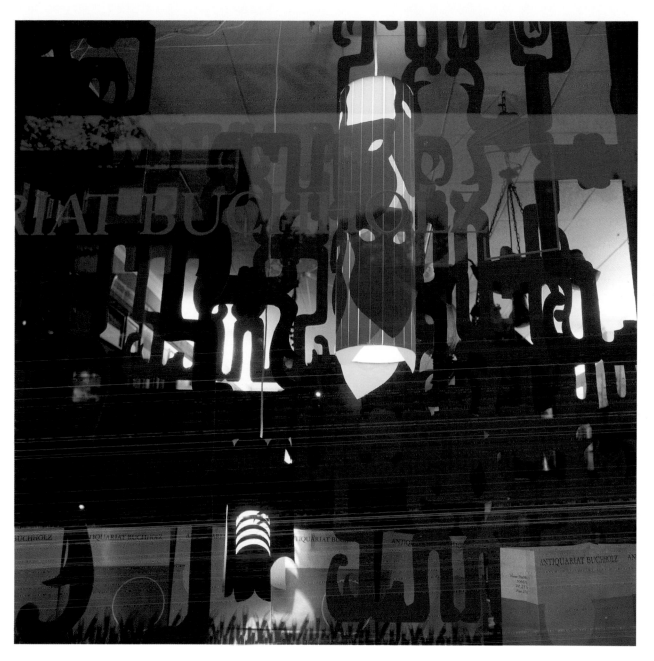

pae white.
Thoughts on Owls by Men of Letters, 2001.
Mixed media, dimensions variable.
Installation at Antiquariat Buchholz, Cologne.

t.j. wilcox.
Photographs of the film Hadrian and Antinous, 2000 (triptych).
R-prints, each 16 x 20" / 41 x 51cm.

t.j. wilcox.
The Little Elephant, 2000.
16mm colour film, silent,
4:38 minutes.

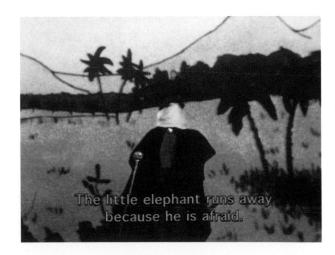

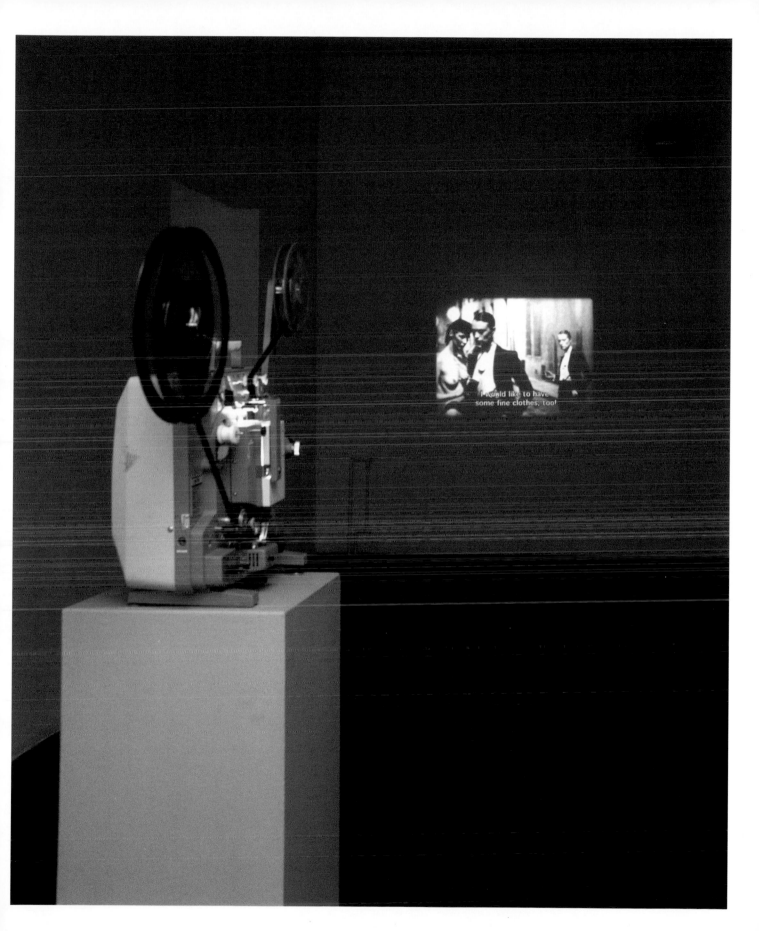

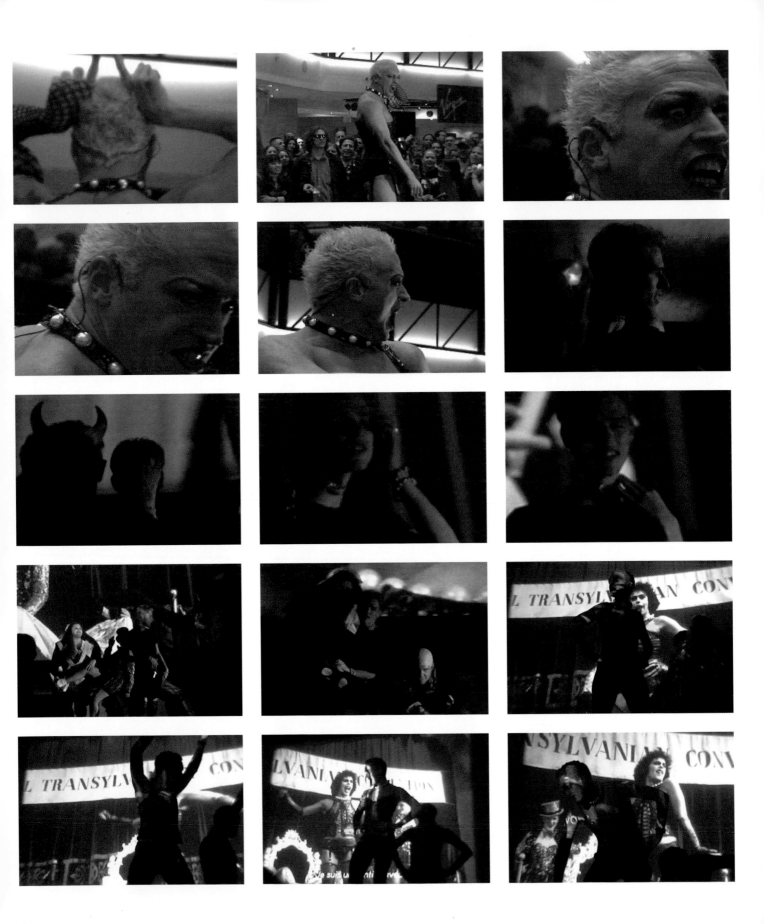

t.j. wilcox.
Midnite Movie (work in progress).
Single channel video projection,
with sound

SELECTED PROJECTS

↓

1996 Dance Floor.
1997 Joy of Photography.
1998 More Joy of Photography.
 The Nazis.
 Full Burn.
1999 A mosaic - DK Smyk, Warszawa, Poland.
 Summer Love –
 The First Polish Western (ongoing).
2000 Twin Moons.
 A Norwegian Photograph.
2001 The Deep.
 Special Sneak Preview.
 A façade illumination design, Dabrowa
 Niemodlinska, Poland.

↓

SELECTED BIBLIOGRAPHY

↓

1996 Mir, Aleksandra, 'Ouverture: Piotr Uklanski',
 Flash Art, Milan, October 1996, p 107.
1997 Higgie, Jennifer, 'Piotr Uklanski', **Frieze**, London,
 December 1998, pp 83-84.
2000 Szymczyk, Adam, 'A Flaming Star, **Nu** (Vol II, No 2),
 Stockholm, 2000, pp 60-65.
 Sanders, Mark, 'Something I Prepared Earlier',
 Dazed and Confused, London, August 2000,
 pp 70-73.
2001 Simpson, Bennett, 'Piotr Uklanski', **Frieze**,
 London May 2001, pp 93-94.

piotr uklanski.

BORN IN WARSZAWA, POLAND, 1968.
LIVES IN NEW YORK AND WARSZAWA.

↓

Piotr Uklanski deals in the seductive currency of pop cultural stereotypes and visual clichés. Working in photography, film, social sculpture and architecture, Uklanski reanimates that which is degraded by rekindling its immanent magic. His work—banal, romantic and beautiful—has a volatile edge and can be as irritating and apparently exploitative as it is mesmerizing.

↓

In **The Joy of Photography** (an ongoing project since 1997), Uklanski has reworked a series of photographic icons, including flowers, sunsets and tigers—drawing on their symbolic currency while undermining the idealised stereotype of a fine art photographer and his subjects. **Sneak Preview** (2001) presented bootlegged video copies of Hollywood films and shifted their black market allure to the public space of a museum. The context clearly alters how such works are received and Uklanski exploits such situations to great effect—as was the case with the media circus generated by his series of photographs of actors playing Nazis. Uklanski's images made of crayon shavings similarly exploit a by-product to create a confetti moment, empty of meaning but still bursting with potential content. These are gestures that draw their power on already given meanings and shifting contexts, but they are potentially combustible and explosive gestures none-the-less.

↓

In an absurdist twist on the already surreal Spaghetti Western, Uklanski has for some time been working on transferring the most American of film genres to his native Poland. This Pierogi Western is strangely well suited to the country, whose open plain is the wild frontier of western capital and where the image of Gary Cooper in **High Noon** was appropriated by Solidarity. It is a project doomed to succeed in excess, proving that romanticism will not have perished so long as Uklanski lives.

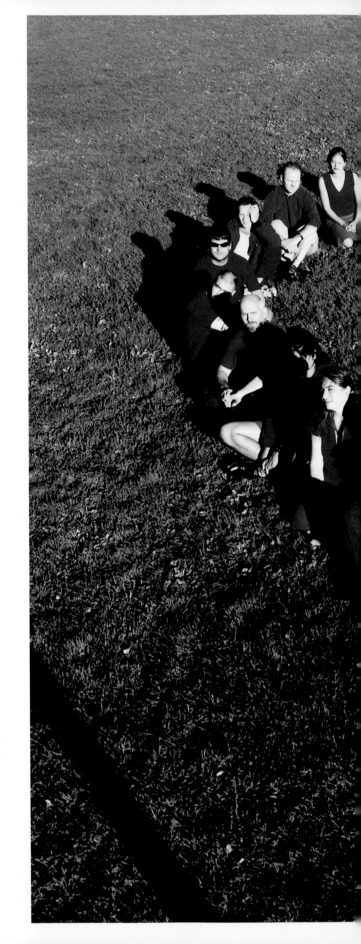

piotr uklanski.
A Norwegian Photograph, 2000.
Blueboard wallpaper print,
dimensions variable.

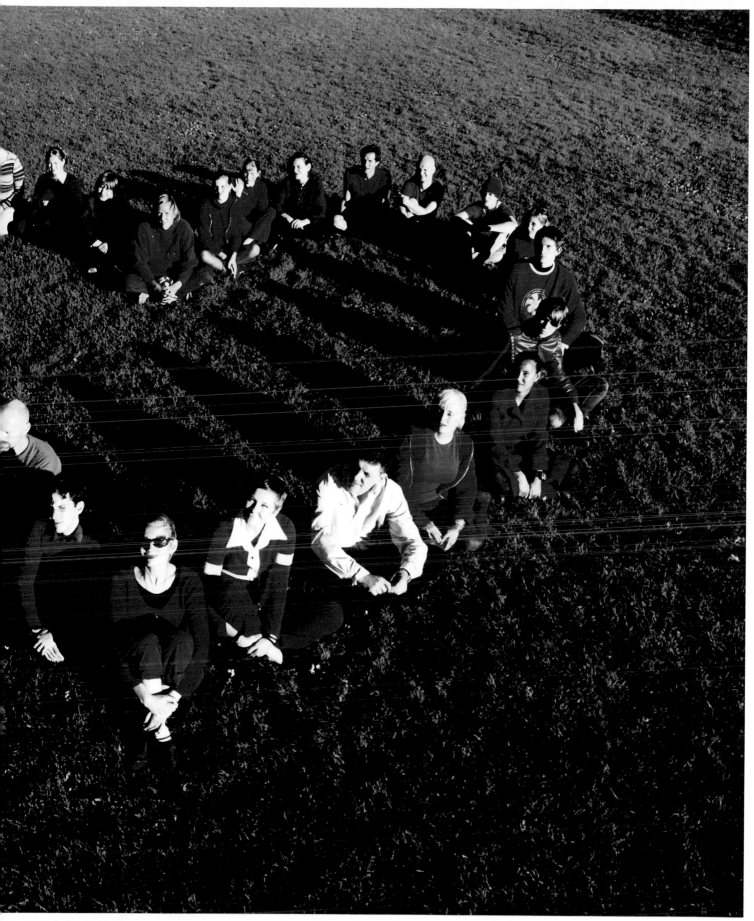

piotr uklanski.
Untitled (Crayon Shavings), 2001.
Wax crayon and plexi-glass in frame,
35 x 40" / 89 x 102cm.

Right: Untitled (Wet Water), 2001.
Water. Installation at Gavin Brown's Enterprize,
New York.

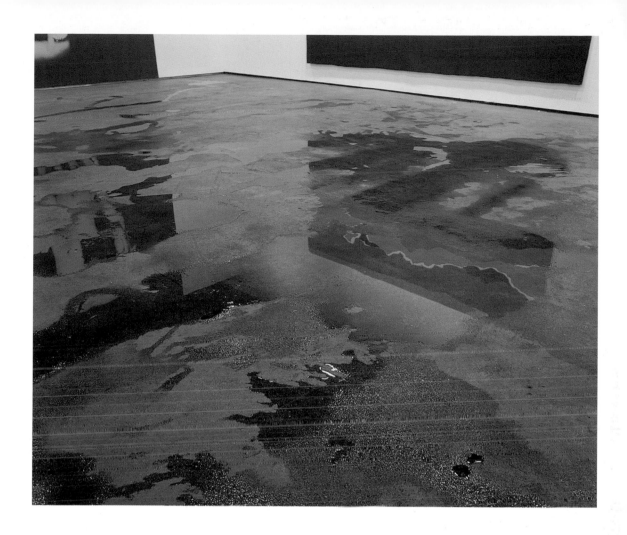

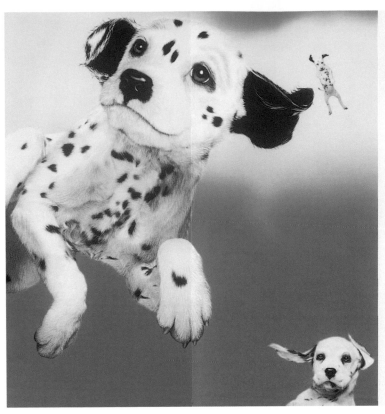

piotr
uklański
special
sneak
preview

2.–11. februar 2001

migros museum für gegenwartskunst

Get Carter

102 dalmatians

Proof of Life

Traffic

What Women Want

Programm

1	Freitag	2. Februar	**Get Carter**
2	Samstag	3. Februar	**102 dalmatians**
3	Sonntag	4. Februar	**Proof of Life**
4	Montag	5. Februar	**Traffic**
5	Dienstag	6. Februar	**What Women Want**
6	Mittwoch	7. Februar	**102 dalmatians**
7	Donnerstag	8. Februar	**Get Carter**
8	Freitag	9. Februar	**Proof of Life**
9	Samstag	10. Februar	**Traffic**
10	Sonntag	11. Februar	**What Women Want**

filmbeginn: 21 uhr

Get Carter
Directed by Stephen T. Kay, Warner Bros.
Starring: Sylvester Stallone, Michael Caine, Mickey Rourke, Miranda Richardson

102 dalmatians
Directed by Kevin Lima, Walt Disney Pictures
Starring: Glenn Close, Gerard Dépardieu

Proof of Life
Directed by Taylor Hackford, Warner Bros.
Starring: Meg Ryan, Russell Crowe

Traffic
Directed by Steven Soderbergh, USA Films
Starring: Michael Douglas, Catherine Zeta-Jones, Benicio del Toro, Dennis Quaid, Don Cheadle

What Women Want
Directed by Nancy Meyers, Paramount Pictures
Starring: Mel Gibson, Helen Hunt

migros museum für gegenwartskunst

einlass: 20 uhr 30 / filmbeginn: 21 uhr

Limmatstrasse 270 CH-8005 Zürich
tel: +41 1 277 2050 fax +41 1 277 6286
aktualisierte news finden sie stets unter
http://www.migrosmuseum.ch

piotr uklanski.
Exhibition brochure; Special Sneak Preview,
Migros Museum, Zurich, 2001.

EDUCATION
↓
1995 Purchase College, State University of New York,
 Purchase, NY.
↓
SELECTED SOLO EXHIBITIONS
↓
1999 Deception, Andrew Kreps Gallery, New York.
2000 Early-Hiroshi, LA Galerie Lothar Albrecht,
 Frankfurt.
 Galleri Wang, Oslo.
2001 Estoa yo Hantastishe de Buddah, Andrew Kreps
 Gallery, New York.
↓
SELECTED GROUP EXHIBITIONS
↓
1996 Piggy Bank in Romper Room, Thread Waxing
 Space, New York.
 100 Photographs, American Fine Art, New York.
1997 E Plurals Nihil, American Fine Art, New York.
 Hey! You never know, LaGuardia Place, New York.
1999 Papermake, Modern Art Inc., London.
 Answer Yes, No, or Don't Know, Andrew Kreps
 Gallery, New York.
2000 Blondies and Brownies, Aktionsforum Parterinsel,
 Munich.
 Greater New York, PS1/MoMA, New York.★
 'high five' im warmen Monat Mai, Galerie Schedler,
 Zurich.
2001 Vertigo and Desire, Ursula-Blickle-Stiftung,
 Kraichtal, Germany.
↓
SELECTED BIBLIOGRAPHY
↓
1999 Sunairi, Hiroshi, 'Hiroshi Forever', Playguy,
 New York, April 1999, pp 2, 32-37.
2000 Field, Genevieve, Nerve / The New Nude, Chronicle
 Books, San Francisco, 2000, pp 67-69.
 Fujimori, Manami, 'Very New Art 2000', Bijutsu
 Techo, Tokyo, January 2000, pp 95-96.
 Turner, Grady T., 'Sexually Explicit Art', Flash Art,
 Milan; May-June 2000, pp 95-96.
2001 Sunairi, Hiroshi, Early-Hiroshi by Hiroshi Sunairi,
 Eikon Sonderdruck, Vienna, 2001..
 Aletti, Vince, 'First Take: Vince Aletti on Hiroshi
 Sunairi', Artforum, New York, January 2001, p 126.

 ★ Exhibition publication produced

hiroshi sunairi.

BORN IN HIROSHIMA, JAPAN, 1972.
LIVES IN NEW YORK.

↓

Hiroshi is an 'egoiste, narcissiste'.
Hiroshi is a performance artist.

↓

One should balance each of the foregoing statements against the other when confronting Hiroshi Sunairi's exuberantly ejaculatory art. Self-exposure is its crucial ingredient—whether within performances, written texts, photo-collages, installations, or a soft porn spread in **Playguy magazine**. Sunairi is not only enthralled with his own image; he loves the idea of watching others take pleasure in looking at this image. There is a high degree of artifice in his self-consciously nubile pose, but there is also an equal amount of genuine libidinal investment—which has a disarming sincerity and undeniable power.

↓

Sunairi has designated his entire production of the past five years as 'Early-Hiroshi'. Indeed, the work and the person cannot easily be uncoupled. In a statement written for his 1999 show **Deception**, the artist states: 'To deceive others, one has to deceive oneself'. Much of what one sees and experiences in Sunairi's art is the artist himself—the pretty, pouting, transgendered post-national—under the spell of his own self-deception. The language in **How I Am Looking** (2000) is subtly positioned to read as a self-assured exclamation but also as a question—styled in the jumbled syntax of some non-native speaker. This image is performative, and provocatively so. **KA*TSU TOU** (1999) and **Cobra** (1999) are examples of Sunairi's collage technique, which employs a limited economy of repeating fragments to maximum effect. His layered constructions appear to breed and swarm across a wall, giving concrete form to the fluid processes of seduction—and of the formation of identity in and across cultures.

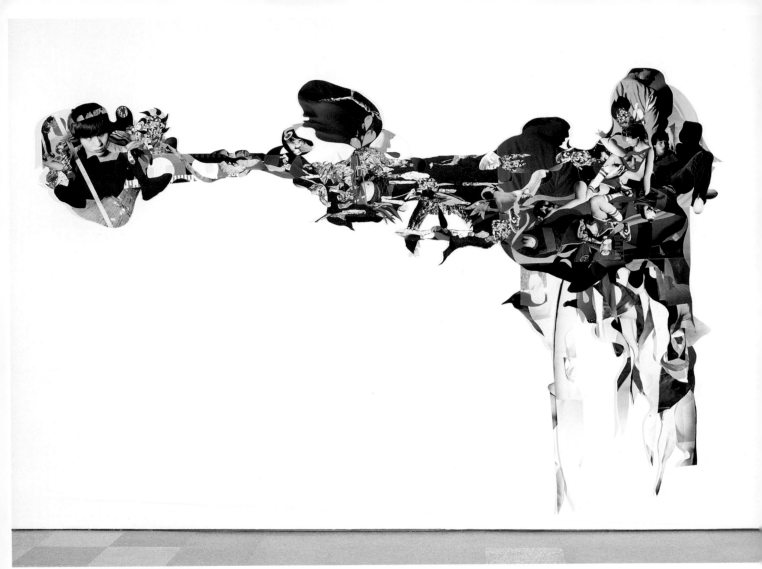

hiroshi sunairi.
How I Am Looking?, 2000.
Drawing with collage on watercolour paper,
18 x 22" / 45 x 55cm.

Left: KA*TSU TOU (ecollagistic artifice), 1999.
Photo collage,
73 x 114" / 185 x 290cm.

how I am looking ?

hiroshi sunairi.
Cobra (stop-motion / slow-motion), 1999.
Photo collage,
76 x 61" / 193 x 155cm.

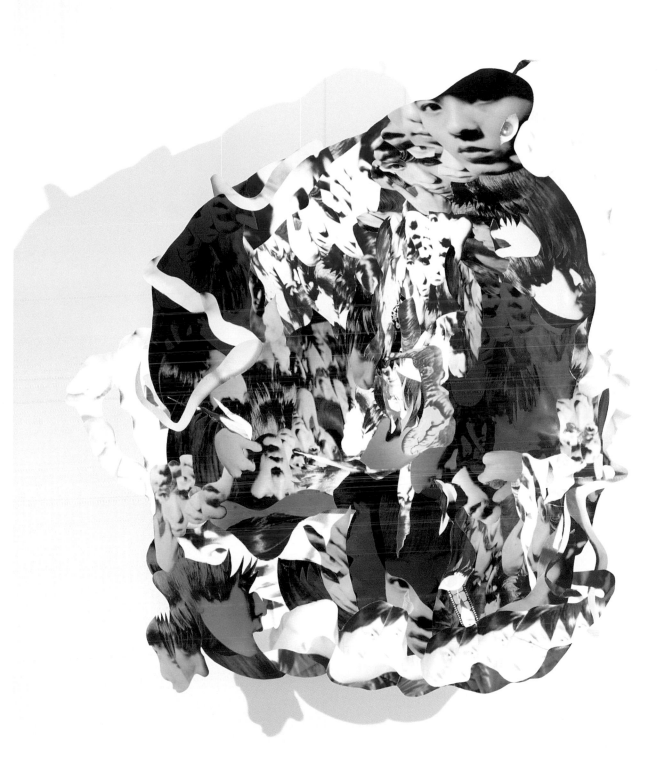

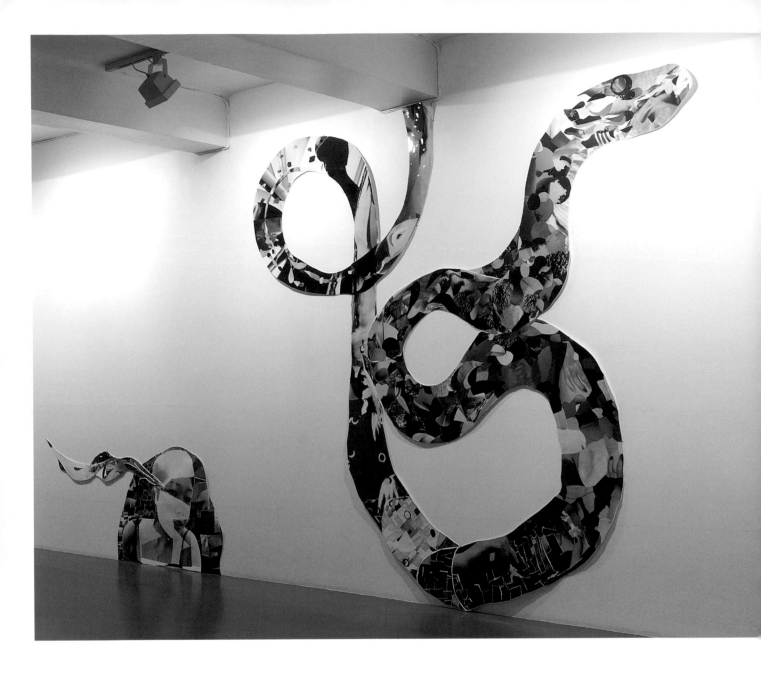

hiroshi sunairi.
Installation at Galleri Wang, Oslo, 2000.

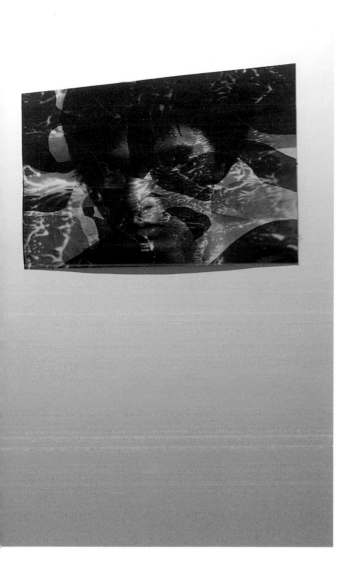

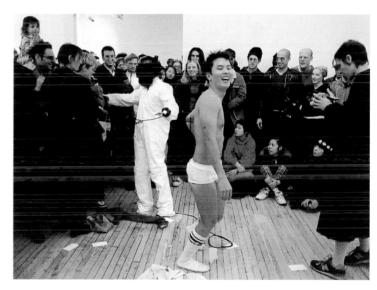

hiroshi sunairi.
Open Early Hiroshi, 1998.
Performance with Elizabeth Bougatsos
and Matthew McAuley, American Fine Art,
New York.

EDUCATION
↓

1993 BA, Columbia University, New York.
Skowhegan School of Painting and Sculpture,
Skowhegan, ME.
↓

SOLO EXHIBITIONS
↓

1999 Robert Prime Gallery, London.
White Room, White Columns, New York.
2001 Marianne Boesky Gallery, New York.
↓

SELECTED GROUP EXHIBITIONS
↓

1998 **How Will We Behave**, Robert Prime Gallery,
London.
Heaven, PS1, New York.
1999 **Down to Earth**, Marianne Boesky Gallery,
New York.
New York Neither/Nor, Grand Arts,
Kansas City, MO.*
2000 **Drawings 2000**, Barbara Gladstone Gallery,
New York.
Pastoral Pop, Whitney Museum
at Phillip Morris, New York.
Greater New York, PS1/MoMA, New York.*
↓

SELECTED BIBLIOGRAPHY
↓

1999 Thorson, Alice, 'But Seriously…Or Not',
Kansas City Star, Kansas City, MO,
4 July 1999, pp J1-5.
2000 Sherman, Sam, 'Rachel Feinstein',
www.**londonart.co.uk**, 7 January 2000.
Lewisohn, Cedar, 'Rachel Feinstein', **Flash Art**,
Milan, January-February 2000, p 46.
2001 Heiss, Alanna, 'Rachel Feinstein', **Connaissance
des Arts**, Paris, January 2001, pp 108-109.
Higgie, Jennifer, 'Material Girl', **Frieze**, London,
April 2001, pp 62-64.

* Exhibition publication produced

rachel feinstein.

BORN IN FORT DEFIANCE, AZ, 1971.
LIVES IN NEW YORK.

↓

Rachel Feinstein's practice alternates giddily between what can be the very dour domains of sculpture and painting. Making glossy, colourful objects and homespun movies, Feinstein sets out to recreate nature as she sees it. Her aim is to make something— a free-standing sculpture, a wall or floor piece, a film—that will be beautiful in and of itself. The given, as she sees it, is that 'a Rachel-maid sculpture will never turn out as perfect and precise as in real life'.

↓

Feinstein's materials are those of everyday crafts: MDF, plaster, denim, mirrored mosaics, rhinestones, beads, velvet and paint. Her objects ramble deliriously through the idylls of nature and culture, often suggesting the exaggerated perspectives of a stage flat, or a silhouetted profile at home in a cartoon world. **Yesterday** (2000) is a combination of painted wood groupings. An eighteenth-century couple is locked in an odd dance while a dog joins in at their feet. Rising behind is a background of curvy columns, a vase of flowers and a smiling Cheshire cat. It's a Hanna-Barbara still life with a dose of Lennon and McCartney to round it off. The floor piece **Echo Lake** (1999) provides a doubled perspective that positions a viewer above and below a bucolic North American summer camp scene. Finally, **Forest Flat** (1999) is a layered view of that moment that hangs between a romantic sunset and the chill of a wood suddenly turned dark and ominous.

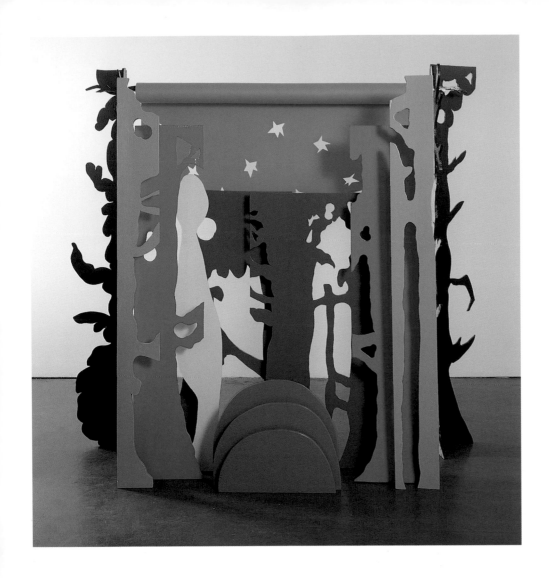

rachel feinstein.
Forest Flat, 1999.
Wood, enamel paint and paper,
72 x 78 x 30" / 183 x 198 x 76cm.

Right: Echo Lake, 1999.
Wood and paint,
1 x 101 x 47" / 3 x 254 x 120cm.

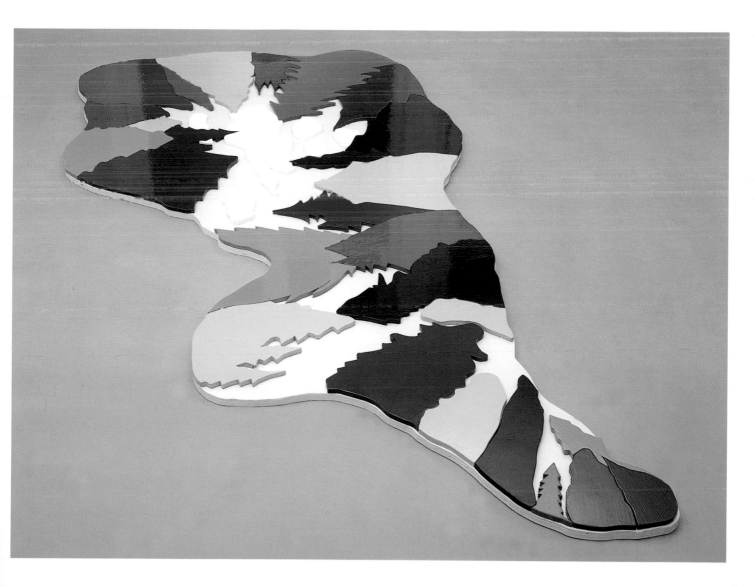

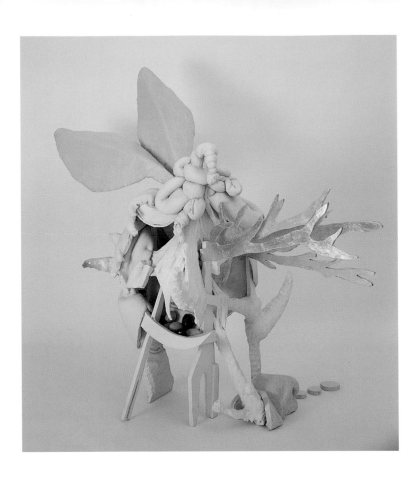

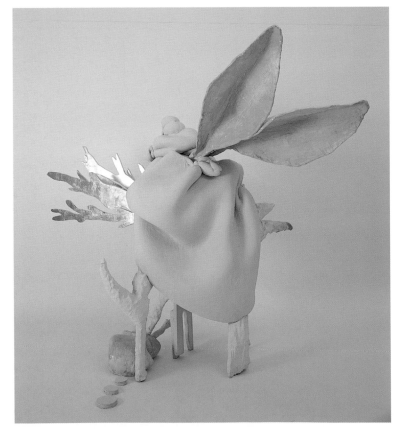

rachel feinstein.
Fat Friend, 2000.
Wood, epoxy, sculpy, plaster,
paint and gold leaf,
60 x 49 x 32" / 152 x 124 x 81cm.

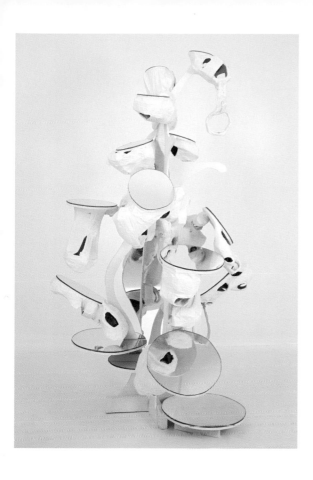

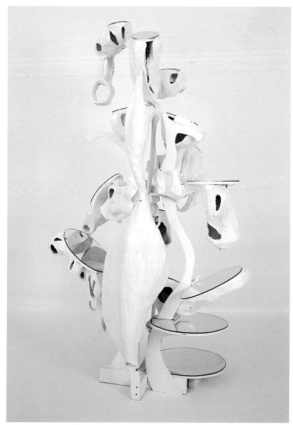

rachel feinstein.
Model, 2000.
Mirrors, wood, plaster and paint,
91 x 41 x 52" / 231 x 103 x 132cm.

rachel feinstein.
Yesterday, 2000.
Wood and enamel paint.
Back piece:
96 x 96 x 1" / 244 x 244 x 4cm.
Front figures:
72 x 60 x 1" / 183 x 152 x 4cm.

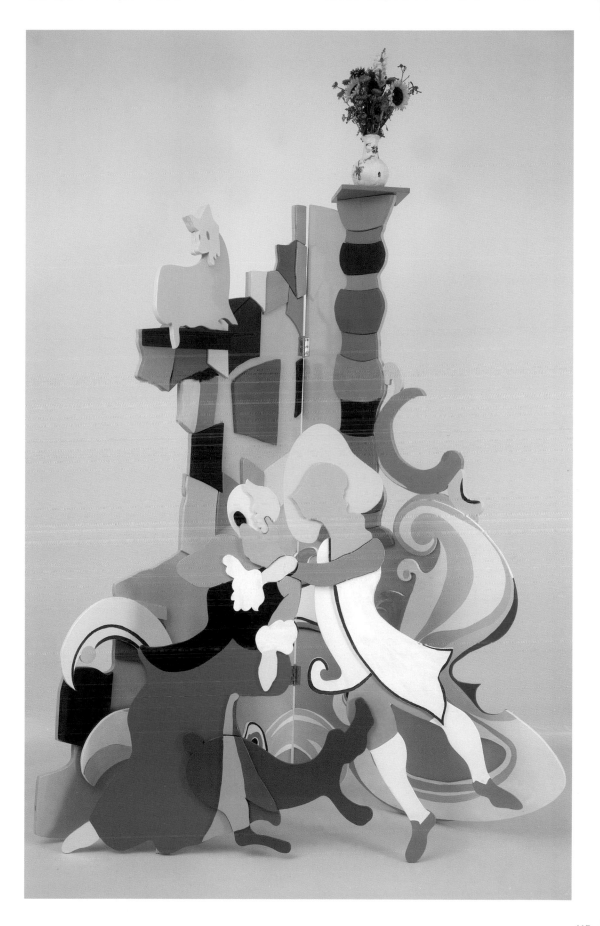

EDUCATION
↓
1991 Staatliche Hochschule für Bildende Künst,
Städel Schule, Frankfurt.
1994 MFA, University of Miami, School of Motion
Pictures, Miami.
↓
SELECTED SOLO EXHIBITIONS
↓
1997 **Government Cut Freestyle**, Miami Arts Project,
Miami International Airport, FL.
1998 Museum of Contemporary Art, Chicago.*
Total, Miami Art Muesum, Miami.*
2000 Gavin Brown's Enterprize, New York.
Centre fur Curatorial Studics,
Annandale-on-Hudson, NY.
2001 Miami Art Museum, Miami.
Site Santa Fe, Santa Fe, NM.*
↓
SELECTED GROUP EXHIBITIONS
↓
1997 **Celluloid Cave**, Thread Waxing Space, New York.*
1998 **Miami Arts Project**, Miami International Airport,
Miami, FL.
Independing Loop, Swiss Institute, New York.
Dara Friedman and Mark Handforth, Gavin
Brown's Enterprize, New York.
1999 **Heads Up**, Museum of Contemporary Art, Miami.
Leftover Festivities, Nature Morte, New Delhi.
2000 **Whitney Biennial**, Whitney Museum of American
Art, New York.*
Black Box, California College of Arts and Crafts
Institute, Oakland, CA.*
Making Time, Palm Beach Institute of
Contemporary Art, Palm Beach, FL (and tour).*
2001 **Making Art in Miami**, Museum of Contemporary
Art, Miami
Zero Gravity, Palazzo des Exposizione
Nationale, Rome.*
↓
SELECTED BIBLIOGRAPHY
↓
1998 Purcell, Greg, 'Dara Friedman', **New Art Examiner**,
Chicago, November 1998, p 49.
2000 Smith, Roberta, 'Dara Friedman', **The New York
Times**, New York, 28 April 2000, p 7.
Fresh Cream, Phaidon Press, London, 2000,
pp 280-285.
2001 Kesterson, Marc, 'Time and Again', **Dutch**,
March-April 2001, p 56.

* Exhibition publication produced

dara friedman.

BORN IN BAD KREUZNACH, GERMANY, 1968.
LIVES IN MIAMI.

↓

Dara Friedman's films are beguiling in their simplicity. Her works are grounded in the medium's formal characteristics and make particular use of repetition, motion and serial permutations. They are related to the tradition of structuralist filmmaking, in which the medium's codes become the site of a self-reflexive investigation.

↓

In **Total** (1997), Friedman structures the film by reversing her destructive activities on the contents of a room. A fixed-camera documents the artist restoring order to a hovel: broken legs return to chairs, shattered mirrors reassemble and cracked plates fly across the room back to her hand and their place on a table. Friedman generates compelling repetitions, but resists allowing her sequences to fall into obvious patterns—as in **Government Cut Freestyle** (1998), where no two dives are alike and each is a means to express originality during a shared experience in summer waters.

↓

Chrissy, Mette, Kristan (2000) has the look of a European commercial for underwear. Three models occupy individual frames, the wind machine rolls, and in slow motion each woman tears open her blouse to reveal her bra. The bursting buttons are scored with syncopated sounds, and as the film loops reverse and repeat a rhythmic soundtrack is created. The effect renders the five-minute film into a seductive sound piece. **Romance** (2001) is a sequence of couples canoodling in the green spaces of Rome. The film measures the playful spontaneity of such private moments against a consciousness of both the camera and the surrounding public.

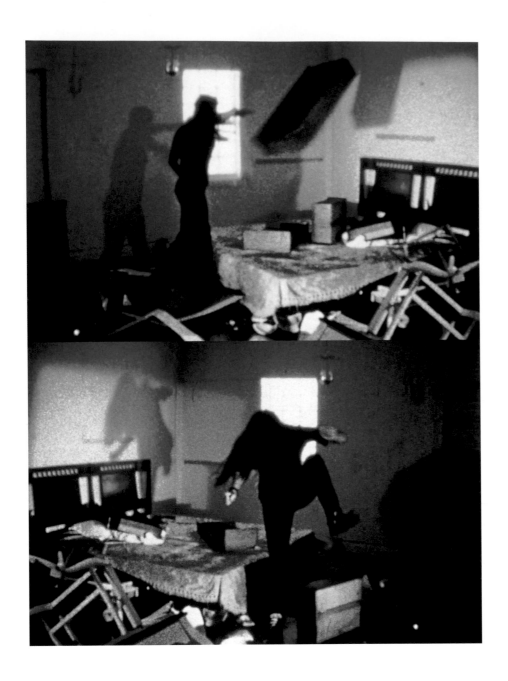

dara friedman.
Total, 1997.
Super-8 colour film, with sound, projected,
12:30 minutes.

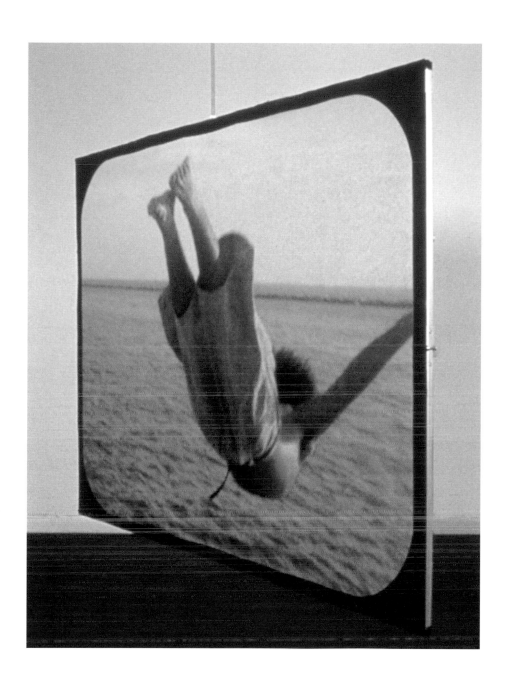

dara friedman.
Government Cut Freestyle, 1998.
16mm colour film transferred to DVD, silent, projected,
9:20 minutes.

EDUCATION
↓
1985 BFA, Texas Christian University, Fort Worth, TX.
1989 MFA, California Institute of the Arts. Valencia, CA.
↓
SELECTED SOLO EXHIBITIONS
↓
1995 Casey Kaplan, New York.
1996 Casey Kaplan, New York.
1998 Taka Ishii Gallery, Tokyo.
 Casey Kaplan, New York.
 Galleri Nicolai Wallner, Copenhagen.
1999 Sadie Coles HQ, London.
2000 Sadie Coles HQ, London.
2001 Casey Kaplan, New York.
 Galerie Emmanuel Perrotin, Paris.
↓
SELECTED GROUP EXHIBITIONS
↓
1996 **Stream of Consciousness: 8 Los Angeles Artists**,
 University Art Museum, Santa Barbara, CA. *
1997 **Highlights from the Permanent Collection**,
 Museum of Contemporary Art, Miami, FL.
 Stills: Emerging Photography in the 1990s,
 Walker Art Center, Minneapolis, MN .*
1999 **Photography: an Expanded View**, Solomon R.
 Guggenheim Museum, Bilbao.
 Drive-By: New Art from LA, South London Gallery,
 London.
2000 **Man**, Arken Museum for Moderne Kunst, Ishoj,
 Denmark.
2001 **Beau Monde**, SITE Sante Fe, Sante Fe, NM.
↓
SELECTED BIBLIOGRAPHY
↓
1998 **Jeff Burton / Untitled**, Composite Press, Tokyo.
1999 Slocombe, Steve, 'Eyeing up Los Angeles:
 Jeff Burton', **Sleazenation**, London, May 1999,
 pp 83-89.
2000 Schubert, Lawrence, 'Meet me in Dreamland',
 Flaunt, Los Angeles, December 2000,
 pp 74-75.
2001 **Dreamland: Jeff Burton**, Powerhouse Books,
 New York, 2001.
 Campion, Chris, 'This is Hardcore',
 Dazed & Confused, London, May 2001, np.

*Exhibition publication produced

jeff burton.

BORN IN ANAHEIM, CA, 1963.
LIVES IN LOS ANGELES.

↓

It has become a cliché, though no less necessary, to introduce Jeff Burton's images by stating that the artist works as a still photographer in the adult film industry in California. This is a waiting game, much of it tedious and all of it mediated, and Burton's personal works are made on the sly during the languid gaps that punctuate a life spent on sets and suburban side streets. The artist describes his work as a kind of espionage, as he wanders around with camera in hand, among subjects largely inured to the presence of the lens.

↓

Pornography and photography are well matched: each trade in the currency of fantasy. Burton's pictures are shy, glancing views of the industry in which he works, offering abruptly cropped views of fleshy action and in-action. It is the material that falls outside of the frame that animates these images. There life is chaotic, occasionally erotic and always charged with content derived from dreams. But Burton focuses his camera on the mundane reality of the periphery—a knee in the grass, a stack of camera cases, the formal configuration of a hotel room. Details are always telling in these carefully designed and colour-saturated images.

↓

When Burton looks to other landscapes, to other locales within LA, it is with the same apparent ennui; yet one is always aware that these are the pictures of one who is infatuated with his surroundings and with the edge.

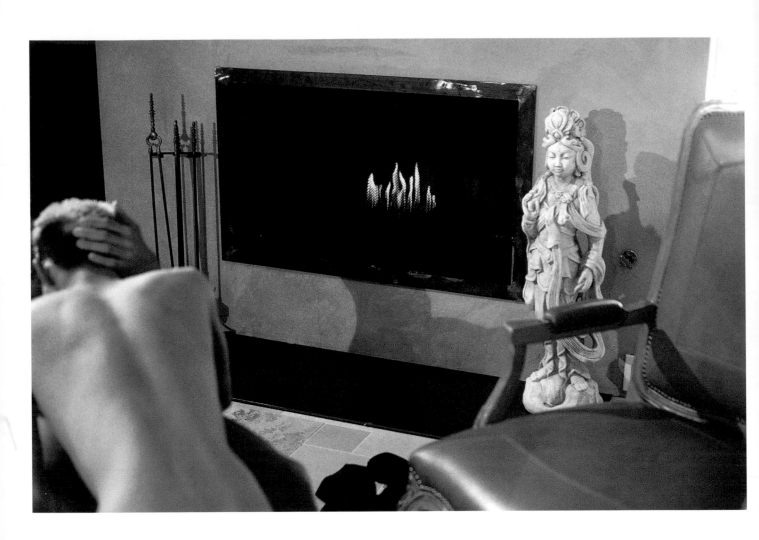

jeff burton.
Untitled #152
(fireplace with sculpture), 2001.
Cibachrome print,
20 x 24"/ 51 x 61cm.

Right: Untitled #141
(Camaro), 2000.
Cibachrome print,
20 x 24"/ 51 x 61cm.

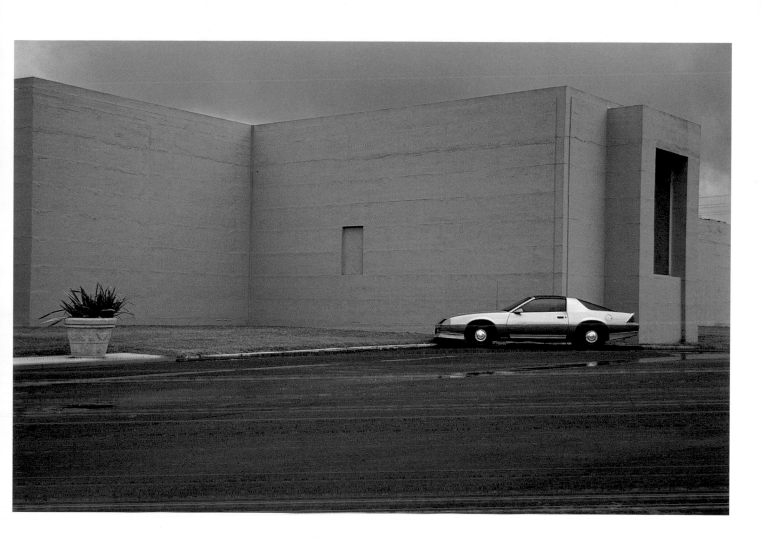

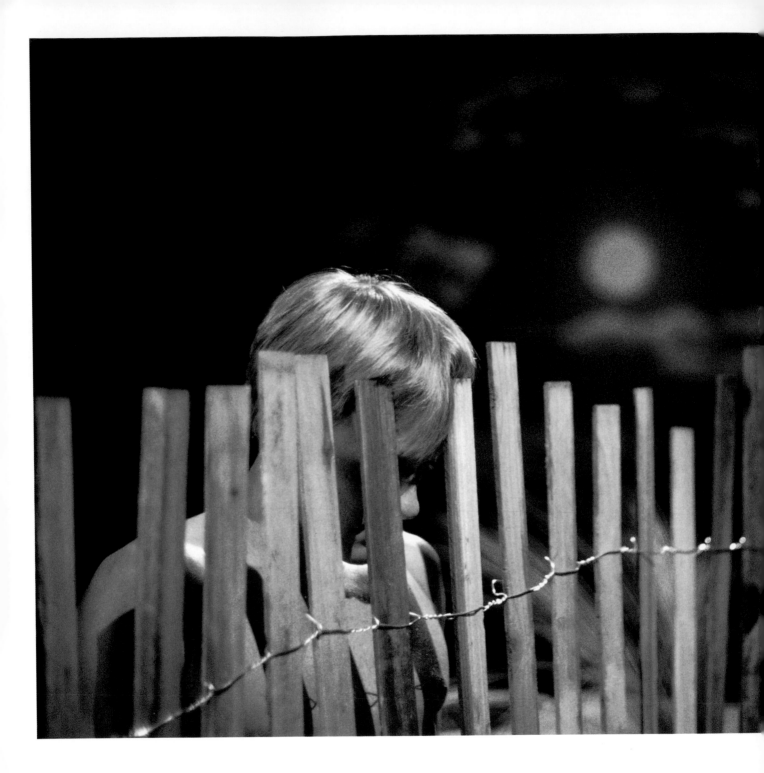

jeff burton.
Untitled #151
(picket fence), 2001.
Cibachrome print,
20 x 24" / 51 x 61cm.

jeff burton.
Untitled #111
(Hollywood), 2000.
C-print,
30 x 40"/ 76 x 102cm.

Right: Untitled #134
(reclining nude man), 2000.
Cibachrome print,
40 x 60"/ 102 x 152cm.

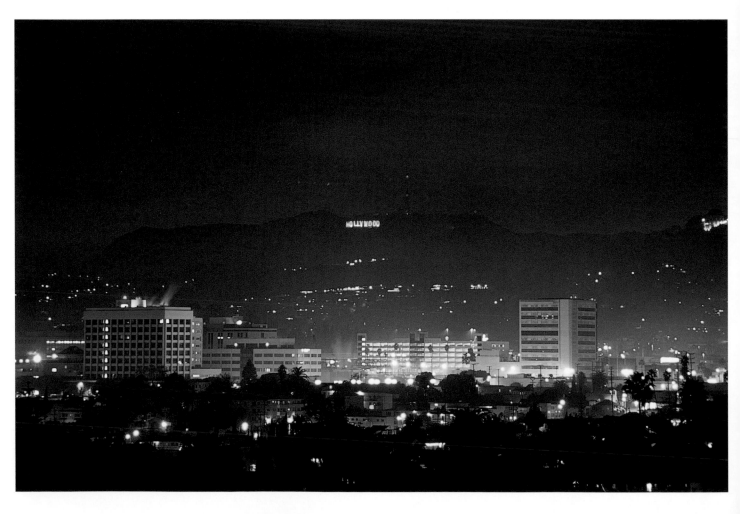

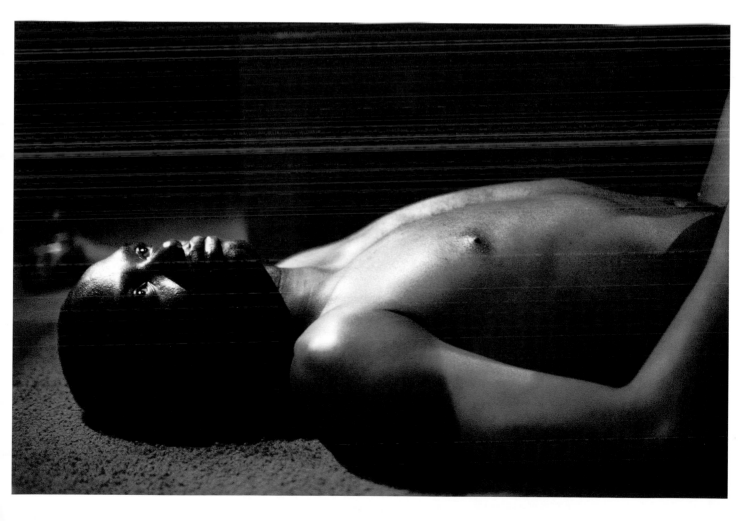

EDUCATION

1987 BFA, San Francisco Art Institute,
San Francisco, CA.
1994 MFA, Hunter College, New York.

SELECTED SOLO EXHIBITIONS

1998 **The Pure Products Go Crazy**, The Project,
New York.
2000 The Project, New York.
Kunst-Werke, Berlin.
2001 The Project, Los Angeles.
Whitney Museum of American Art, New York.
Kunsthaus Glarus, Glarus, Switzerland.
Orpheus Descending, The Public Art Fund, World
Trade and Financial Centers, New York.

SELECTED GROUP EXHIBITIONS

1995 **In a Different Light**, UC Berkeley Museum, CA.★
Pervert, UC Irvine Art Gallery, CA.★
1996 **Memories of Over-development: Philippine
Diaspora in Contemporary Art**, UC Irvine Art
Gallery, CA (and tour).★
1998 **At Home and Abroad: 21 Contemporary Filipino
Artists**, Asian Art Museum, San Francisco
(and tour).★
2000 **Whitney Biennial**, Whitney Museum of
American Art, New York.★
Greater New York, PS1/MoMA, New York ★
Hypermental, Kunsthaus, Zurich (and tour).
City Visions, Media City Seoul 2000, Seoul, Korea
Extraordinary Realities, Columbus Museum
of Art, Columbus, OH.
2001 **Venice Biennale**, Venice.★
Bitstreams, Whitney Museum of American Art,
New York.
Out of Place, Museum of Contemporary Art,
Chicago.

SELECTED BIBLIOGRAPHY

2000 Soloman, D, 'A Roll Call of Fresh Names and Faces',
The New York Times, New York, 16 April, 2000, np.
Hunt, David, 'Man Trap', **Frieze**, London, June –
August 2000, pp 98-99.
Siegel, Katy, 'Openings: Paul Pfeiffer', **Artforum**,
New York, Summer 2000, pp 174-175.
Piene, Chloe, 'Eating and Excreting, **Flash Art**,
Milan, October 2000, pp 84-86.
Griffin, Tim, 'Technological Knockout', **Time Out
New York**, New York, 28 December 2000, p 61.

★ Exhibition publication produced.

paul pfeiffer.

BORN IN HONOLULU, HAWAII, 1966.
LIVES IN NEW YORK.

↓

Paul Pfeiffer's work is preoccupied by visible and invisible systems of representation. In particular the artist looks at film and television, and their role in the manufacture, multiplication and distribution of human images. Pfeiffer is best known for his dazzling digital manipulations of found footage from NBA broadcasts and popular films – in works that largely efface the constructed media identity of the sampled personalities.

↓

Through his painstaking manipulations and minia-turised presentations – Pfeiffer's video projections are often the size of snapshots – the artist reverses the aggrandizing processes that film enacts on a celebrity's identity. **The Long Count** (2001) is a triptych based on a legendary trio of Muhammad Ali fights, including 'The Thrilla in Manila' and 'The Rumble in the Jungle'. A mere two-minute segment of video can take Pfeiffer as long as four months to construct; and in each part of this work he has condensed the final round of the fight and digitally removed Ali and his opponent. The combatants are reduced to a halo cast across the baying crowd.

↓

Poltergeist (2000) is a sculptural object, but no less immersed in the digital world and in film. Inspired by the ghostly movement of objects in Spielberg's movie of the same name, Pfeiffer has produced a pyramid of stacked chairs untouched by human hand – using 3D modelling software and the latest technology in laser-fused plastics. **Leviathan** (1998) is part of an extended series of photo-pieces where the artist deconstructs ideal images of Western architecture and the body. In this digital print Pfeiffer creates an outline of an already anthropomorphic cathedral through careful partings in a blonde wig.

paul pfeiffer.
Leviathan, 1998.
Digital c-print,
60 x 48" / 152 x 122cm.

paul pfeiffer.
Prologue to the Story of the Birth of Freedom, 2000.
Colour video loops on twin monitors, silent.

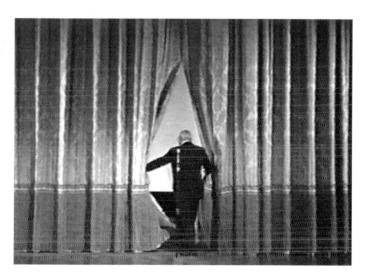

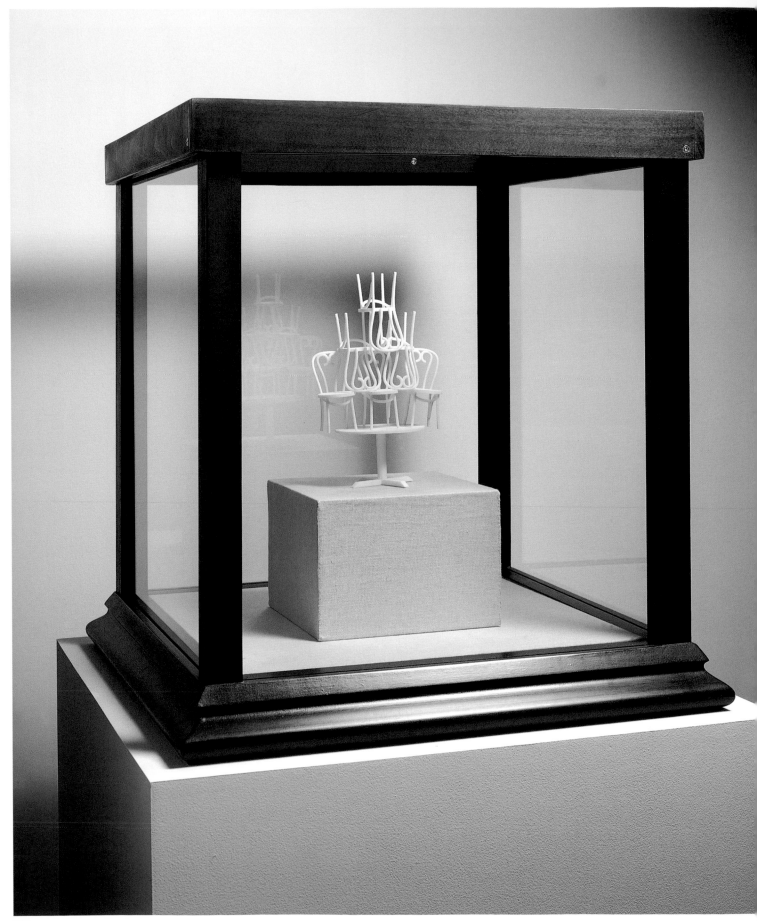

paul pfeiffer.
Poltergeist, 2000.
Laser-fused polyamide powder, wood, glass and linen,
8 x 4 x 4" / 20 x 10 x 10cm;
vitrine 24 x 22 x 22" / 61 x 56 x 56cm.

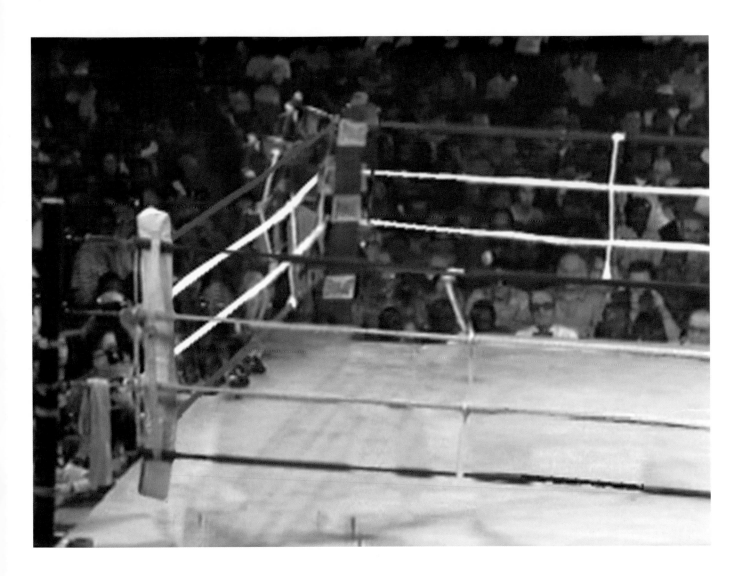

paul pfeiffer.
The Long Count (Rumble in the Jungle), 2001.
Colour video loop on monitor, silent.

EDUCATION
↓
1996 BFA, University of Texas at Austin, TX.
1997 MFA, Suny Purchase College, New York.
↓
SELECTED SOLO EXHIBITIONS
↓
2000 Leo Koenig Inc., New York.*
2001 Nicola Spovieri, London.
 Paolo Curti Gallery, Milan.
 Taka Ishi Gallery, Toyko.
↓
SELECTED GROUP EXHIBITIONS
↓
1999 **Visions in conjunction with Rirkrit Tiravanija's
 Apartment 21**, Gavin Brown's Enterprize,
 New York.
 In My Room, White Columns, New York.
 Artist in the Marketplace, Bronx Museum,
 New York.
2000 **Greater New York**, PS1/MoMA, New York.*
2001 **Come on Feel the Noise**, Asbaek Gallery,
 Copenhagen.
↓
SELECTED BIBLIOGRAPHY
↓
2000 Cotter, Holland, 'Innovators Burst Onstage One
 (Kapow!) at a Time', **The New York Times**, New York,
 10 November 2000, p E31.
 Sirmans, Franklin, 'Eric Parker', **Time Out
 New York**, New York, 30 November 2000, p 92.
2001 Kawachi, Taka, 'Erik Parker – Superstar',
 Marie Claire, Japan, January 2001, p 72.

 * Exhibition publication produced

erik parker.

BORN IN STUTTGART, GERMANY, 1968.
LIVES IN NEW YORK.

↓

Erik Parker makes word paintings grounded in a stylistic hybrid of Rorschach drawings, genealogical charts, psychedelic posters and graffiti art. His aim is to create work that will 'look the way a hip hop song sounds'. The artist, who grew up just outside San Antonio, is one in a line of thieving white boys who have invigorated the look and sound of American culture via the crossover. Parker's art is based in cultural sampling and jamming, and he revels in an elaborate litany of names and places, moments and movements, the familiar and forgotten, street culture and high art.

↓

The words and phrases that Parker invokes are encased in thought balloons that link one to another like a great intestine, creating a web of associations that evoke an era, moment or scene. **The Way We Was** (2000) is a mapping of the history and culture of New York in the eighties, taking in the then new art and money that shaped the times. The entire world and all eras are open to Parker's boundless coverage. **Unlimited Epidemic** (2001) charts the trials and tribulations of British beef. Closer to home, **Texecuted** (2001) lists all those put to death under the governorship of George the Younger. Parker's is just the kind of history painting that the times demand.

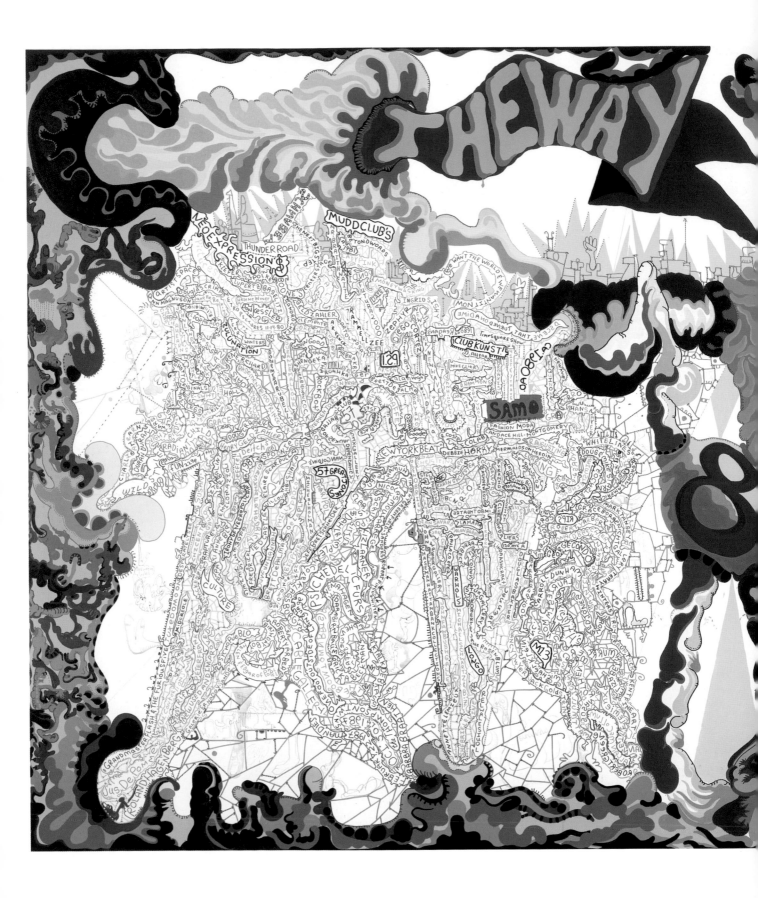

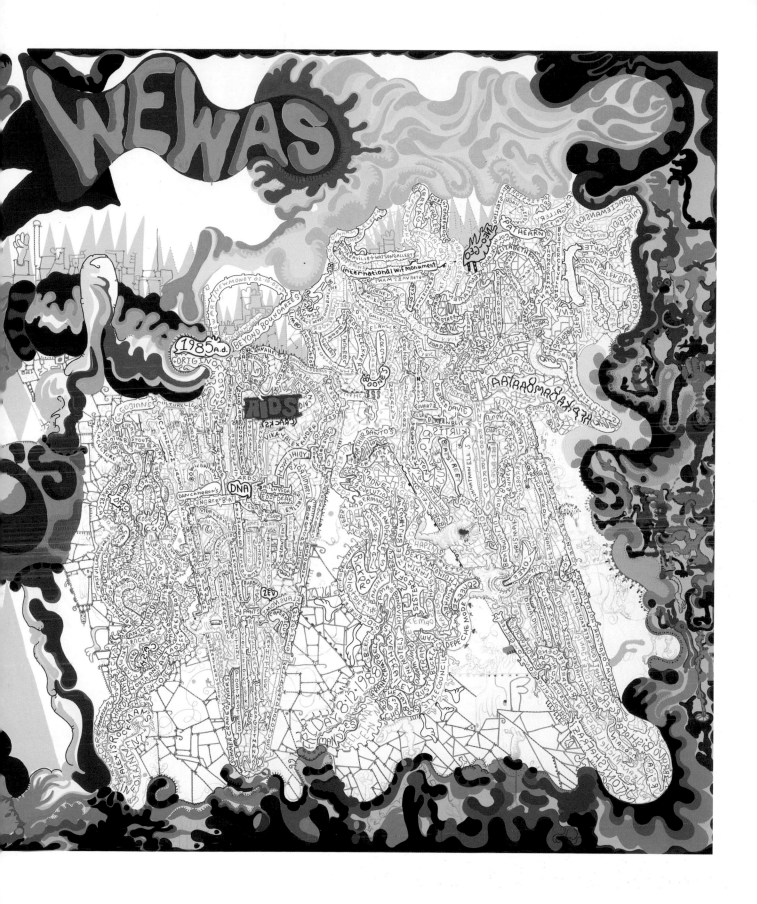

145

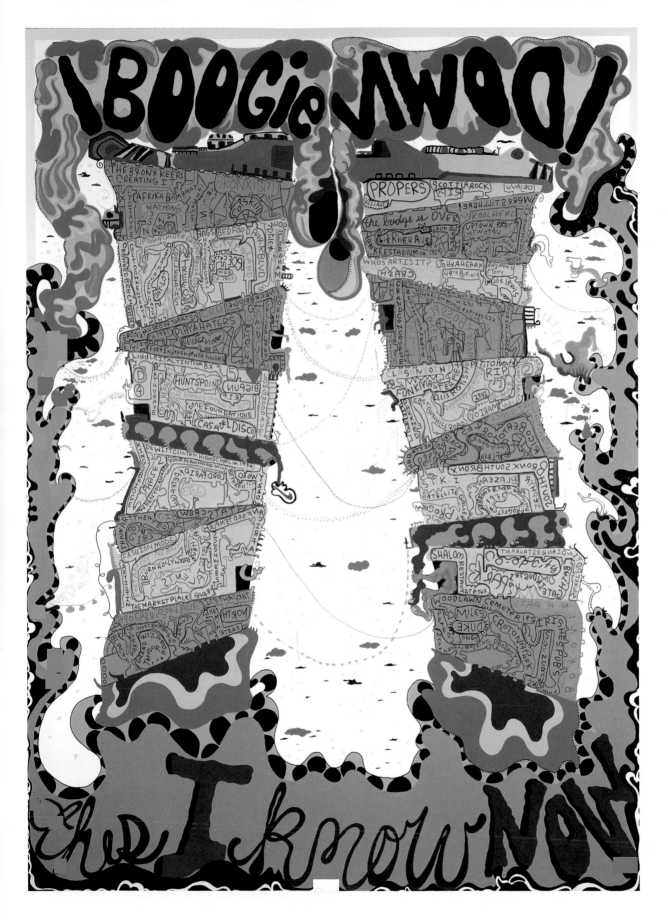

erik parker.
Boogie Down – 'This I Know Now', 2001.
Mixed media on canvas,
84 x 60"/ 213 x 152cm. (Right: detail)

Previous Page:
The Way We Was, 2000.
Acrylic on canvas,
96 x 180"/ 244 x 457cm.

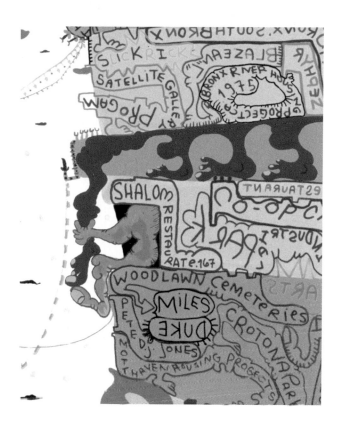

erik parker.
Unlimited Epidemics, 2001.
Mixed media on paper,
83 x 63"/ 210 x 160cm.

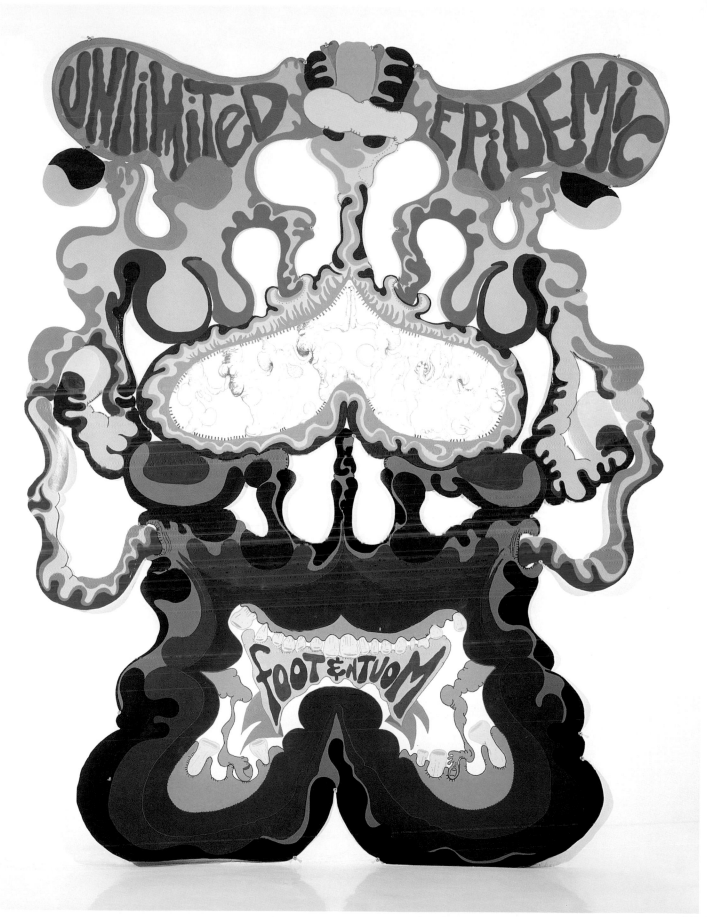

149

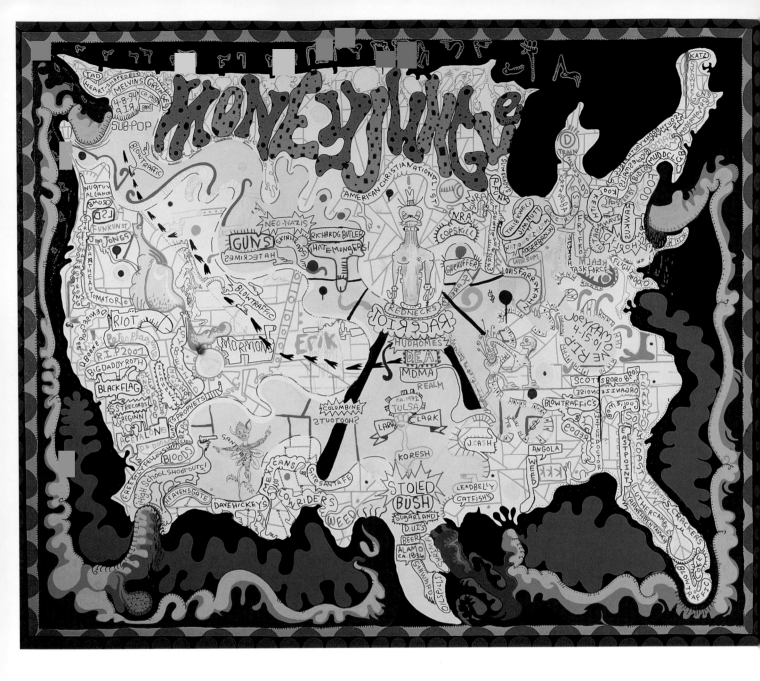

erik parker.
Money Jungle, 2001.
Mixed media on canvas,
60 x 72" / 152 x 183cm.

EDUCATION
↓
1991 BA, Atlanta College of Art, Atlanta, GA.
1994 MFA, Rhode Island School of Design,
Rhode island, RI.
↓
SELECTED SOLO EXHIBITIONS
↓
1995 **The High and Soft Laughter of the Nigger
Wenches At Night**, Wooster Gardens/Brent
Sikkema, New York.
Look Away! Look Away! Look Away!, Bard
College Center For Curatorial Studies,
Annandale-on-Hudson, NY.
1996 **From the Bowels to the Bosom**,
Wooster Gardens/Brent Sikkema, New York.
1997 **Upon My Many Masters – An Outline**, San
Francisco Museum of Modern Art,
San Francisco, CA.*
Presenting Negro Scenes [...], The Renaissance
Society, University of Chicago, Chicago
(and tour). *
1998 Vienna State Opera House, Vienna.
Wooster Gardens / Brent Sikkema, New York.
1999 **Kara Walker: No mere words can Adequately
reflect [...]**, California College of Arts and Crafts
Institute, Oakland,CA (and tour).
2000 **Why I Like White Boys, an Illustrated Novel by
Kara E. Walker Negress**, Centre d'Art
Contemporain, Geneva.
Des Moines Art Center, Des Moines, IA.*
2001 Brent Sikkema Gallery, New York.
Disturbing Allegories, Vanderbilt University Fine
Arts Gallery, Nashville, TN.
↓

SELECTED GROUP EXHIBITIONS
↓
1996 **New Histories**, Institute of Contemporary Art,
Boston.*
No Doubt, Aldrich Museum, Ridgefield, CT
1997 **Whitney Biennial**, Whitney Museum of American
Art, New York.*
No Place (like Home), Walker Art Center,
Minneapolis, MN.*
1998 **Global Vision, New Art from the 90s**, Deste
Foundation, Athens.
Strange Days, Art Gallery of New South Wales,
Sydney.*
1999 **Istanbul Biennial**, Istanbul.
Art-Worlds in Dialogue, Museum Ludwig, Cologne.
Carnegie International, Carnegie Museum of Art,
Pittsburgh, PA.*
2000 **Age of Influence: Reflections in the Mirror of
American Culture**, Museum of Contemporary Art,
Chicago.
2001 **Schatten Risse, Silhouetten und Cutouts**,
Kunstbau Lenbachhaus, Munich.*
Waterworks, Nordiska Akvarellmuseet,
Skärhamn, Sweden.*
↓
SELECTED BIBLIOGRAPHY
↓
1999 Frankel, David, 'Kara Walker', **Artforum**, New York,
April 1999, p 122.
2000 Dubois Shaw, Gwendolyn, 'Final Cut', **Parkett**
(No 59), New York/Zurich, 2000, p 129-133.
Janus, Elizabeth, 'As American as Apple Pie',
Parkett (No 59), New York/Zurich, 2000,
p 130-141.
Walker, Hamza, 'Nigger Lover or Will There Be Any
Black People in Utopia?', **Parkett** (No 59),
New York/Zurich, 2000, pp 152-160.

* Exhibition publication produced

kara walker.

BORN IN STOCKTON, CA, 1969.
LIVES IN RHODE ISLAND.

↓

In the middle years of the nineties Kara Walker set out, as she puts it, 'to uncover the often subtle and uncomfortable ways racism and racist and sexist stereotypes influence and script our everyday lives'. The cut-paper silhouette presented itself as a solution, its black shadow the most concise way to sum up the range of her interests. In antebellum America the form was favoured by the Southern aristocracy, and is still associated with 'true' representations, particularly of children. Already a fetish, the silhouette permits Walker to mix beauty, lust and violence within its polite perimeters.

↓

Walker's practice is concerned with the historical content of the 'low' arts—slave narratives, pornographic tales, minstrel songs and broadside advertisements for the sale of women and children. This material is augmented by the artist's experiences in contemporary America, where the longing for a romanticised and homogenous past still lingers. **Insert for Parkett** (1999) belongs to an ongoing series of drawings and watercolours entitled Negress Notes, in which Walker establishes themes that may find their way into her wall pieces.

↓

The title of the wall piece **Camptown Ladies** (1998) comes from the opening line of a nineteenth-century folksong by Stephen Foster, whose apparently nonsensical lyrics—penned in Black English Vernacular and still sung today by school children—contain darkly sexual allegorical content: 'De Camptown ladies sing dis song—Doo-dah! doo-dah!'. Not constrained by a framing edge, Walker's **Emancipation Approximation** (1999-2000) is an extended tableau, roaming through the racial stereotypes that still haunt America. Such works do not so much tell a story as compel the viewer to confront their own.

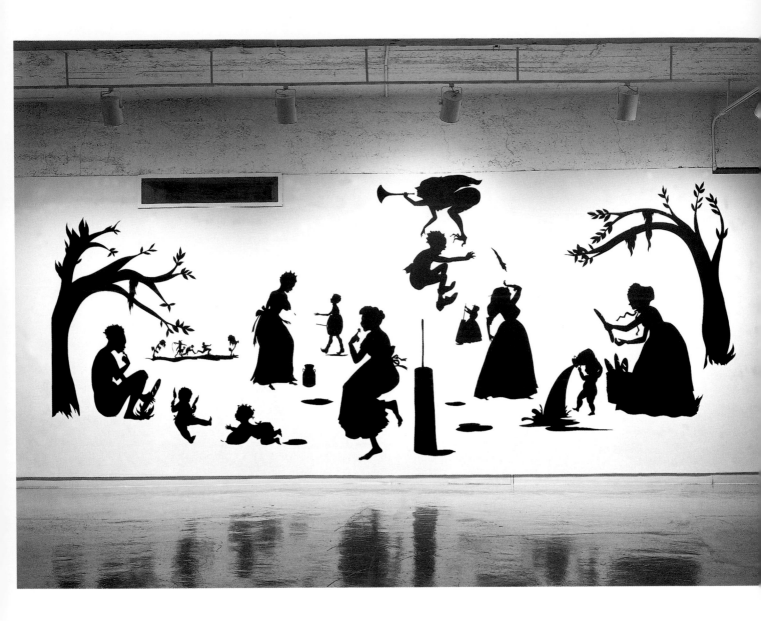

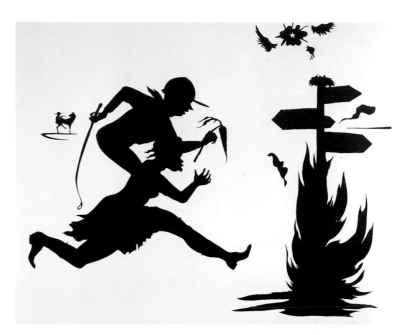

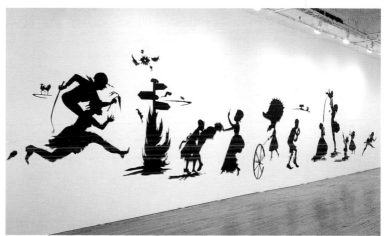

kara walker.
Camptown Ladies, 1998 (details).
Cut paper on wall.

Left: **Untitled (Bread and Milk)**, 1998 (detail).
Cut paper on wall.
Installation at The Forum, St Louis, MO.

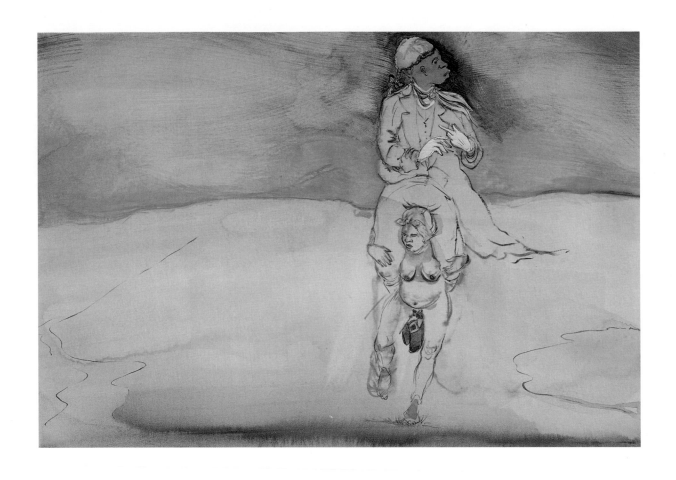

kara walker.
Landscape (from **Insert for Parkett**), 1999.
Watercolour and gouache on paper,
11 x 16" / 28 x 41cm.

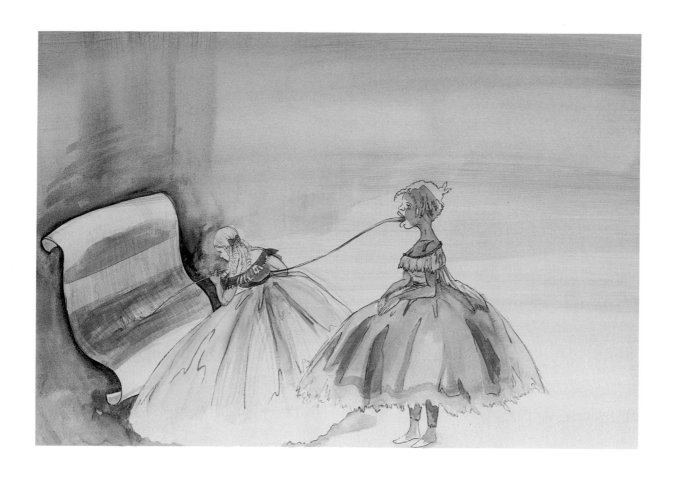

kara walker.
Landscape (from Insert for Parkett), 1999.
Watercolour and gouache on paper,
13 x 17" / 32 x 44cm

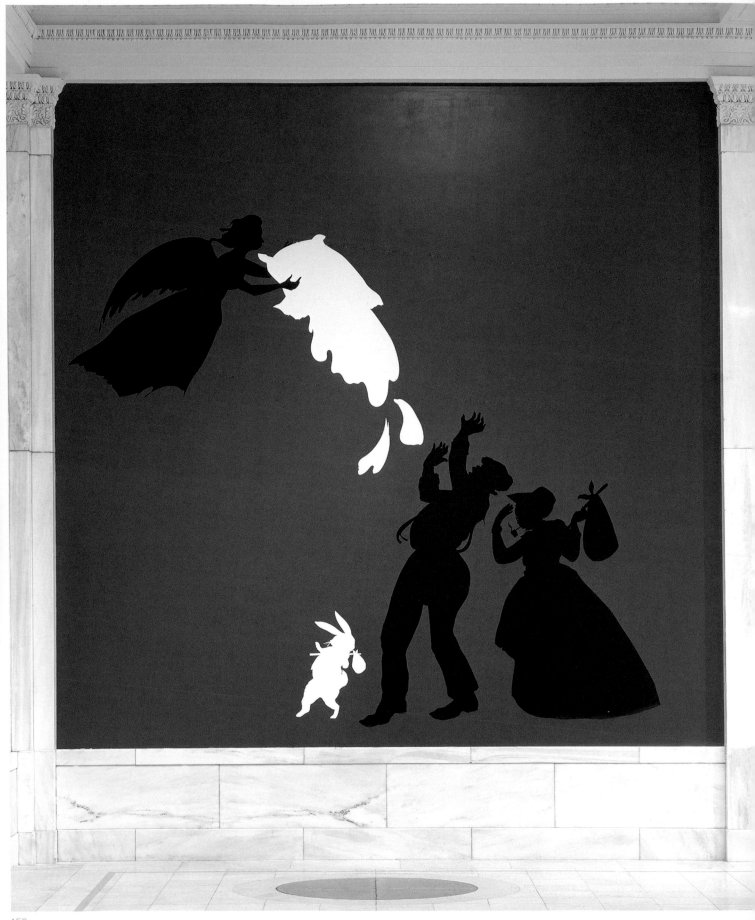

EDUCATION
↓
1989 BFA, The Cooper Union, New York.
1995 MFA, University of California, Los Angeles.
↓
SELECTED SOLO EXHIBITIONS
↓
1996 **What Happened to Amy?**, Casey Kaplan, New York.
1997 **Once in Love With Amy**, Casey Kaplan, New York.
1998 **Focus Series: Amy Adler**, Museum of
Contemporary Art, Los Angeles. ✴
The Problem Child, Entwistle, London.
1999 c/o-Atle Gerhardsen, Oslo.
Why Would I Lie?, Taka Ishii Gallery, Tokyo.
Nervous Character, Margo Leavin Gallery,
Los Angeles.
2000 **Chapter & Verse**, Casey Kaplan, New York.
2001 **Amy Adler Photographs Leonardo diCaprio**,
The Photographers' Gallery, London.
Different Girls, No Limits Events, Milan.
↓
SELECTED GROUP EXHIBITIONS
↓
1995 **In a Different Light**, University Art Museum,
Berkeley, CA.
1996 **Stream of Consciousness: 8 Los Angeles Artists**,
University Art Museum, University of California,
Santa Barbara, CA .✴
1997 **Spheres of Influence: Selections from the
Permanent Collection**, Museum of Contemporary
Art, Los Angeles.
1999 **Amy Adler Curates Joni Mitchell**, Los Angeles
Contemporary Exhibitions, Los Angeles.
2000 **Urs Fischer with Amy Adler**, Delfina Project
Space, London.
Kwangju Biennale 2000, Kwangju, Korea.
2001 **New Acquisitions from the Dakis Joannou
Collection**, Deste Foundation, Athens.
↓
SELECTED BIBLIOGRAPHY
↓

1998 Kotz, Liz, 'Amy Adler: Surrogates', Art/Text,
Los Angeles, May-July 1998, pp 28-31.
1999 Lord, M.G., 'A Thousand Words: Amy Adler',
Artforum, New York, April 1999, pp 110-111.
2000 Smith, Roberta, 'Amy Adler', **The New York Times**,
New York, 12 May 2000, p 7.
2001 **I Am A Camera**, The Saatchi Gallery, London, 2001.
Summer, Francis, 'I Shot Leonardo', **Sleazenation**,
London, May 2001, pp 94-96.

✴ Exhibition publication produced

160

amy adler.

BORN IN NEW YORK, 1966.
LIVES IN LOS ANGELES.

↓

Amy Adler's elaborately layered and distinctive working method situates the event of a drawing between two photographic acts. Starting with photos of herself or others—either found or staged—Adler makes a drawing from a photograph and then photographs the drawing. The original source material and the resultant pastel drawing are then destroyed once the final photo-graphic image is made. The resultant cibachromes are presented as unique images —rather than multiple editioned prints—thereby further complicating their status.

↓

Adler's practice is in fact a fusion of media that includes not only photography and drawing but also embraces performance. The drawing and the photo are each treated as performative spaces where she engages with issues of identity, desire and sexuality. Her work explores the channeling of these drives through various media—both mass and artistic. Such a melding of media produces images that are not only distanced by her varied acts of mediation, but also strangely intimate. The images (often presented in series) contain traces of unsettling narratives and on-going acts of story telling.

↓

In works such as **What Happened to Amy?** (1996) the artist drew upon her own life, deploying a drawing style related to the carefully modelled line of the teenager, and exploring the psychic space of the coming-of-age drama. Adler is once again her own model in **Nervous Character** (1999), which suggests the animated cell in its sequence of 24 pictures (it is notable that cinematic film contains 24 frames per second). In other works Adler has turned to images of celebrity. Series such as **Different Girls** (2000) and **Amy Adler Photographs Leonardo DiCaprio** (2001) contain unstable images of identity and desire, in which control passes uneasily between the artist, the viewer and the 'star' depicted.

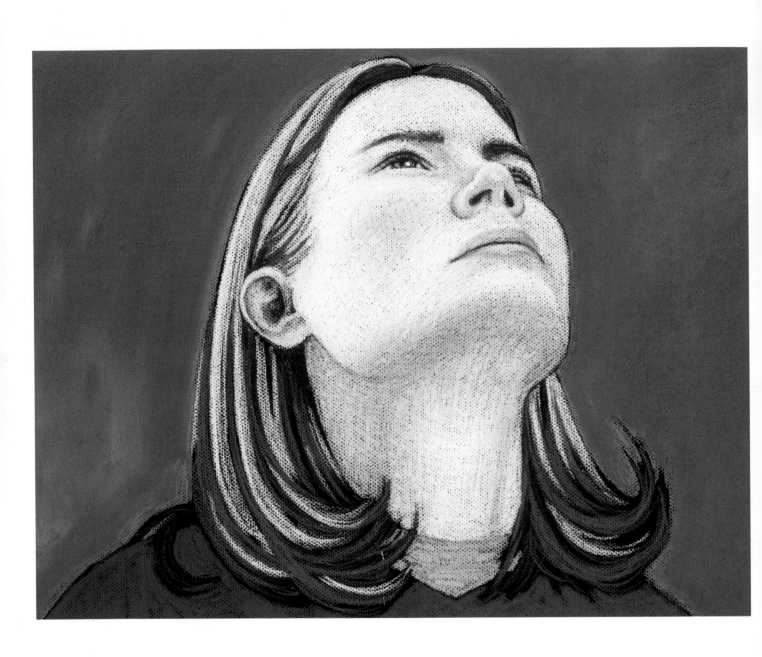

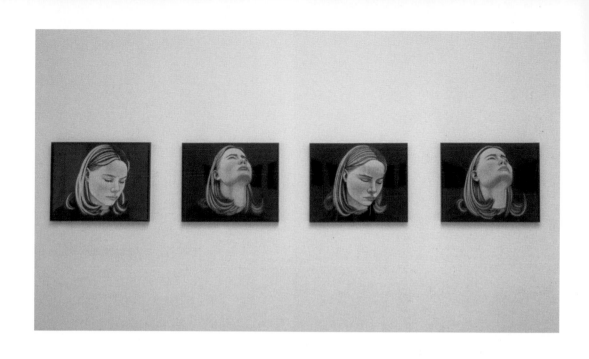

amy adler.
Nervous Character, 1999
(various parts from 24-part series).
Cibachrome prints,
each 24 x 36" / 61 x 91cm.

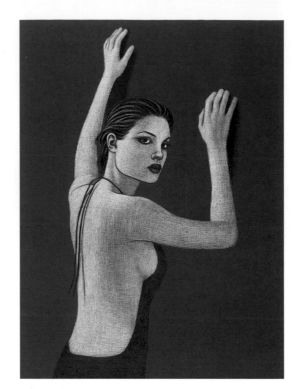

amy adler.
Different Girls, 2000 (five-part series).
Cibachrome prints, each either
60 x 40"/152 x 102cm or 40 x 60"/102 x 152cm.

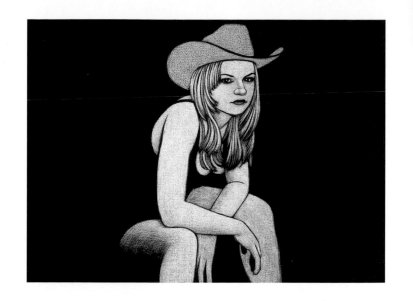

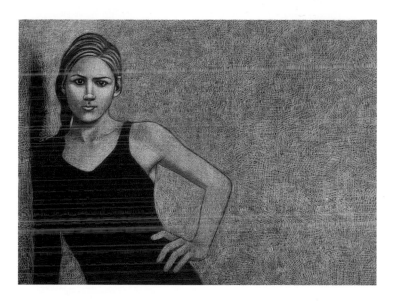

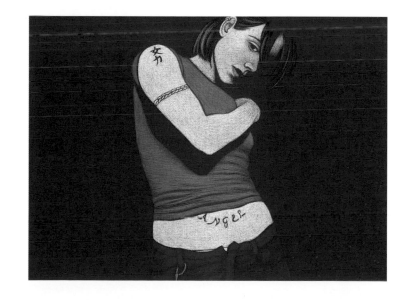

amy adler.
Amy Adler Photographs Leonardo DiCaprio, 2001
(one part from six-part series).
Cibachrome print, 60 x 40" / 152 x 102cm.

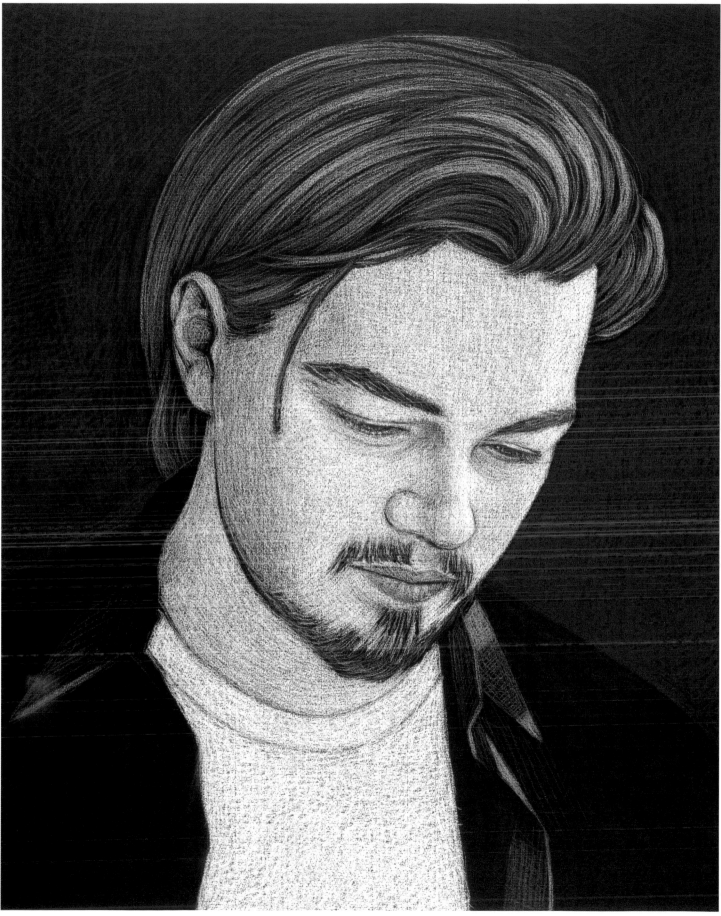

1968-1973

Hawaii

1974-1976

thinking that my life is so good that something bad must be about to happen

1974-1976

"Jonny Horowitz, Jonny Horowitz"

1977-1979

buying Playgirl magazine from a vending machine in the entry way of the Holiday Inn

1980-1981

1982-1987

I think I have AIDS

1988-1993

NICK AT NITE

1994-2000

1994-2000

jonathan horowitz.
The Jonathan Horowitz Show, 2000.
Installation with multi-channel video, monitors, audio equipment and vinyl wall text.

Right: installation at Greene Naftali Gallery, New York.
Above: stills from individual videos.

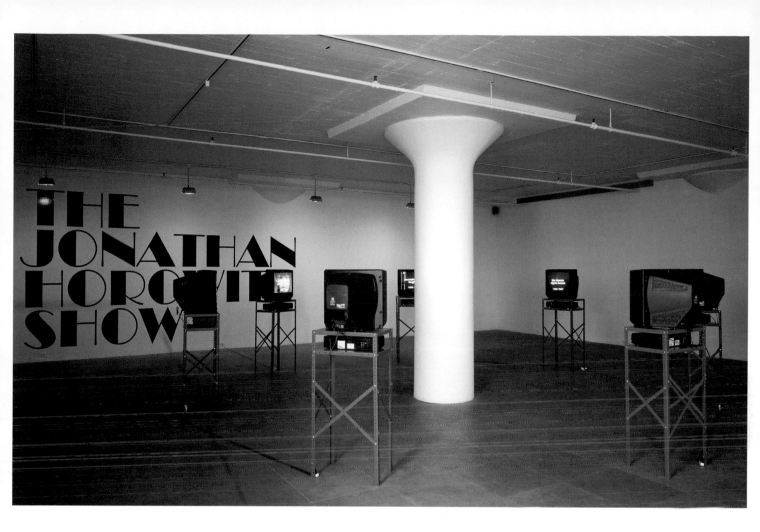

Eric Roberts
Giancarlo Giannini
Dennis Hopper
Burt Young
1988

Justine Bateman

Sally Field
Dolly Parton
Shirley Maclaine
Daryl Hannah
Olympia Dukakis
Julia Roberts
1989

Robin Williams
Dustin Hoffman
Julia Roberts
Bob Hoskins

Tim Robbins
Greta Scacchi
Fred Ward
Whoopi Goldberg
Peter Gallagher
Brion James
1992

Julia Roberts
Denzel Washington
1993

Julia Roberts
Nick Nolte
1994

Alan Alda, Woody Alan,
Drew Barrymore, Lukas Haas,
Goldie Hawn, Gaby
Hoffmann, Natasha Lyonne,
Edward Norton, Natalie
Portman, **Julia Roberts**, Tim
Roth, David Ogden Stiers
1997

Julia Roberts

Mel Gibson
Julia Roberts

Julia Roberts
Susan Sarandon
Ed Harris
1998

jonathan horowitz.
Best Actress, 2001.
24 laser prints,
each 9 x 11"/ 22 x 29cm.

172

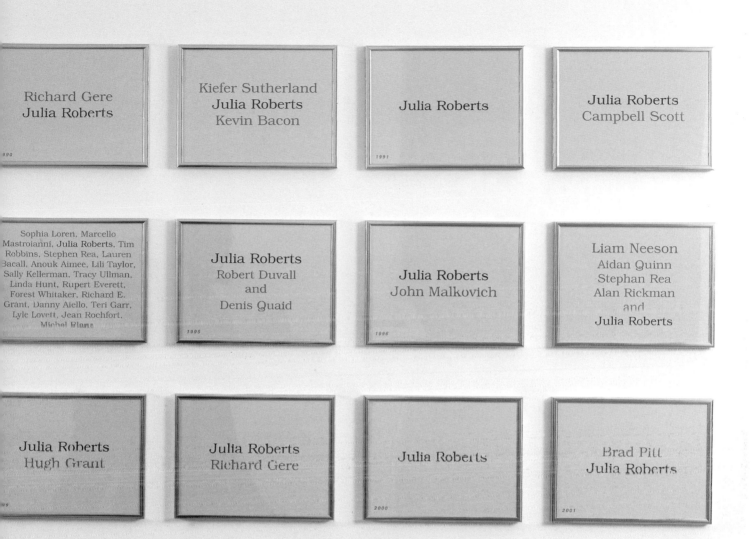

talking without thinking
(in the voice of Marilyn Monroe)

jonathan horowitz.
Talking Without Thinking (in the Voice of Marilyn Monroe), 2001.
Installation with cd, audio equipment and vinyl wall text.

EDUCATION
↓
1989 Studio 70, Fort Thomas, KY.
1992 School of the Museum of Fine Arts, Boston.
1993 Skowhegan School of Painting and Sculpture,
 Skowhegan, ME.
 ↓
SOLO EXHIBITIONS
↓
1994 Mario Diacono Gallery, Boston.
1996 Anthony d'Offay Gallery, London.*
 Mary Boone Gallery, New York.
1998 Gagosian Gallery, New York.*
 IKON Gallery, Birmingham, England.*
1999 Mario Diacono, Boston.
 Galerie Max Hetzler, Berlin.*
2000 Anthony d'Offay Gallery, London.
 Ellen Gallagher: Pickling, Galerie Max Hetzler,
 Berlin.
2001 **blubber**, Gagosian Gallery, New York.*
 ↓
SELECTED GROUP EXHIBITIONS
↓
1994 **In Context**, Institute of Contemporary Art,
 Boston.
1995 **Whitney Biennial**, The Whitney Museum of
 American Art, New York.*
 Degrees of Abstraction, Museum of Fine Arts,
 Boston.
1996 **Inside the Visible**, Institute of Contemporary Art,
 Boston (and tour).*
 **Art at the End of the 20th Century: Selections
 of the Whitney Museum of American Art**,
 Alexandros Soutzos Museum, Athens (and tour).
1997 **Project Painting**, Basilico Fine Arts and Lehmann
 Maupin Gallery, New York.
 Projects, Irish Museum of Modern Art, Dublin.
1999 **(Corps) Social**, Ecole Nationale Supérieure des
 Beaux-Arts, Paris.
2000 **Making Sense: Ellen Gallagher, Christian Marclay,
 Liliana Porter**, Contemporary Museum, Baltimore,
 MD.*
 Greater New York, PS1/MoMA, New York.*
2001 **From Rembrandt to Rauschenberg**, Blanton
 Museum of Art, Austin, TX.
 ↓

SELECTED BIBLIOGRAPHY
↓
1997 Halley, Peter, 'Ellen Gallagher with Peter Halley,
 Index, New York, July-August 1997, pp 6-15.
1998 Smith, Roberta, 'Ellen Gallagher', **The New York
 Times**, New York, 20 March 1998, np.
 Hunt, Ron, 'Ellen Gallagher', **Modern Painters**,
 London, Winter 1998, np.
1999 Eichler, Dominic, 'Ellen Gallagher', **Frieze**, London,
 June-August 1999, pp 96-97.
2001 Belcove, Julie L., 'Gallagher's Travels', **W**, New York,
 March 2001, pp 245-249, 528.

 * Exhibition publication produced.

ellen gallagher.

BORN IN PROVIDENCE, RI, 1965.
LIVES IN NEW YORK.
↓

At first glance Ellen Gallagher's paintings appear to be made up from abstract patterns, and her use of grids, of layering, of the accumulation of tiny marks, suggest an artist whose concerns are largely formal. At close range, however, Gallagher's paintings reveal themselves to be more messy, more goofy, more brutal and more strange.
↓

The feature of Gallagher's work that is most discussed is the set of tiny cartoon-ish motifs which she builds into her paintings. These signs include exaggerated eyes, tongues, lips and bow ties, derived from a history of black stereotypes and of minstrel shows in particular; as well as heads of wasp-ish women with Atomic Age hairdos. Such images carry some of their original comic resonance, but the way Gallagher isolates and repeats these signs brings out their latent aggression and banality. The way she builds them into waves and swarms suggests structures that are natural, or fantastical, as well as social. And in the end the work is much larger than the sum of these signs. Gallagher's art isn't 'about' being African-American, being female. But it is certainly about how meaning is created and re-created, and about the queasy duality of power and resistance.
↓

Recently Gallagher has been making a series of works using wig ads torn from old copies of **Ebony** magazine. 'They start in the Fifties and then break off right at the height of the Black Power movement,' she explains. 'I don't deny their oppressive nature and that they're about a complex relationship to whiteness and power dynamics. But at the same time, there's this way in which black women embody those wigs that is also really empowering. Things get reduced to, "If you had an Afro, you were free." People forget or don't understand that these were very complicated, destructive forms that can also be embodied with a kind of power and assertiveness.'

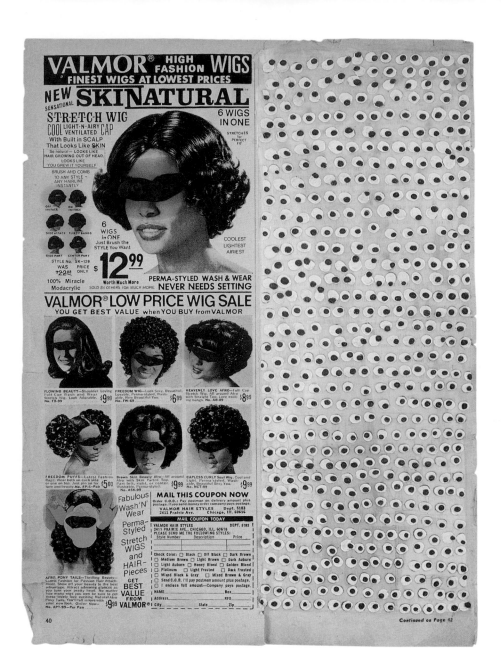

ellen gallagher.
Untitled, 2000.
Oil, pencil and plasticene on paper,
13 x 10" / 33 x 25cm.

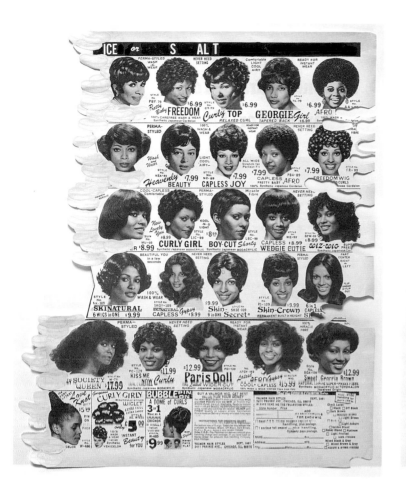

ellen gallagher.
Untitled, 2001.
Paper collage on paper,
13 x 10"/ 33 x 25cm.

Right: Untitled, 2001.
Oil, pencil and plasticine on paper,
13 x 10"/ 33 x 25cm.

ellen gallagher.
Bling Bling, 2001.
Rubber, paper and enamel on linen,
96 x 120" / 244 x 305cm.

EDUCATION

1984 BFA, San Jose University, San Jose, CA.
1989 MFA, University of California, Los Angeles.

SELECTED SOLO EXHIBITIONS

1995 Ace Gallery, New York.
1996 Yerba Buena Center for the Arts, San Francisco.
 Cincinnati Contemporary Art Center,
 Cincinnati, OH.
 Ace Contemporary Exhibitions, Los Angeles.
1997 **Secret Sync**, Ace Contemporary Exhibitions,
 Los Angeles.
 Southeastern Center for Contemporary Art,
 Winston-Salem, NC.
1998 Galleria Milleventi, Milan.
 The Pneumatic Quilt, Ace Contemporary
 Exhibitions, Los Angeles.
1999 Akira Ikeda Gallery, Taura.
 Ace Gallery, New York.
2000 White Cube, London.
 Überorgan, MASS MoCA, North Adams, MA
 (and tour).*
 Miyake Design Studio, Tokyo, Japan.
 Pentecost, Ace Gallery, Los Angeles.
2001 **Directions**, Hirshhorn Museum and Sculpture
 Garden, Washington, DC.

SELECTED GROUP EXHIBITIONS

1995 **In the Black**, Irvine Fine Arts Center, Irvine, CA.*
 California in Three Dimensions, California Center
 for the Arts, Escondido, CA .*
 Veered Science, Huntington Beach Art Center,
 Huntington Beach, CA.*
1996 **Narcissism**, California Center for the Arts
 Museum, Escondido, CA .*
 Nordic Biennale, Arken Museum of Modern Art,
 Copenhagen.*
1997 **Yard Sale**, Milwaukee Art Museum, Milwaukee, WI.
1998 **Etre Nature**, Foundation Cartier pour l'Art
 Contemporain, Paris.*
1999 **Zero Gravity**, Whitney Museum of American
 Art at Champion, Stamford, CT.
 Venice Biennale, Venice.
 Head To Toe: Impressing the Body, University
 Gallery, University of Massachusetts at
 Amherst, MA.
2000 **The Greenhouse Effect**, Serpentine Gallery,
 London.
 Arte Americana, Ultimo Decennio, Ravenna, Italy.

SELECTED BIBLIOGRAPHY

1997 Duncan, Michael. 'Recycling the Self', **Art in
 America**, New York, May 1997, pp 112-115.
1999 Kastner, Jeffrey. 'Tim Hawkinson', **Sculpture**,
 Hamilton, NJ, July-August 1999, pp. 70-71.
2000 Miles, Christopher, 'A Thousand Words: Tim
 Hawkinson Talks About Überorgan', **Artforum**,
 New York, September 2000, p 153.
2001 Herbert, Martin, 'Body Rhythms', **Tema Celeste**,
 Milan, March-April 2001, p 76-79.

* Exhibition publication produced

tim hawkinson.

BORN IN SAN FRANCISCO, 1960.
LIVES IN LOS ANGELES.

The human body—with its system of organs, veins and skin—is both the starting point and underlying metaphor for much of Tim Hawkinson's art. When Hawkinson uses his own body in his work, it is for the same reason that he uses found objects or readily available materials: 'it's a working method that I've developed out of an interest in economy, in streamlining. It's just nice to have something that is always there'.

Mappings of the artist's own body feature in works such as **Pentecost** (1999), a large tree constructed from cardboard and paper tubes, filled with life-size figures that use their various appendages to tap out rhythmic sounds against the branches. One of the characteristics of Hawkinson's work is to make audible the silent communications that structure our bodies. **Überorgan** (2000) is exactly that: a massive musical organ originally created for the ribbed abdominal cavity of a museum in Massachusetts. In this work Hawkinson has created an organ so large that we can hear the sound of it own workings.

Hawkinson does not treat culture as a foreign agent that is artificially introduced to the human host. Indeed, the networks that make up a body, culture or machine are capable, in his hands, of being hot-wired together as one—perhaps otherworldly—organism.

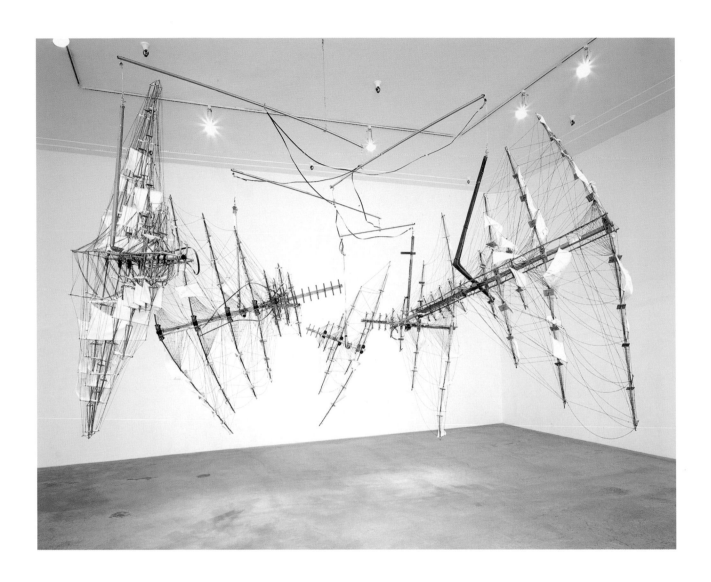

tim hawkinson.
Untitled (Mobile), 1998.
TV aerials, fabric, string and wood,
dimensions variable.

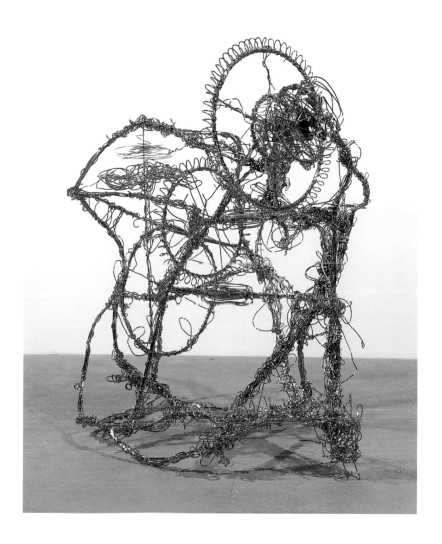

tim hawkinson.
Gin, 1999.
Chrome wire,
38 x 36 x 28" / 97 x 91 x 71cm.

tim hawkinson.
Bath Jinn, 1999.
Ball-point pen on paper,
123 x 47" / 312 x 119cm.

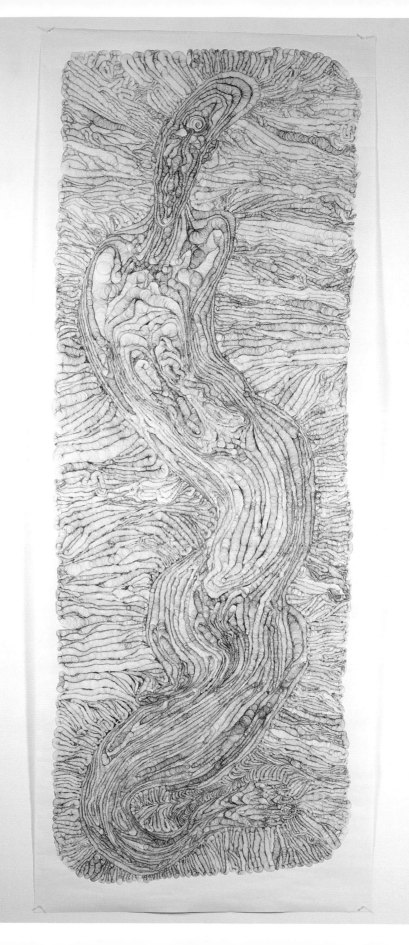

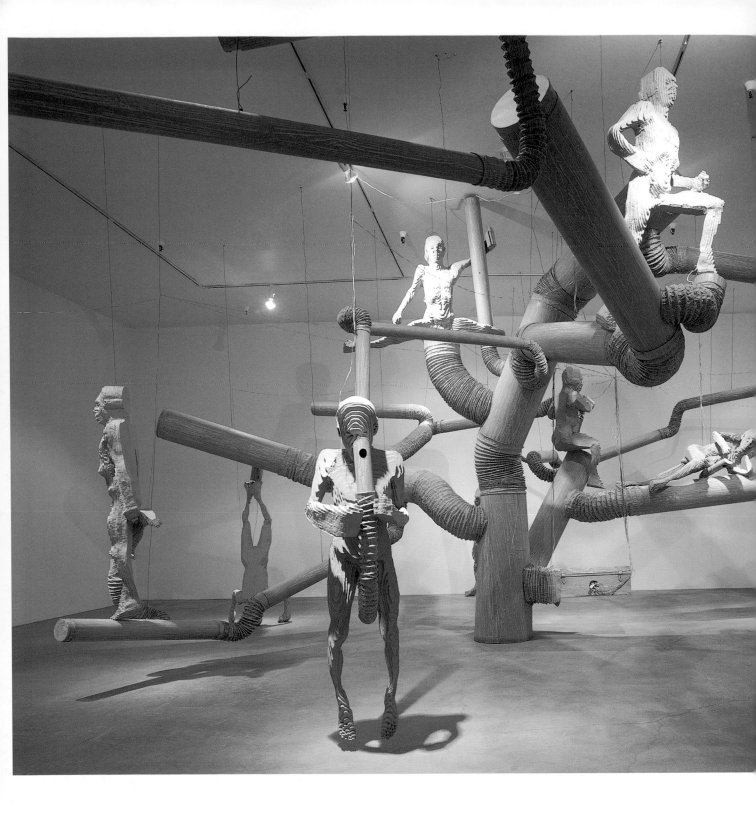

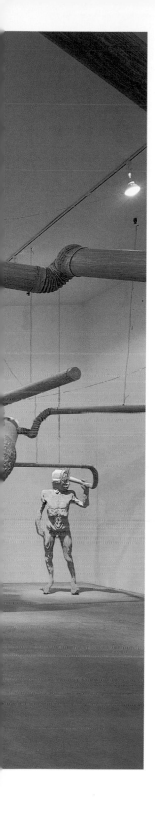

Pentecost, 1999.
Polyurethane, foam, sonotubes and mechanical
components, dimensions variable.

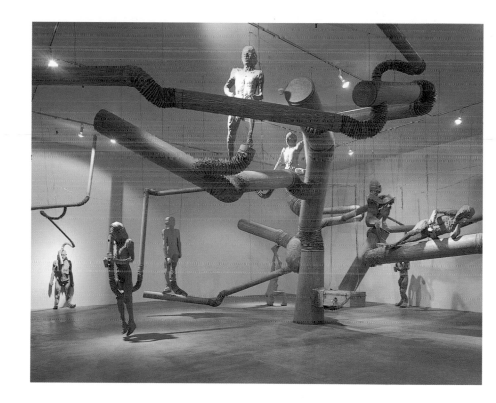

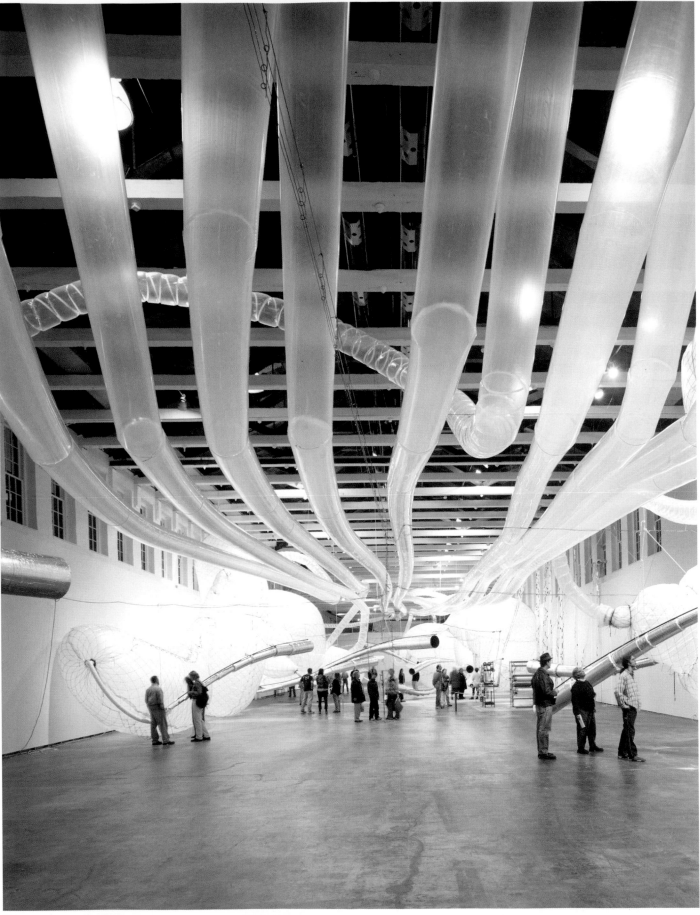

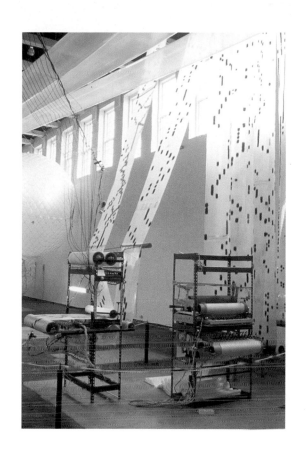

tim hawkinson.
Überorgan, 2000.
Woven polythene, nylon net, cardboard
tubing and mechanical components.
Installation at Massachusetts Museum
of Contemporary Art.

EDUCATION
↓
1982 BA, California State University,
Fullerton, CA.
↓
SELECTED SOLO EXHIBITIONS
↓
1994 Galerie Anne de Villepoix, Paris.
1995 Christopher Grimes Gallery, Santa Monica, CA.
Jack Tilton Gallery, New York.
1996 Center for the Arts at Yerba Buena Gardens,
San Francisco.
1997 Jack Tilton Gallery, New York.
1998 Christopher Grimes Gallery, Santa Monica, CA.
Gravity's Rainbow, Whitney Museum of American.
Art at Philip Morris, New York.*
Galerie Gebauer, Berlin.*
Galerie Anne de Villepoix, Paris.
2000 James Cohan Gallery, New York.*
2001 White Cube, London.
↓
SELECTED GROUP EXHIBITIONS
↓
1993 **The Final Frontier**, The New Museum
of Contemporary Art, New York.
1995 **Painting Outside Painting**, The Corcoran Gallery
of Art, Washington, DC.
Pittura/Immediata, Neue Galerie am
Landesmuseum Joanneum und Kunstlerhaus,
Graz, Austria.
1996 **Multiple Identity: Selections from the Whitney
Museum of American Art**, Alexandros Soutzos
Museum, Athens (and tour).
1997 **Heart, Mind, Body and Soul**, Whitney Museum of
American Art, New York.
Current Undercurrent: Working in Brooklyn,
Brooklyn Museum of Art, New York.
1998 **Project 63: Karin Davie, Udomsak Krisanamis,
Bruce Pearson, Fred Tomaselli**, Museum of
Modern Art, New York.
2000 **Lyon Biennial**, Lyon.*
**Twisted: Urban and Visionary Landscapes in
Contemporary Painting**, Stedelijk Van
Abbemuseum, Eindhoven, The Netherlands.*
Open Ends, The Museum of Modern Art, New York.
↓

SELECTED BIBLIOGRAPHY
↓
1998 Pagel, David, 'Exploring Realm of Intoxicating
Illusions', **The Los Angeles Times**, Los Angeles,
27 February 1998, p F22.
1999 Volk, Gregory, 'Transportive Visons',
Art in America, New York, July 1999, pp 78-80.
Harris, William, 'He Dropped Out of Drugs and
Put Them in His Art', **The New York Times**,
New York, 19 December 1999, p C50.
2001 Wakefield, Neville, 'He Brings Ideas to Life',
Interview, New York, January 2001, p 22.
Frances, Richard, 'Fred Tomaselli', **Artforum**,
New York, February 2001, p 150.

* Exhibition publication produced

fred tomaselli.

BORN IN SANTA MONICA, CA, 1956.
LIVES IN NEW YORK.

↓

Fred Tomaselli's paintings have a feel of the American vernacular about them. Perhaps it is their quilt-like construction, or the way their swirling psychedelic motifs can resemble the paisley patterns of a cowboy's bandana. This said, his works revel in the kind of optical shimmer that much modern American painting has resisted.

↓

Tomaselli uses both acrylic paint and an array of found images, bugs, flowers, medicinal herbs, hallucinogenic plants and – perhaps most provocatively – various illicit and over-the-counter pills. These materials are collaged and composed over a wooden panel and encased within numerous layers of resin. Tomaselli's art has a pronounced literary aspect that finds expression in his visual enquiries into the pairings of nature and culture, utopia and dystopia. **Gravity's Rainbow** (1999) is a massive five-panel piece named after Thomas Pynchon's equally sprawling novel, and both writer and artist share a taste for purposeful ambiguity and a mix of science fiction and fantasy.

↓

Tomaselli states that he tries to keep the viewer 'as off-balance as possible to the reality of what they're seeing'. **Bug Blast** (1998) is a Big Bang of leaves, moths and insects punctuated by a galaxy of white pills. While **Torso Large** (1999) and **Untitled (Expulsion)** (2000) are examples of the kind of humanist cosmology in which he is particularly interested. Tomaselli's eye candy is always food for the head – as in **Cadmium –Phosphene Swirl** (2000), its hex-signs of pills and hemp calling up the seas and skies of this and other worlds.

fred tomaselli.
Bug Blast, 1998.
Pills, leaves, insects, photocollage,
resin and acrylic on wood panel,
60 x 60" / 152 x 152cm.

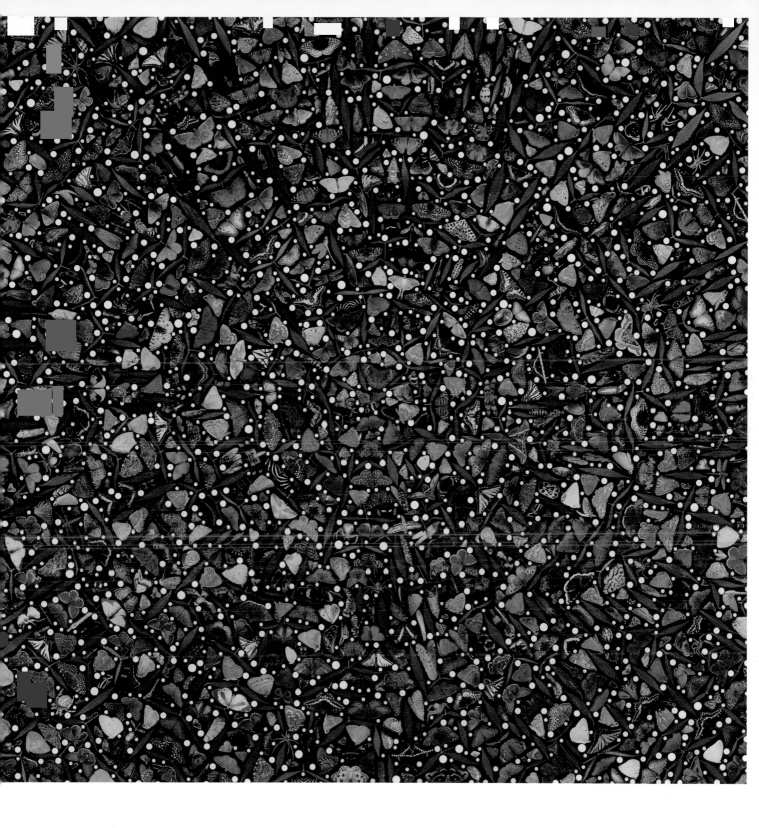

199

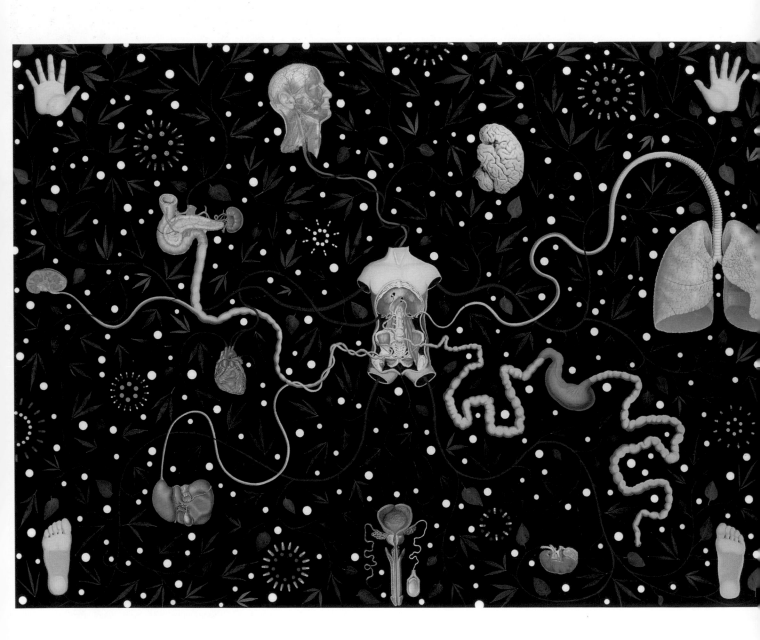

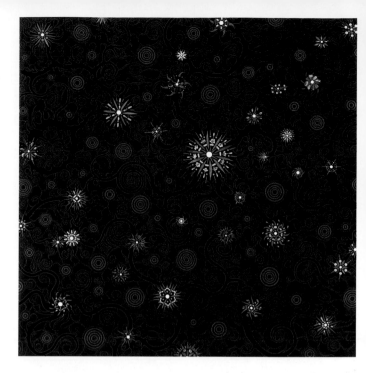

fred tomaselli.
Cadmium Phosphene Swirl, 2000.
Pills, leaves, photocollage,
acrylic and resin on wood panel,
60 x 60" / 152 x 152cm.

Left: lorso Large, 1999.
Leaves, photocollage, pills, acrylic
and resin on wood panel,
54 x 72" / 137 x 183cm.

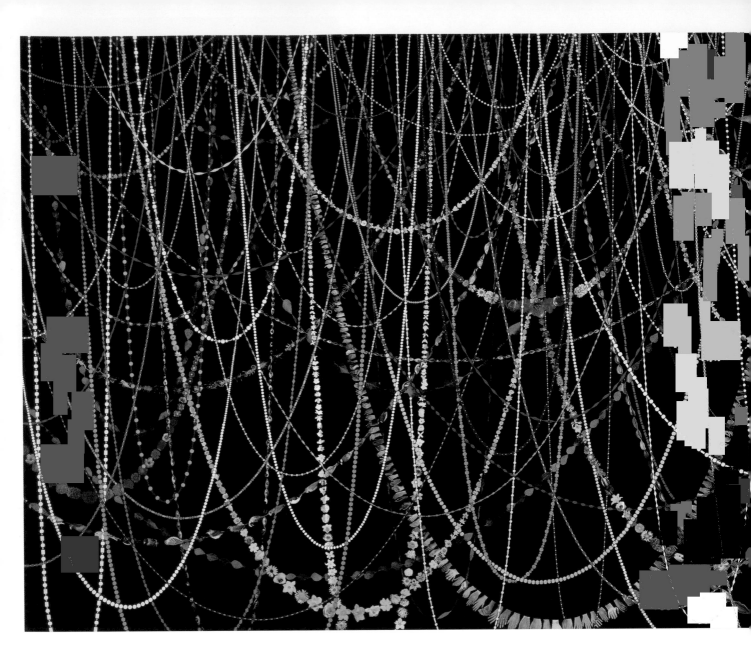

fred tomaselli.
Gravity's Rainbow, 1999.
Leaves, pills, photocollage, flowers,
acrylic and resin on wood panel,
90 x 240" / 229 x 610cm.

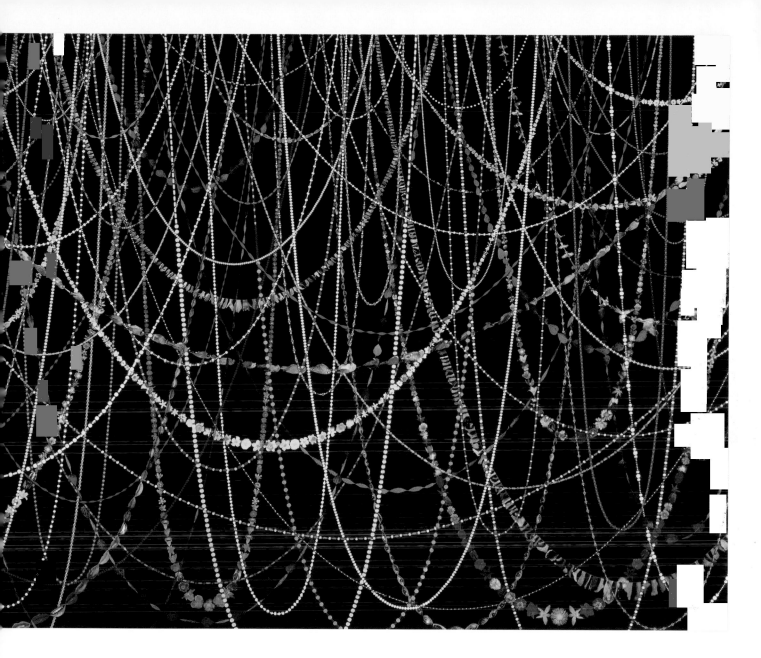

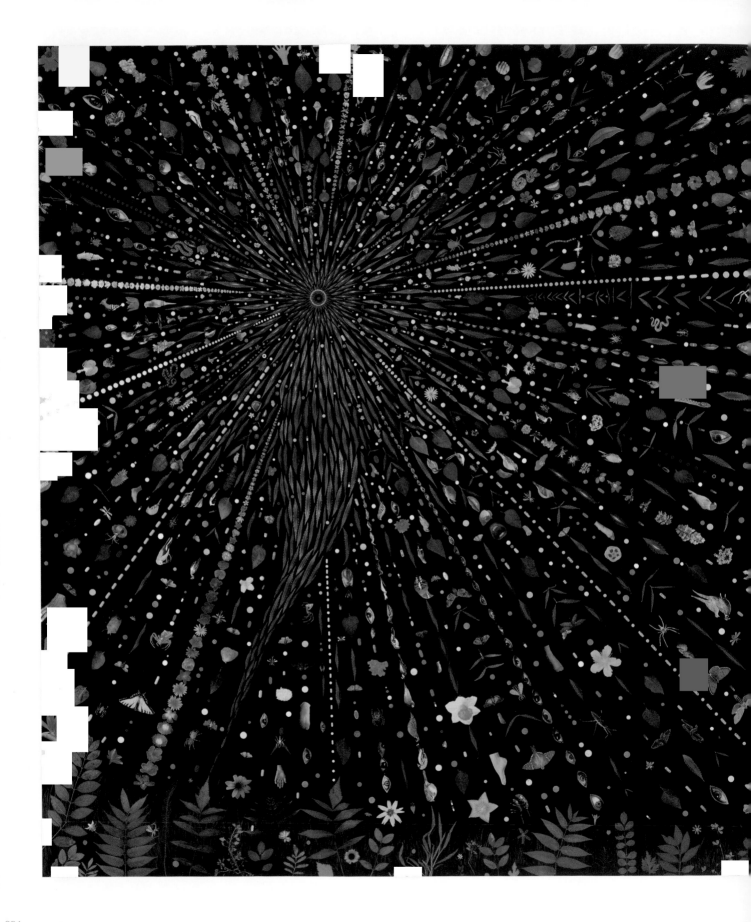

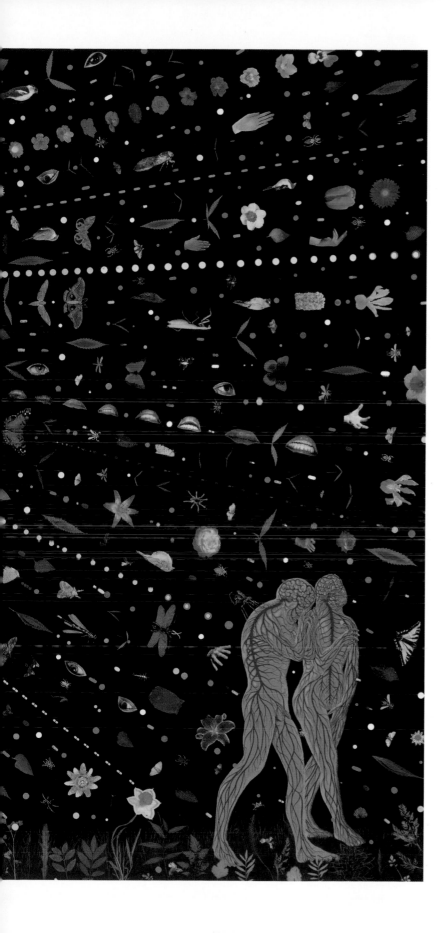

fred tomaselli.
Untitled [Expulsion], 2000.
Leaves, pills, insects, photocollage,
acrylic and resin on wood panel,
84 x 120" / 213 x 305cm.

EDUCATION
↓
1995 MFA, University of Illinois at Chicago, Chicago.
 BFA, Washington University, St Louis, MO.
↓
SOLO EXHIBITIONS
↓
1993 Feature Inc, New York.
1995 **Projects 50: Tom Friedman**, Museum of Modern
 Art, New York.★
1996 Stephen Friedman Gallery, London.
 Feature Inc, New York.★
1997 The Saint Louis Art Museum, St Louis, MO.★
 Feature Inc, New York
1998 Tomio Koyama Gallery, Tokyo.
 Stephen Friedman Gallery, London.
2000 Museum of Contemporary Art, Chicago
 (and tour).★
 Feature Inc, New York.
2001 Fabric Workshop and Museum, Philadelphia, PA.
 Stephen Friedman Gallery, London.
 Tomio Koyama Gallery, Tokyo.
↓
SELECTED GROUP EXHIBITIONS
↓
1996 **Affinities: Chuck Close and Tom Friedman**,
 The Art Institute of Chicago, Chicago. ★
 Universalis: 23, São Paulo.★
1997 **A Lasting Legacy: Selections from the Lannan
 Foundation Gift**, The Geffen Contemporary
 at MOCA, Los Angeles.
 Lovecraft, Centre for Contemporary Art,
 Glasgow (and tour).
1998 **Young Americans 2**, The Saatchi Gallery, London.★
 Poussière (Dust Memories), Fonds Régional d'Art
 Contemporain de Bourgogne, Dijon, France
 (and tour).★
2000 **Open Ends,** The Museum of Modern Art,
 New York.★
2001 **Casino 2001**, Stedelijk Museum voor Actuele
 Kunst, Ghent.
↓

SELECTED BIBLIOGRAPHY
↓
1997 Smith, Roberta, 'Tiny Objects, Grandiose
 Statements', **The New York Times**, New York,
 24 October, 1997, p E35.
2000 Frankel, David, 'X-Acto Science: Tom Friedman',
 Artforum, New York, Summer 2000, pp 138-141.
 Quinones, Paul, 'Tom Friedman', **Flash Art**, Milan,
 May/June 2000, pp 115-116.
2001 **Tom Friedman**, Phaidon Press, London, 2001.

★ Exhibition publication produced

tom friedman.

BORN IN ST LOUIS, MO, 1965.
LIVES IN NORTHAMPTON, MA.

↓

Thirty-six dollars combined to make one large dollar bill. A caterpillar constructed from the artist's hair and placed high on a wall. A drawing made by tracing projected images from a variety of sources; the resulting linear enclosures cut out, leaving only the lines, and then hung by monofilament from the ceiling. The descriptions of Friedman's work and procedures are as compelling as the pieces themselves—indeed, his art exists as both a conceptual proposition to be considered and a material investigation that he performs. Friedman plays both the inquiring scientist and the experimental subject in his art of transformations, multiplications, mutations, deviations and magnifications.

↓

Friedman's materials are everyday and close-at-hand, and his work—at once infinitely fragile and the product of obsessively concentrated labour—is domestic in scale. A set of simple rules usually structure the rational procedures and almost organic accumulations that take place in his work. For example: a cubed network of one-quarter inch sections of polystyrene connected at right angles. Such rules serve as both the camouflage and the framework for the labour and logic invested in the materials. It can be difficult to discern exactly where and when the building up and the breaking down begins to happen—indeed, one action often relies on the other, underscoring the circular and tantalising logic embedded in Friedman's works.

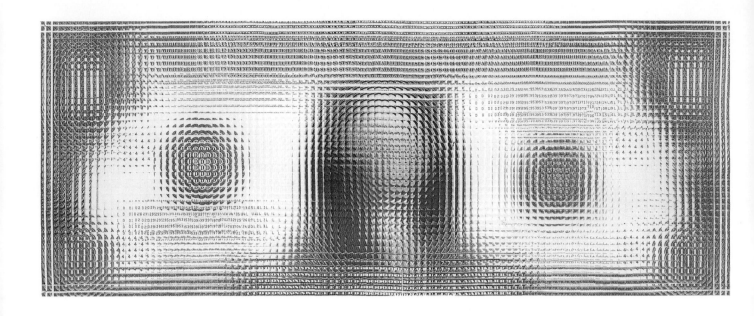

tom friedman.
Untitled, 1999.
Dollar bills,
14 x 35" / 36 x 90cm.

tom friedman.
Untitled, 1999.
Hair, 1 x 1 1/4 x 2 1/2" / 2.5 x 3 x 6cm

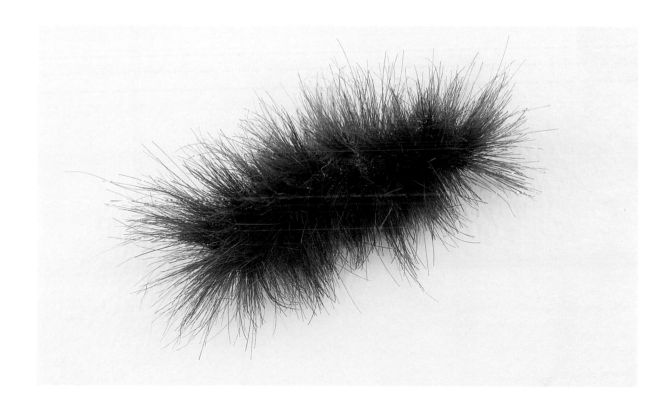

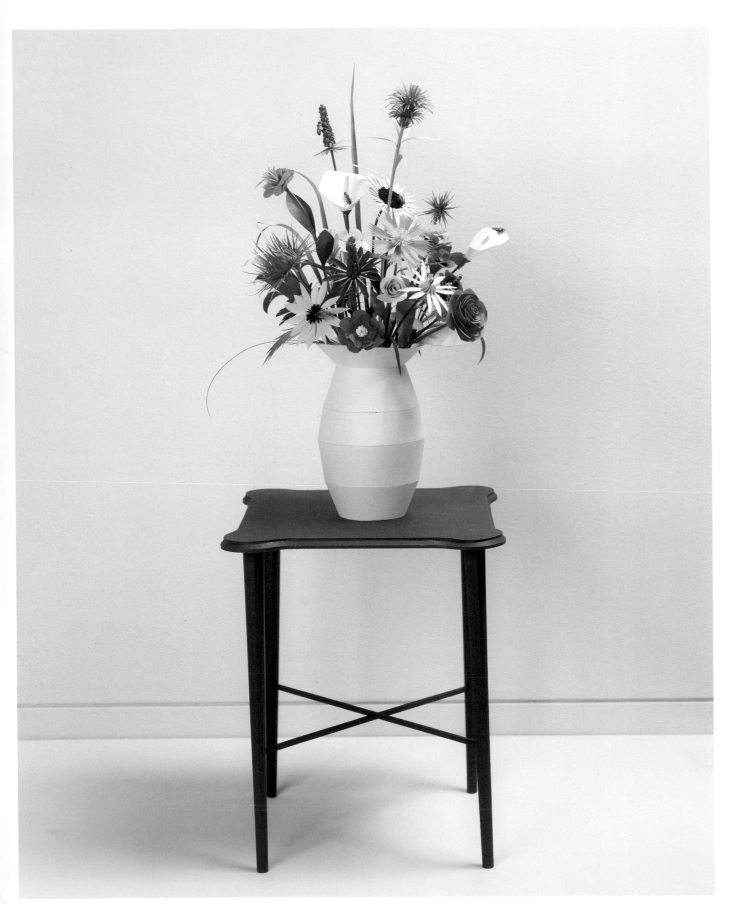

tom friedman.
Untitled, 2000.
Paper, beeswax, clay, wire, paint and fuzz,
28 x 12 x 12"/ 71 x 30 x 30cm.

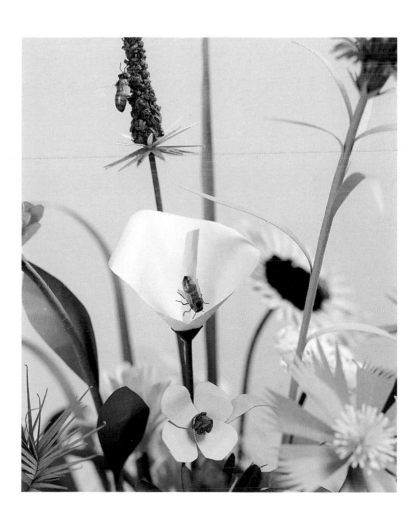

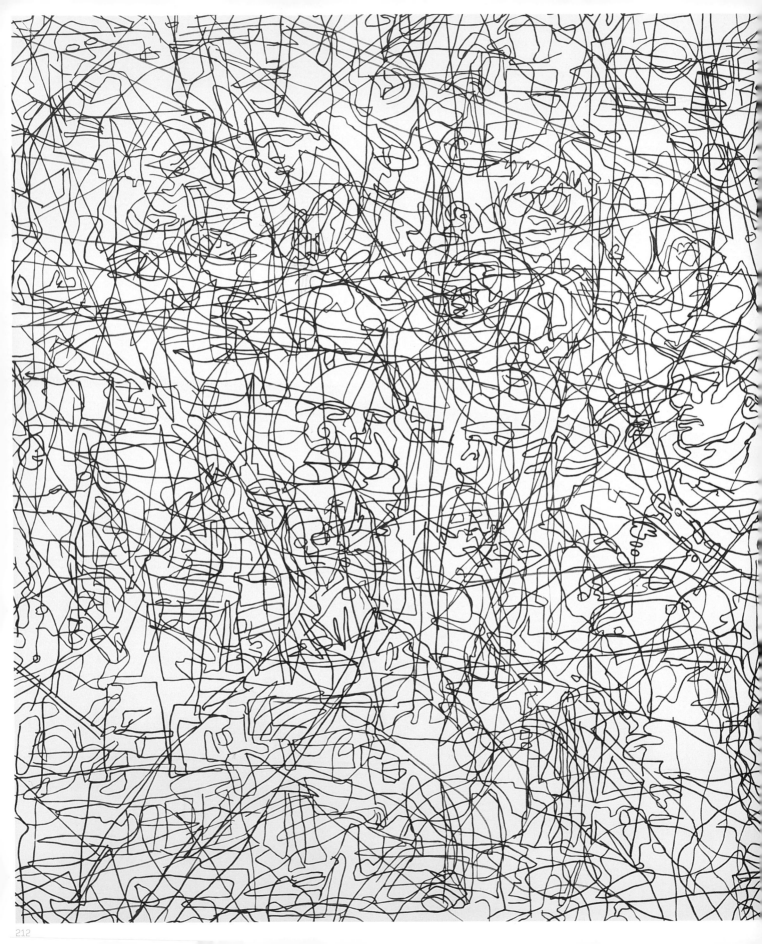

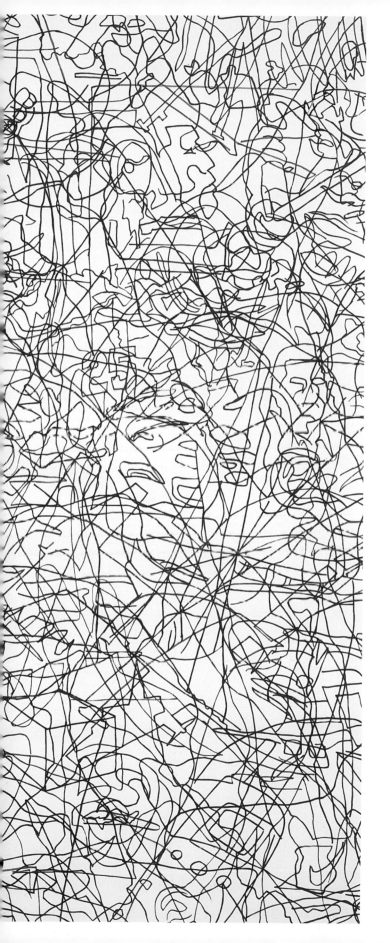

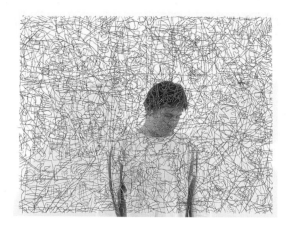

tom friedman.
Untitled, 2000.
Ink on paper, suspended by monofilament,
30 x 39" / 76 x 99cm.

tom friedman.
Untitled, 2000.
Polystyrene insulation,
16 x 16 x 16" / 41 x 41 x 41cm.

Right: **Untitled**, 2001.
Chicken wire and painted Styrofoam balls,
13 x 13 x 13" / 33 x 33 x 33cm.

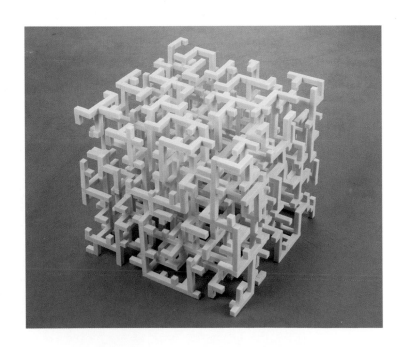

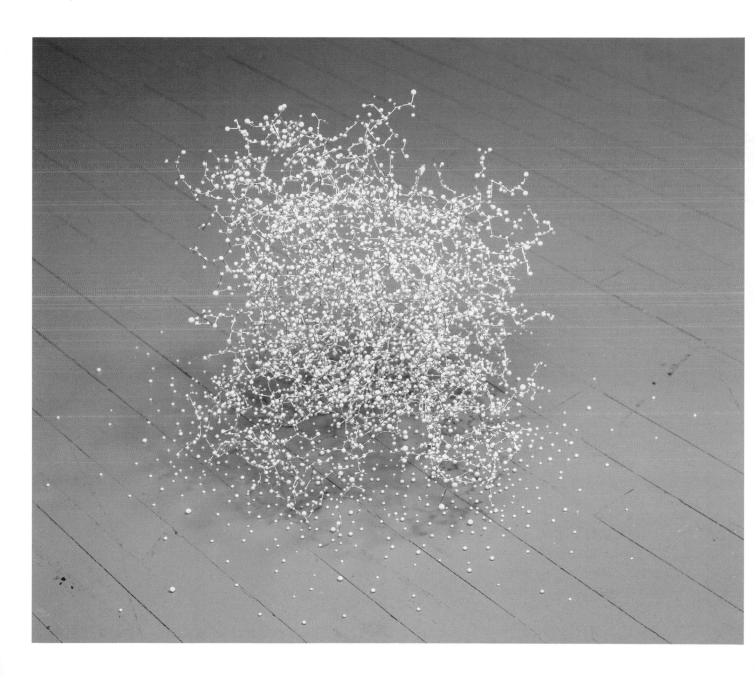

EDUCATION
↓
1995 BFA, The College of Art, Atlanta, GA.
↓
SELECTED SOLO EXHIBITIONS
↓
1998 **Hidden Branches**, Anna Kustera Gallery, New York.
1999 **Neutral Territory**, Anna Kustera Gallery, New York.
2000 Andrew Kreps Gallery, New York.
↓
SELECTED GROUP EXHIBITIONS
↓
1997 **Atlanta Biennial**, Nexus Contemporary Art
 Center, Atlanta, GA.*
1999 **From Your House To Our House**,
 Nexus Contemporary Art Center, Atlanta, GA.
 Visitor, White Columns, New York.
2000 **Greater New York**, PS1/MoMA, New York. *
 21st Century Group Show, Gavin Brown's
 Enterprize, New York.
2001 **Rocks and Trees**, Photographic Resource Center,
 Boston.
↓
SELECTED BIBLIOGRAPHY
↓
2000 Blair, Dike, 'Roe Ethridge', **Time Out New York**,
 New York, 2 November 2000, p 58.
 Griffin, Tim, 'Art of the Deal', **Nylon**,
 New York/London, April 2000, p 34.
 Griffin, Tim, 'Roe Ethridge', **Art in America**,
 New York, February 2000, pp 126-126.
 McKinney, Casey, 'Roe Ethridge', **Animal Stories**
 Magazine, New York, Spring 2000, pp 4-14.
2001 Ethridge, Roe, 'Portfolio of Selected Works',
 Index, New York, April-May 2001,
 pp 14, 16, 18-19.

 * Exhibition publication produced

roe ethridge.

BORN IN MIAMI, FL, 1969.
LIVES IN NEW YORK.

↓

Roe Ethridge's photography celebrates the invisible connections that exist between seemingly disparate realms. His work, evincing a deadpan beauty grounded in the mundane, emerges from the interstices of fine art photography and the magazine imagery of fashion or music or film. The gap between these two spheres — always somewhat artificial — is closing ever tighter and Ethridge escapes being left behind amongst the remnants of either camp.

↓

Ethridge has worked in various formats and genres of photography — from pinhole studies of flower arrangements to the arch-Americana of the photography of the open road. What is uncanny is how his images flow together and find their own equivalence. Ethridge delights in exhibiting works such as **Nancy** (2001) with others such as **Young Pine (Winter)** (1999) or **Ambulance Accident** (2000), forming a compelling suite that reveals connections that transcend style or technical mastery. Ethridge has a grasp of the negative harmonies that structure a fugue, that allow words to have meaning or indeed make photography possible. This permits him to make images that challenge us to be absorbed by the beauty that connects a flaw to its necessary partner in perfection.

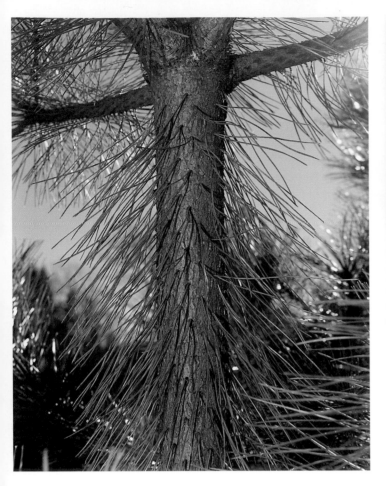

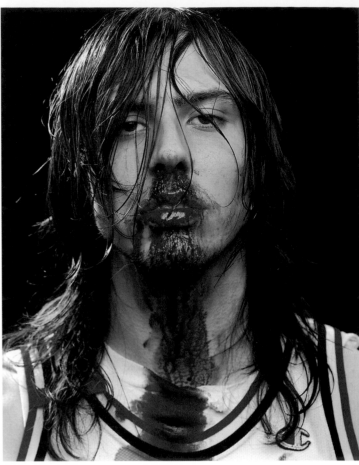

roe ethridge.
Young Pine (Winter), 1999.
C-print, 38 x 30" / 96 x 76cm.

roe ethridge.
Andrew WK, 2000.
C-print, 30 x 24" / 76 x 61cm.

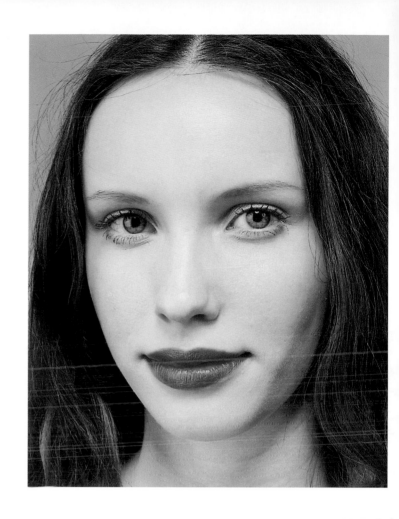

roe ethridge.
Next Model Sabrina, 2000.
C-print, 38 x 30" / 96 x 76cm.

roe ethridge.
Ambulance Accident, 2000.
C-print, 24 x 30" / 61 x 76cm.

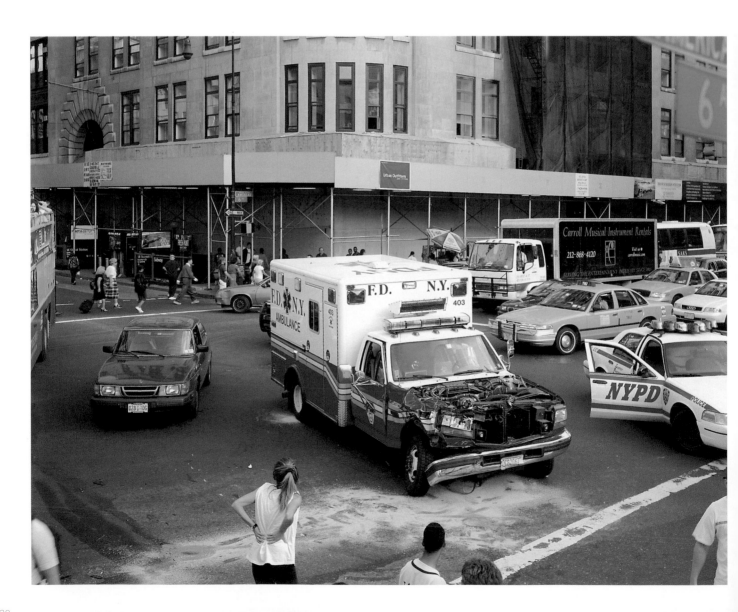

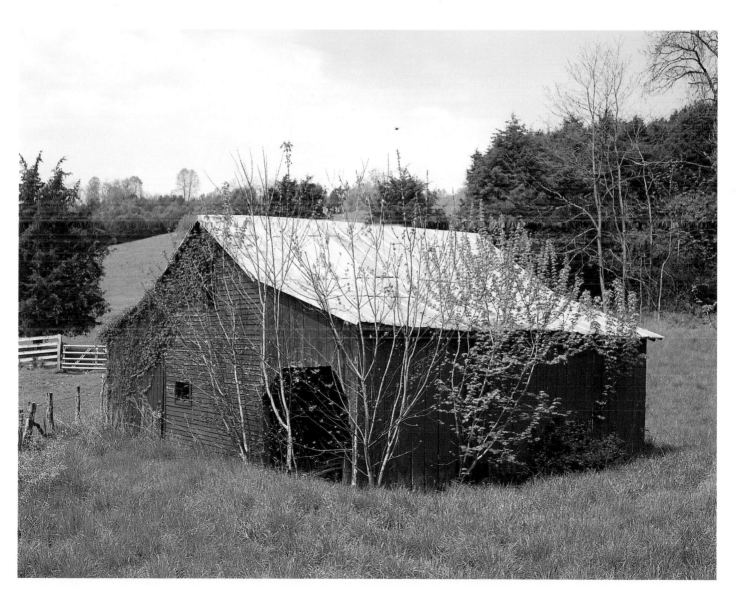

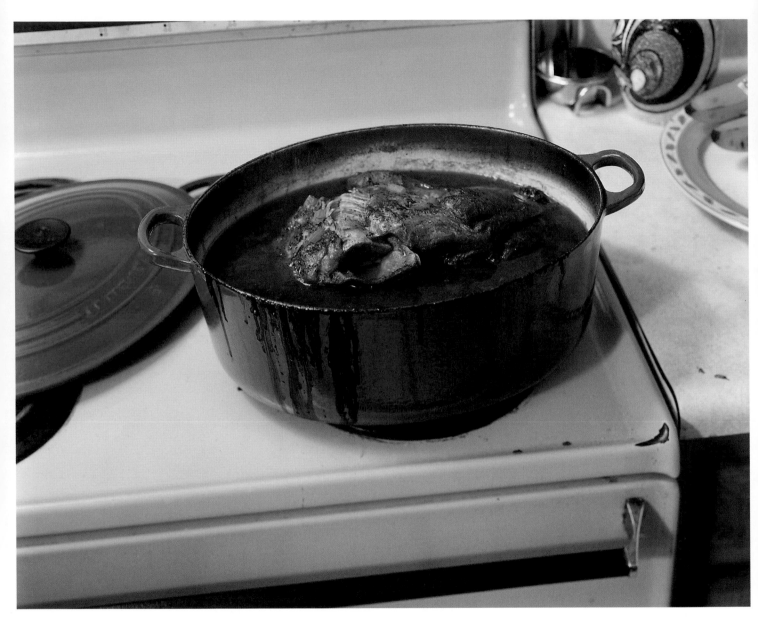

roe ethridge.
Pork Shoulder Cooling, 2000.
C-print, 24 x 30"/ 61 x 76cm.

roe ethridge.
Nancy, 2001.
C-print, 30 x 24"/ 76 x 61cm.

EDUCATION
↓
1992 BA, University of California, Berkeley, CA.
1997 MFA, University of California, Los Angeles.
↓
SOLO EXHIBITIONS
↓
1998 Brent Petersen Gallery, Los Angeles.
2001 Regen Projects, Los Angeles.
↓
SELECTED GROUP EXHIBITIONS
↓
1999 **Los Angeles**, Galerie Philomene Magers
 and Maximilian Verlag, Munich.
 The Perfect Life; Artifice in LA, Duke University
 Museum of Art, Durham, NC.*
2000 **00**, Barbara Gladstone Gallery, New York.*
 LA, Monika Spruth and Philomene Magers,
 Cologne.
 Mise en Scène: New LA Sculpture,
 Santa Monica Museum of Art, Santa Monica, CA
 (and tour).*
2001 **Sonsbeek 9: Locus/Focus**, Arnhem,
 The Netherlands.
 **Bright Paradise: Exotic History and
 Sublime Artifice**, The University of Auckland
 Art Gallery, Auckland.*
↓
SELECTED BIBLIOGRAPHY
↓
1999 Hainley, Bruce, 'Openings: Paul Sietsema',
 Artforum, New York, February 1999, p 86.
2000 Pettibon, Raymond, 'Paul Sietsema by
 Raymond Pettibon', **Issue**, New York, 2000,
 pp 146-151.
 'Paul Sietsema', **ZOO**, London, August 2000, p 198.

 * Exhibition publication produced

paul sietsema.

BORN IN LOS ANGELES, 1968.
LIVES IN LOS ANGELES.

↓

Paul Sietsema's concerns are in many respects those of a traditional sculptor: space, time and objects. However, in his work the meditations of an object maker are complicated by a poetics of absence, for Sietsema works with film, and the objects he shoots are painstaking constructs: material stand-ins, props and set pieces.

↓

Made in 1998, **Untitled (Beautiful Place)** is a nineteen-minute silent film shot on both black and white and colour stock. Sietsema's minimalist film is compiled of eight sequences that focus with forensic detail on individual plants. In one section the camera scans the length and breadth of a spindly pink orchid. In another a delicate forest flower is isolated in the night. These plants belong to the exotica of the cultural past. The feel of Sietsema's film suggests that we have seen all this before—in home movies, a darkened high school classroom or even perhaps a pop music video. These plants appear to belong to nature but refer—like the 3D spaces that feature in his unfinished film **Empire**—to the realm of cultural memory and meaning.

↓

Sietsema's objects exist as immaterial projections within the dreamlike frame of cinema. They are thus decoys onto which we can project and read far wider content than may ostensibly be contained in such specific objects as a flower, or a reconstruction of a culturally loaded architectural space.

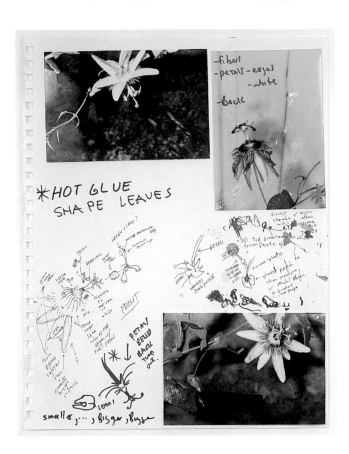

paul sietsema.
Notebook page from Untitled
(Beautiful Place), 1998.
Pen, ink and photograph on paper,
14 x 11" / 35.5 x 28cm.

Right: Film still from Untitled
(Beautiful Place), 1998.
16mm film in B&W and colour,
silent, 19 minutes.

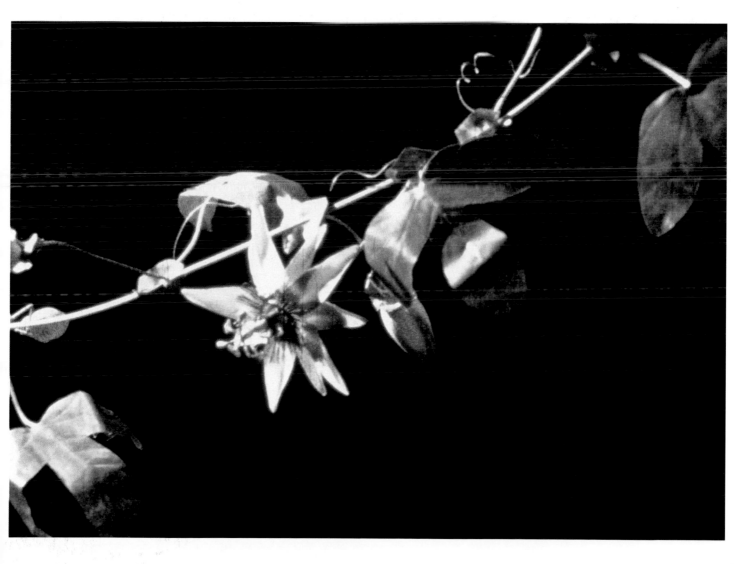

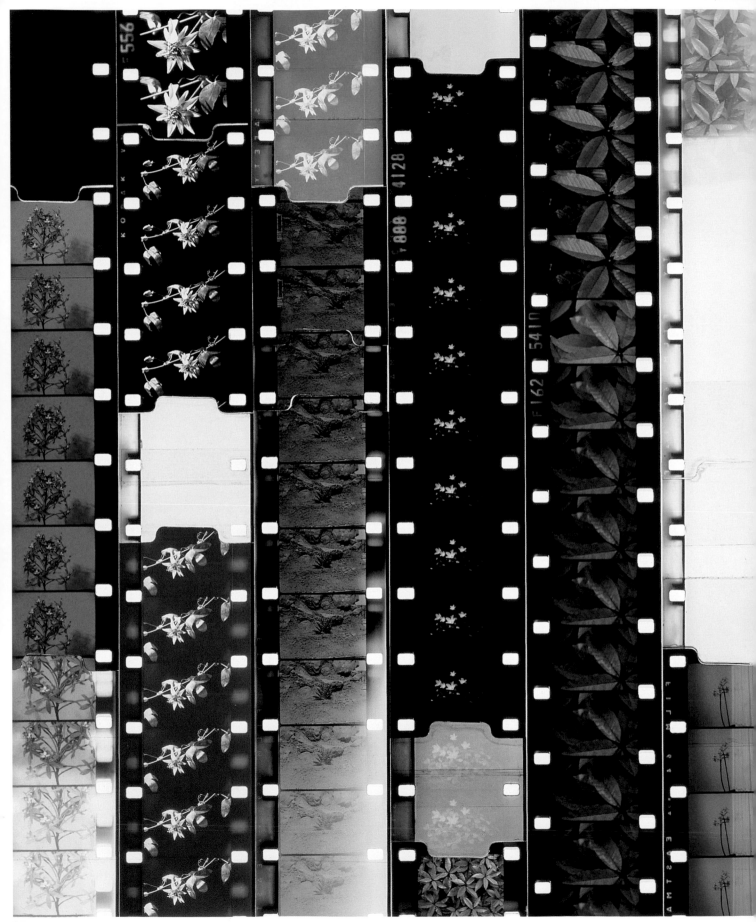

paul sietsema.
Film strips from Untitled
(Beautiful Place), 1998.
16mm film in B&W and colour,
silent, 19 minutes.

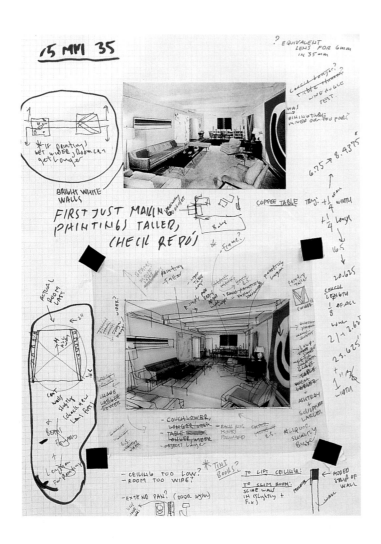

paul sietsema.
Notebook page from Empire, 2000.
Ink and collage on paper,
17 x 12" / 42 x 30cm.

Right: **Film strips from Empire**, 2000.
16mm film in B&W and colour,
silent (work in progress).

evan holloway.
Color Theory Stick, 2000.
Wood, acrylic paint and metal,
42 x 70 x 44" / 107 x 178 x 112cm.

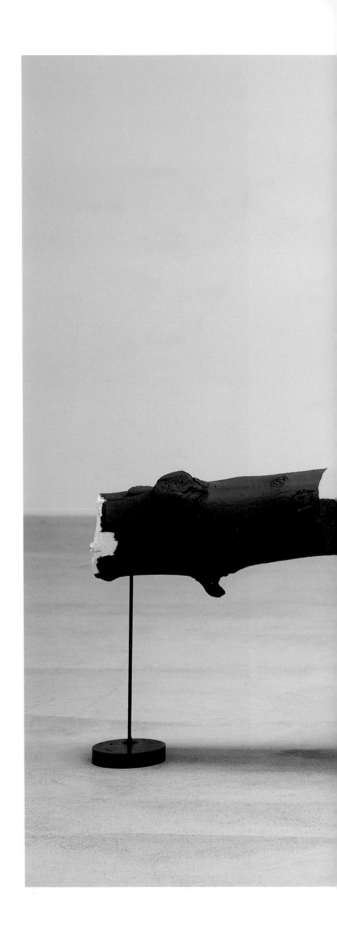

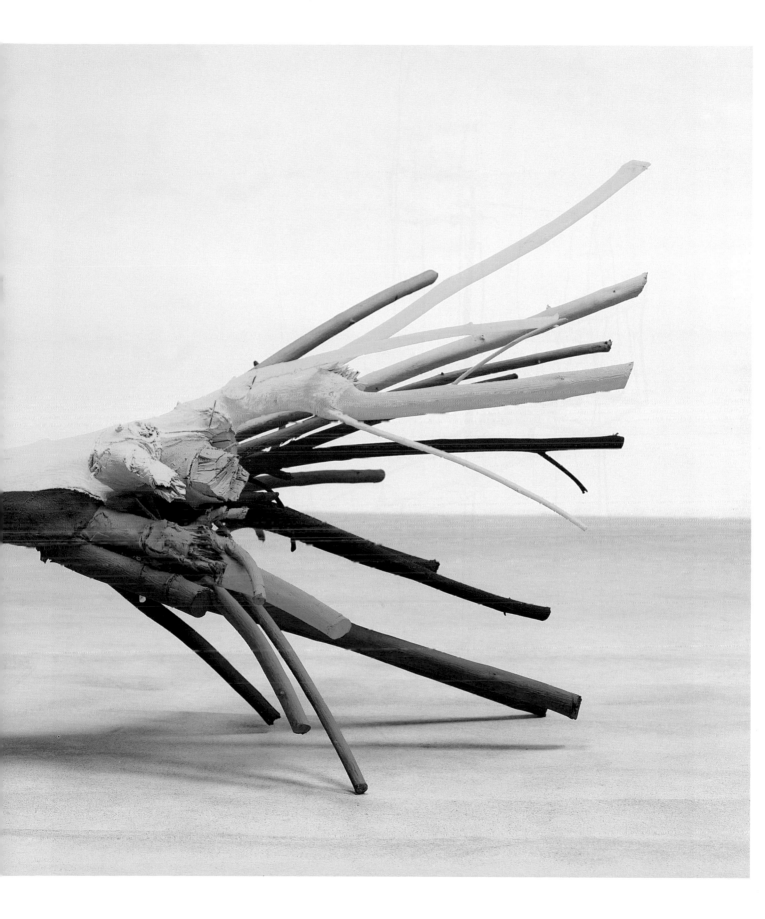

EDUCATION
↓
1991 BA, Sarah Lawrence College, New York.
1993 MFA, Yale School of Art, New Haven, CT.
↓
SOLO EXHIBITIONS
↓
2001 Nicole Klagsbrun Gallery, New York.
Above the Grid, PS1/MoMA, New York.
↓
SELECTED GROUP EXHIBITIONS
↓
1997 **Visionaires**, Museum of Contemporary Art,
Los Angeles.
2000 **Some New Minds**, PS1/MoMA, New York.
Open Ends, The Museum of Modern Art, New York.
Greater New York, PS1/MoMA, New York.★
Shockwave, Raucci/Santamaria Gallery, Naples.
2001 **Venice Biennale**, Venice.★
↓
SELECTED BIBLIOGRAPHY
↓
2001 Stephanson, Anders, 'Openings: John Pilson',
Artforum, New York, April 2001, pp 128-129.
Huberman, Anthony, 'John Pilson', **Flash Art**, Milan,
March-April 2001, p 107.

★ Exhibition publication produced

john pilson.

BORN IN NEW YORK, 1968 .
LIVES IN NEW YORK.

↓

John Pilson began as a photographer before discovering the brave new world of digital video and desktop editing. His photographic portraits often document the private connections that surface in a corporate environment, and his videos share the same cubicle-land as their backdrop. Yet Pilson's work does not offer a critique of such alienating spaces. Instead his interest is in how the constraints of the corporate world create the possibility for particular gestures— creative actions and playful interventions that can occur within the perimeters of 'work'.

↓

The title of **Interregna** (1999-2000) refers to intervals between the reign of kings. This ten-minute video explores those points at which authority is suspended, when continuity collapses and control is abrogated. A bare-chested office worker hurdles over a series of flimsy cubicle partitions—because they are there and because he can; a man in a suit hides in the office lavatory, devoting the stolen moment to winding toilet paper around his arm; another worker breaks into song while staring at her flickering monitor. Pilson structures his films around such disjointed narrative fragments.

↓

Above the Grid (2000) follows a couple of manager types that have an uncanny knack for doo-wop harmonies. As Pilson's camera haunts the corridors, bathrooms and elevators of an office building— transitional spaces of potential privacy—balls break into flight and bounce down stairs. **Mr Pick-Up** (2000) is an unrehearsed video shot in a single take. Here, a middle-aged lawyer misses a meeting as he picks up and drops his folders and files—again and again.

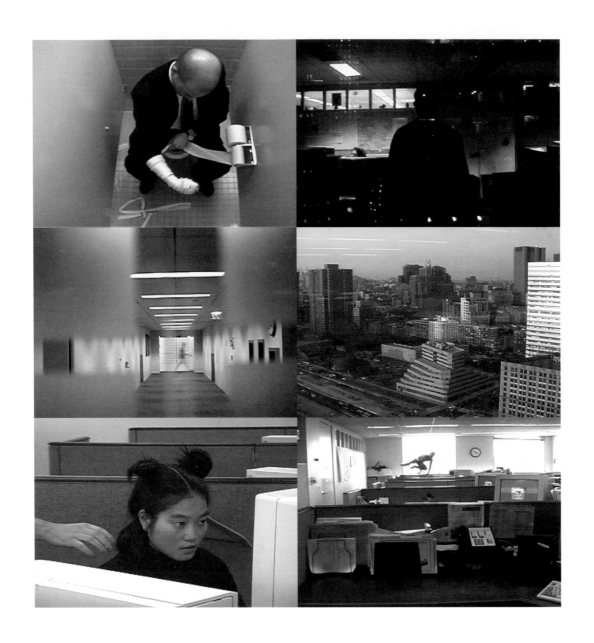

john pilson.
Interregna, 1999-2000.
Two channel video on monitors,
with sound, 10:30 minutes.

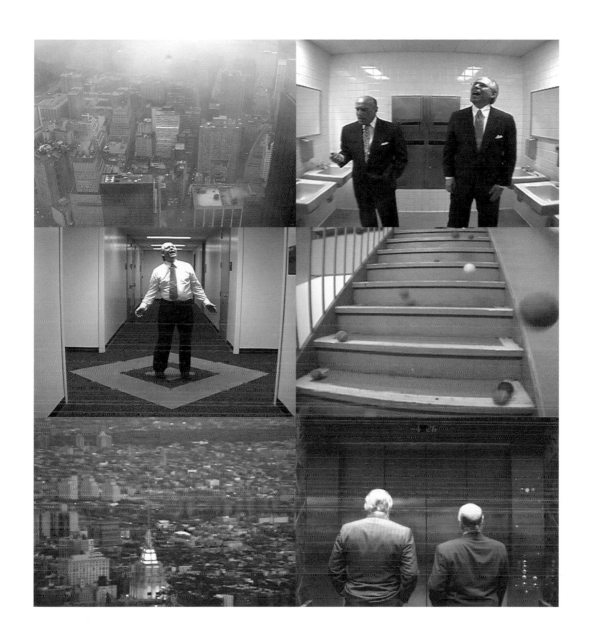

john pilson.
Above the Grid, 2000.
Two channel video on monitors,
with sound, 9:30 minutes.

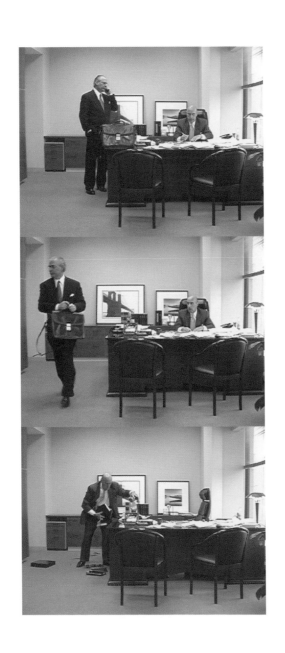

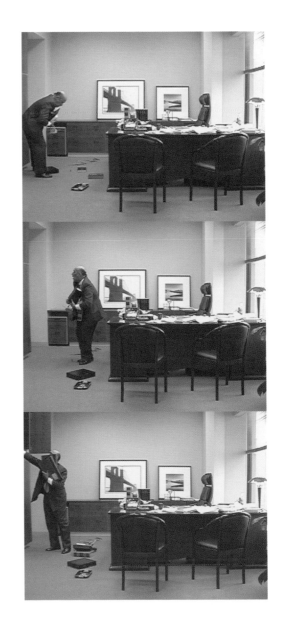

john pilson.
Mr Pick-Up, 2000.
Three channel video on monitors,
with sound, 17:00 minutes.

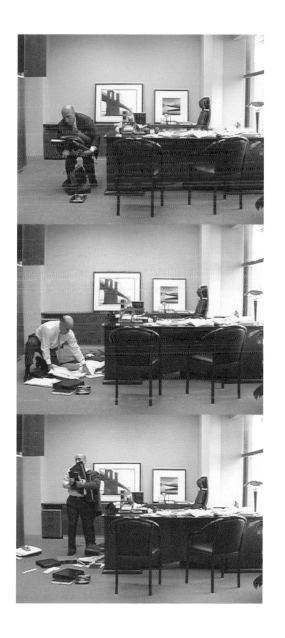

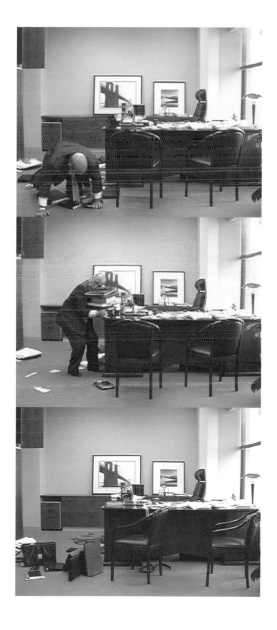

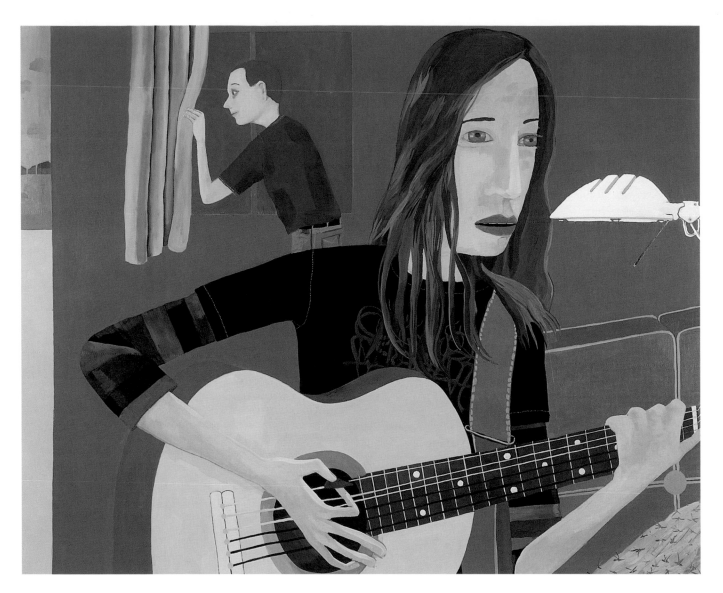

brian calvin.
Nowhere Boogie, 2000.
Acrylic on canvas,
48 x 60" / 122 x 152cm.

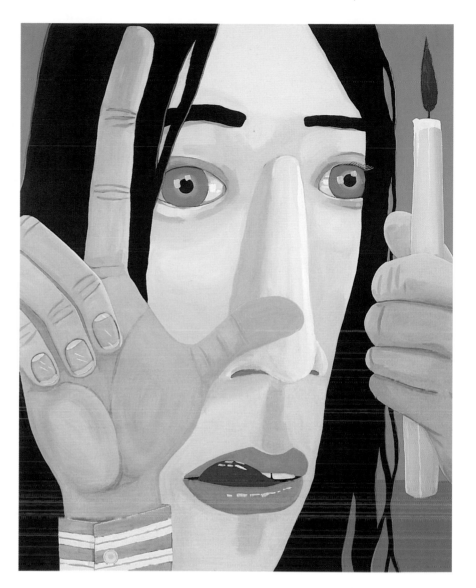

brian calvin.
Fearless, 2000.
Acrylic on canvas,
60 x 48" / 152 x 122cm.

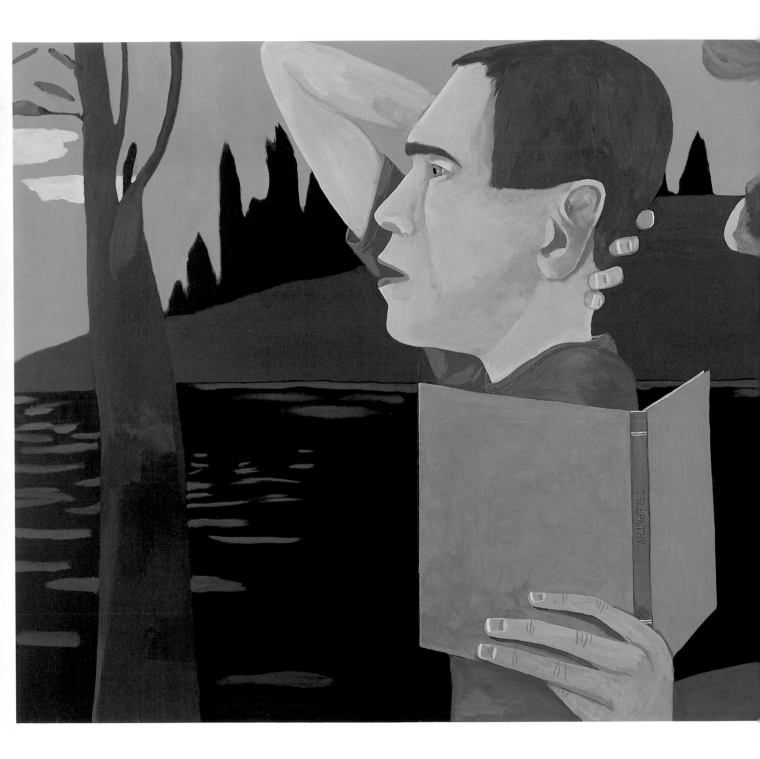

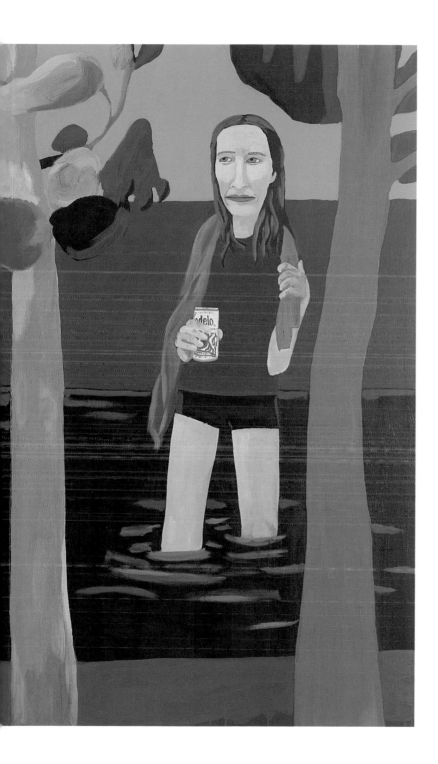

brian calvin.
California Freeform, 2000.
Acrylic on canvas,
60 x 108" / 152 x 274cm.

brian calvin.
Don't Be Denied, 2000.
Acrylic on canvas,
36 x 60" / 91 x 152cm.

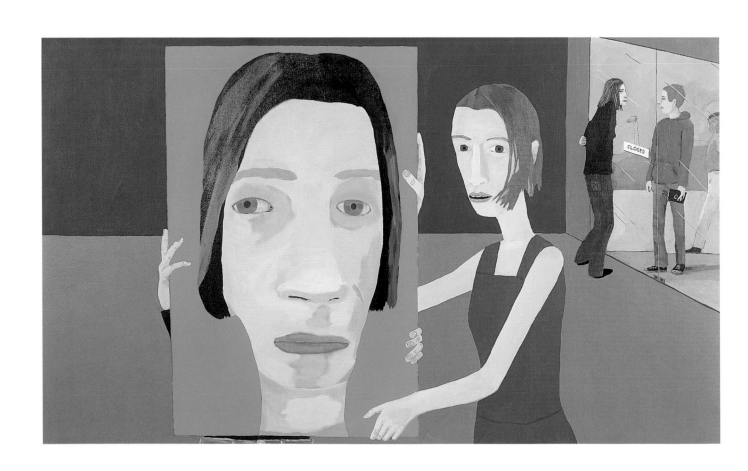

brian calvin.
Half Mast, 2001.
Acrylic on canvas,
14 x 11" / 36 x 28cm.

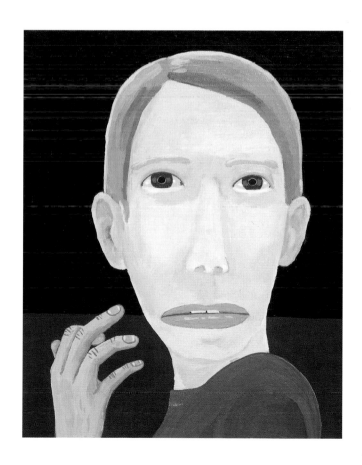

beach.

ricci albenda.
Beach., 1998.
Acrylic on canvas,
32 x 61" / 81 x 155cm.

Right: Yellow., 1998; Chimpanzee., 1998.
Mixed media.
Installation at Van Laere
Contemporary Art, Antwerp.

yellow.

chimpanzee.

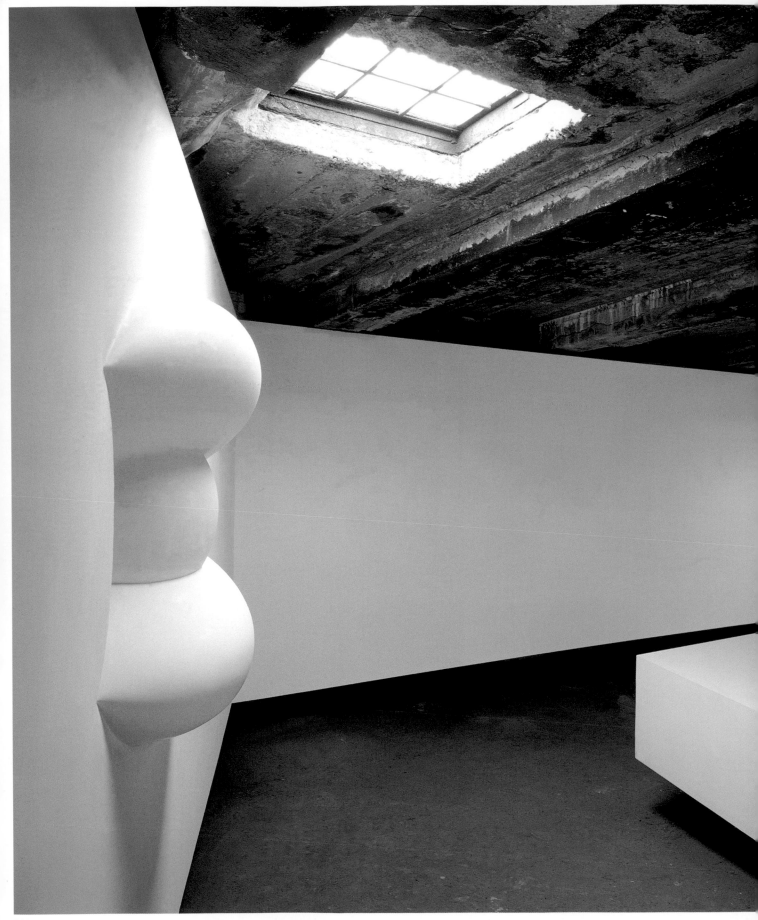

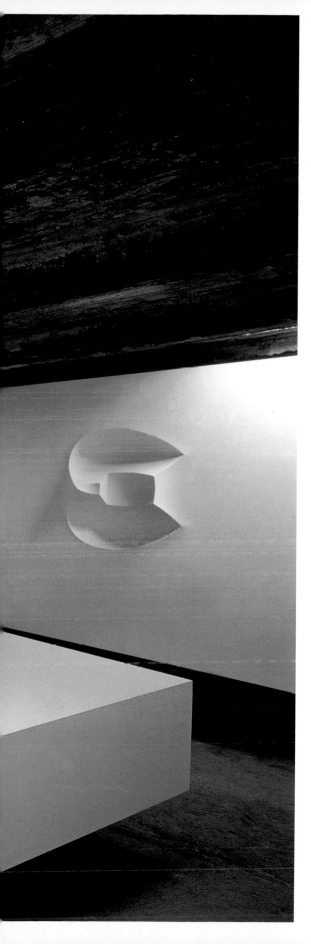

ricci albenda.
Action at a Distance, 2000.
Mixed media. Installation at
PS1/MoMA, New York.

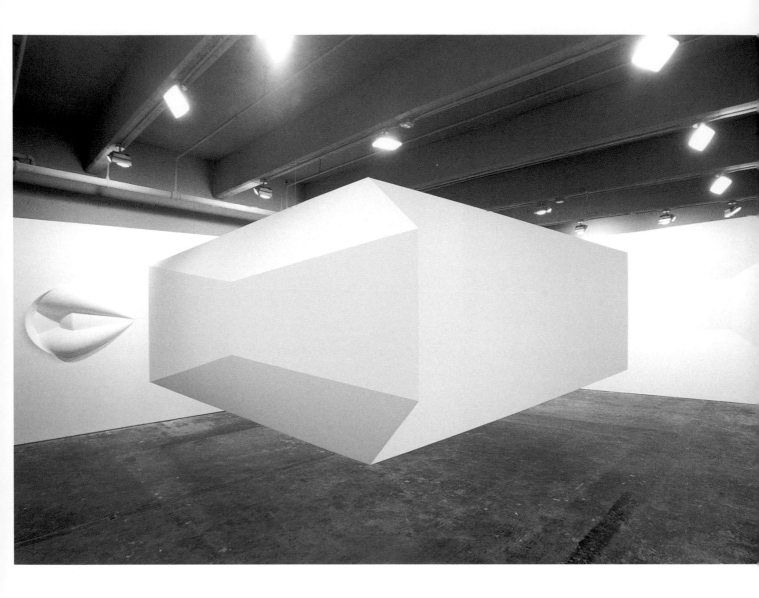

ricci albenda.
Tesseract, 2001.
Mixed media.
Installation at
Andrew Kreps Gallery,
New York.

ricci albenda.
Portal to Another Dimension
(Genevieve) / Positive, 2001 (detail).
Fibreglass,
90 x 120" / 229 x 305cm.

EDUCATION
↓
1986 California Institute of the Arts, Valencia, CA.
↓
SELECTED SOLO EXHIBITIONS
↓
1993 Petzel/Borgmann Gallery, New York.
1995 Neugerriemschneider, Berlin.
Friedrich Petzel Gallery, New York.
1997 University of South Florida Art Museum,
Tampa, FL.*
Gallerie Paul Andriesse, Amsterdam.
1998 Douglas Hyde Gallery, Trinity College, Dublin.*
Sadie Coles HQ, London.
Metro Pictures, New York.
2000 Neugerriemschneider, Berlin.
Centre Georges Pompidou, Paris.
↓
SELECTED GROUP EXHIBITIONS
↓
1995 Narcissistic Disturbance, Otis College of Art
and Design, Los Angeles.*
Human/Nature, New Museum of Contemporary
Art, New York.
1997 Gothic, Institute of Contemporary Art,
Boston (and tour).*
1998 Hungry Ghosts, Douglas Hyde Gallery, Dublin.*
Spectacular Optical, Thread Waxing Space,
New York (and tour).
1999 Presumed Innocent, CAPC Musée d'Art
Contemporain de Bordeaux, Bordeaux.*
Abracadabra, Tate Britain, London.
2000 Age of Influence-Reflections in the Mirror of
American Culture, Museum of Contemporary
Art, Chicago.
Fact/Fiction: Contemporary Art That Walks
the Line, San Francisco Museum of Modern Art,
San Francisco, CA.
Greater New York, PS1/MoMA, New York.*
↓

SELECTED BIBLIOGRAPHY
↓
1998 Greene, David, 'Keith Edmier', Frieze, London,
May 1998, pp 80-81.
1999 Art at the Turn of the Millennium, Taschen,
Cologne, 1999.
2000 Johnson, Ken, 'Keith Edmier and Richard Phillips',
The New York Times, New York, 21 January
2000, np.
Richard, Frances, 'Keith Edmier/Richard Phillips',
Artforum, New York, April 2000, p 143.
Jones, Ronald, 'Keith Edmier and Richard Phillips',
Frieze, London, May 2000, p 98.

* Exhibition publication produced.

keith edmier.

BORN IN CHICAGO, 1967.
LIVES IN NEW YORK.

↓

The subject of the artist's past figures greatly in Keith Edmier's art. For all of us the past is a strange mixture of personal experiences and received information, of cultural trivia and hard facts. This is reflected in **Beverly Edmier, 1967** (1998), a life-sized rendering of the artist's mother made from opalescent pink resin. Dressed in a pink Chanel suit like the one Jackie wore on that day in Dallas, the subject gazes lovingly towards her exposed womb, cradling the surreally visible foetus of her un-born son, the artist. The work has an elegiac air, a quality emphasised in **Emil Dobbelstein and Henry J. Drope, 1944** (2000)—a memorial for the artist's two grandfathers, who died before he was born.

↓

These are dreamlike visions in sculpture, yet Edmier's art retains a darkly sensual humour that cushions what could be construed as melancholia or nostalgia. When considering his creations it is worth noting that as a teenager the artist worked part-time in a dental laboratory, and that later he was employed making special effects prosthetics for horror movies. **Victoria Regia (First Night Bloom)** and **Victoria Regia (Second Night Bloom)** (1998) is based on a water lily whose form exhibits both male and female flowers during its two-night life cycle. We meet with this piece from an underwater perspective, suggested to Edmier by his memory of the scene in Apocalypse Now where Captain Willard rises out of the water en route to kill Kurtz. As in all of Edmier's work, it is impossible to separate the artist's own vision from the cultural flotsam that surround us.

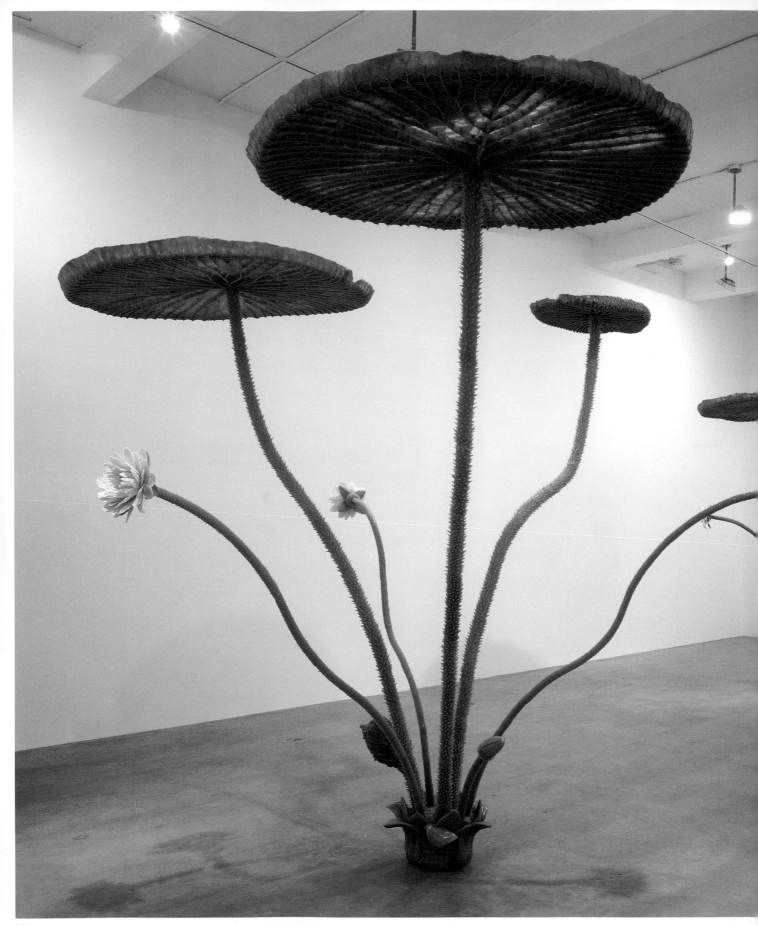

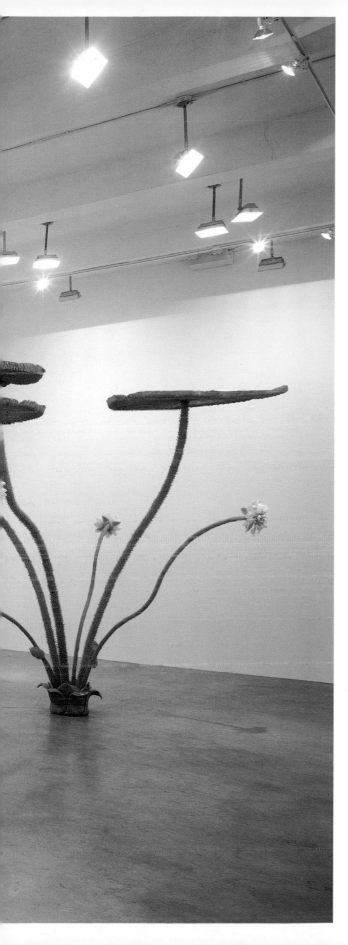

keith edmier.
Victoria Regia (First Night Bloom)
and Victoria Regia (Second Night Bloom), 1998.
Polyester resin, silicone rubber, acrylic,
polyurethane, pollen, steel,
each 112 x 128 x 133" / 285 x 325 x 338cm.

keith edmier.
Beverly Edmier, 1967, 1998.
Cast resin, silicone, fabric, paint,
51 x 31 x 26"/ 129 x 80 x 67cm.

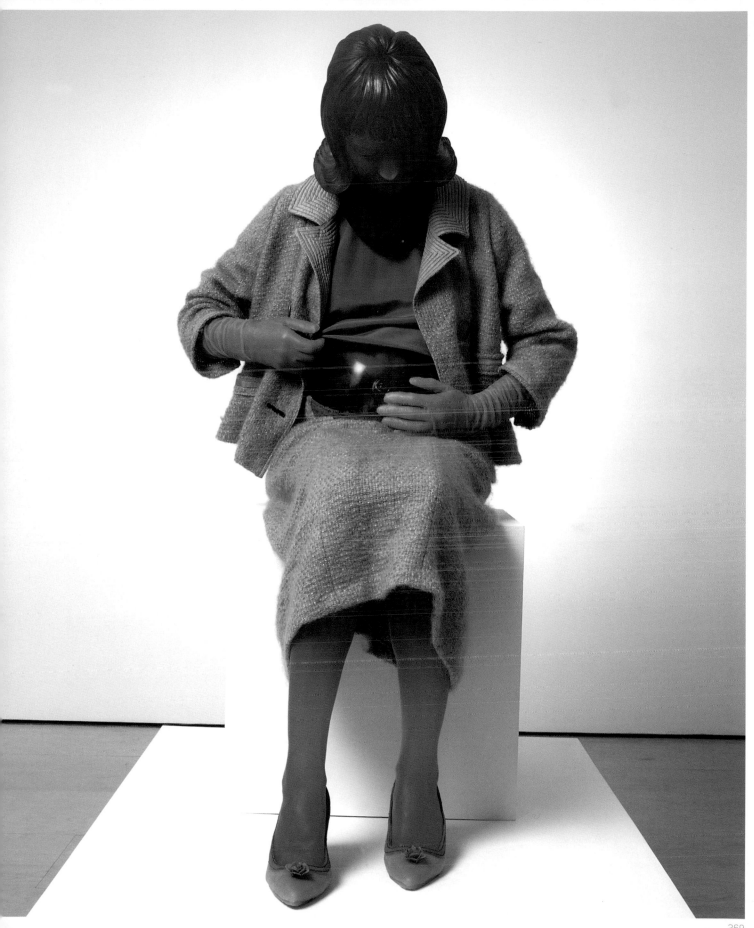

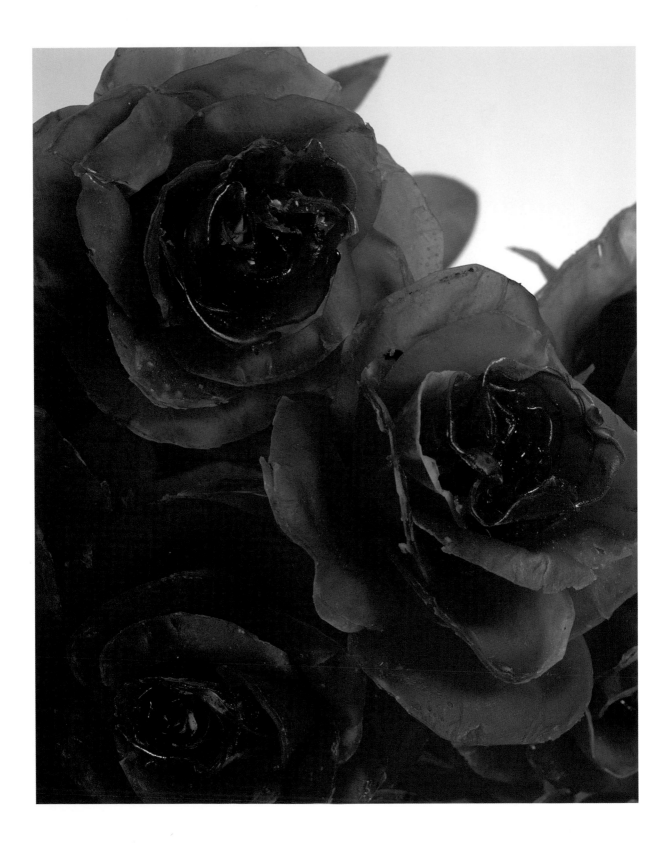

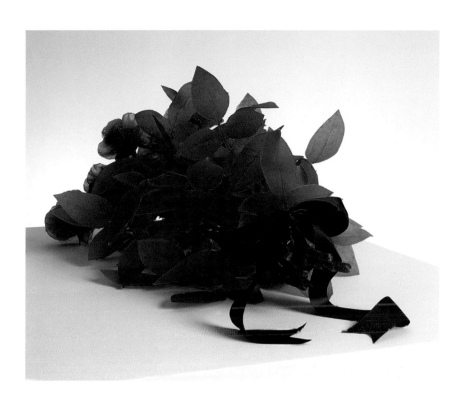

keith edmier.
A Dozen Roses, 1998.
Cast resin, acrylic paint and ribbon,
14 x 20 x 31" / 36 x 51 x 80cm

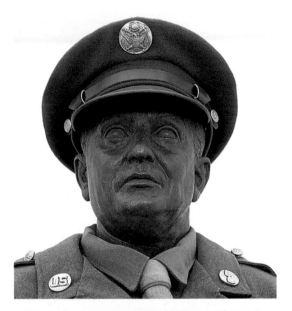
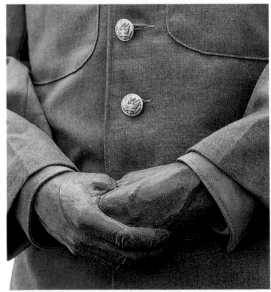

keith edmier.
Front: **Presidential Wreath**, 1999.
Silicon, dental acrylic, acrylic paint, steel polyurethane,
polypropylene and enamel paint,
64 x 40 x 36" / 163 x 102 x 92cm.

Back: **Emil Dobbelstein and Henry J. Drope**, 1944, 2000.
Bronze, granite, wool, brass, leather, cotton,
silk thread, cast cement, plastic and steel,
622 x 220 x 220" / 245 x 87 x 87cm.

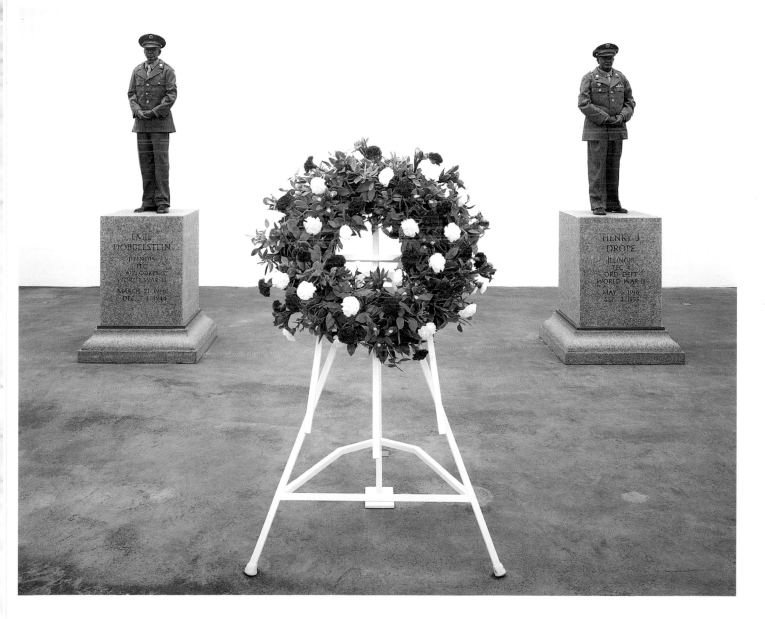

WHEN ARE WE NOW

Joan Didion looks around her and observes 'accidie'. In her essay 'The White Album' (1968-1978), she details how the cultural prevalence for finding things 'interesting' (e.g., whether a naked woman on a ledge is a suicide or an exhibitionist) unsettles her. The way contemporary existence is interpreted as an improvised narrative – as opposed to something scripted, the script now 'mislaid' – makes her more and more disturbed, as frequently the events do not fit into any narrative she recognises. Didion cites the Manson murders at Sharon Tate Polanski's house on Cielo Drive. She cites the murder of silent film star Ramon Novarro by Paul and Tommy Scott Ferguson (a trick gone awry, something – sex, a pleasure, a reprieve from loneliness or diminished fame – gone awry, somehow prefiguring AIDS in its complication of sex, randomness and demise). She cites the destabilising example of Huey Newton and Jim Morrison's 'insistence upon the love-death as the ultimate high'. All of it proliferates to allow Didion's experience of 'an attack of vertigo and nausea' to seem to her not 'an inappropriate response to the summer of 1968'.

↓

George W. S. Trow interrogates the omnipresence of television – its metastasising success and its creation of the regime of 'the cold child'. In his essay 'Within the Context of No Context' (1978), he mourns, by savage analysis, the decline of adulthood, and in its place, a statistical, non-contextual grid of fake intimacy and toothless 'adolescent orthodoxy'. He provides a history for the decline of **Life** and the success of **People**, linking it to the con of celebrity and 'experts'

who are anything but. Trow documents the formation of the 'context of no-context', how the 'aesthetic of the hit' defaces authority.

↓

Published a little more than a year apart, these interventions by Didion and Trow are the most resonant and trenchant histories of what might be referred to, conveniently, as the culture of the 1970s. It is interesting to note how both Didion and Trow deploy autobiography, the self trying to make sense of the self and what surrounds it. In her essay (and the book of essays to which it gave a name), Didion attempts to study the end of one mood or atmosphere and its replacement or pollution by something else. What was at stake was more than trying to figure out the fiction of one decade turning into another. But was she studying a crisis, apocalypse now, or just a chronic malaise? Trow, after meditating upon contemporary media and eviscerating it, finds himself saddened by the fact that irony and self-torture seem to be the only means by which he can understand who he is or what he has inherited. There are few finer examples of two writers struggling to explicate – clearly, with such razor blade intellectual chic, such enthralling style – how things devolved, how everyone got to be where they are. Yet their writing remains one of the surest examples of how to combat and confront such devolution.

↓

I was born in 1965. As a child and teenager of – or perhaps just deposited in – the seventies and early eighties, I find it impossible to abandon or ignore the aesthetic and cultural moment that most affected how I think, how I understand what I see and what I inherited. I'm not ready to attempt a history of the climate

of my childhood. I'm still recovering from the Bicentennial and the stars-and-stripes vest and white pants that I was forced to wear (my mother had made our family matching outfits from ersatz satin). I am interested in the now – the sound and look and feel of now. It is the only moment in which living is possible, like it or not. The now, my now, the now of everyone around my age, is – if not coherent in any other way – made coherent and irradiated by the seventies, by the cultural disarray and kookiness of that decade, that fiction. The struggle to convey the consequence of now, of contemporaneity, may mean – in part – appalling the standards which one was taught to hold dear. Appalling them may require knowing them, knowing them may require believing they exist. This is a solace. Didion and Trow find little encouragement in the moment, and yet there is, among all the accidie and decline, so much, so much to consider. It glows in the dark.

↓

MASON REESE

A plump little redhead – well, he writes in his autobiography, **The Memoirs of Mason Reese** (1974), that his hair is 'sort of an orange-Popsicle colour' – Mason Reese had an enormous but very brief popularity as a star of television commercials. Imagine a seven-year-old with the head of Jimmy Durante and you have an idea of his effect. For a while his star shone so brightly that, in addition to hawking product for Betcha Bacon, Underwood Devilled Ham and Thick-n-Frosty, he was a guest on **The Dick Cavett Show**, co-hosted **The Mike Douglas Show** ('for a couple of weeks, a week in the fall and a week at Christmastime'), and held a regular gig in New York City 'reporting news for kids on WNBC-TV'. Even **Women's Wear Daily** – for a special Thanksgiving article – wanted to know what he was thankful for. After joking ('I'm thankful I'm not the turkey') he told the **WWD** reporter: 'I'm happy the soldiers are with their families and the turkey is big enough to fill them up'. Even a tyke who existed more as a representation of a child than as an actual kid could have Vietnam on his mind.

↓

On the final page of his **Memoirs**, written when he was 'seven years old, forty-five inches tall' and weighed 'fifty-pounds' (the memoirs spend a disturbing amount of time on his eating habits and weight), Reese wrote:

↓

> When I grow up, I hope to have a Mason Reese Show And Mike [Douglas] can come on and share it with me. It may sound conceited, but I think it will happen. I work very hard. There are plenty of nights when I'd rather watch TV or draw pictures, but I memorise my news assignments instead. If someday people say, 'You can't act like you used to act,' or if I stop being famous, it will make me very hurt. Maybe it won't happen, because people say I'm an original... whatever that is.

↓

Of course, the kind of celebrity of which Mason Reese was an example existed before him, but he may be the first child – because of television? because of his embodiment of advertising? – to place 'being famous' in relation to 'hurt'. He was young and famous and then disappeared as if he never existed. I read online that he's working in a sushi restaurant. It happened. It must have hurt. It hurts, now.

↓

remember Adrian Zmed? He starred in **Grease 2**? Do you remember **Grease 2**? It launched, at the very least, Michelle Pfeiffer. She sang 'Cool Rider' about dreamy Maxwell Caulfield.) On **Melrose Place**, Locklear played Amanda Woodward Parezi Burns McBride Blake McBride, head of an advertising agency and mean bitch landlord of the 4616 complex.

↓

I'm not sure what to say about Locklear. She could have been just a late-1970s or 1980s version of Farrah Fawcett, but despite her marriage to a big-time rock star (Bon Jovi's Richie Sambora), Locklear has had more longevity than sad Farrah. Locklear may be the quintessential Spelling Star. In fact, her appearance is a reminder of Aaron Spelling's omnipotence and ubiquity as a producer of television shows throughout my youth. **The Love Boat. Fantasy Island** (with the white-suited exoticism of Ricardo Montalban and dwarf Hervé Villechaise). Locklear's resilient, take-no-prisoners endurance (in her characters and her career), her bitchiness and her blonde acumen (paradoxically no-nonsense), make her – albeit strangely – a model of getting work done and moving on. A model of a kind of happiness.

↓

OVER THE EDGE

'In 1978, 110,000 kids under 18 were arrested for crimes of vandalism in the United States. This story is based on true incidents occurring during the 70s in a planned suburban community of condominiums and townhomes, where city planners ignored the fact that a quarter of the population was 15 years old or younger.' So reads the prologue to one of the most emotionally accurate movies about teenagers ever made.

Over the Edge (1979) is a fictional document of the confluence of teenage disaffection, economic malaise, and the almost Situationist consequences of architectural mismanagement. 'New Granada' is a housing development slowly going under. When plans for a Cineplex and shopping centre fall through, the community supervisor and his board hope to lure Texas investors to construct an industrial office park, razing the makeshift teen community centre. Written by Charlie Haas and Tim Hunter (who would go on to direct **River's Edge** and **Tex**), directed by Jonathan Kaplan and produced by George Litto, a large part of the emotional and intellectual success of the film stems from a cast of (at that point) mostly unknowns channelling something unnerving, tender, and real. The film launched Matt Dillon's career.

↓

The only other American film that says as much about the turmoil of teenage existence is Dennis Hopper's **Out of the Blue** (1980), starring Linda Manz. I watched both films again the other day and found myself crying. I'm not sure if the tears were because these movies take place in the middle of nowhere, a desert (which seems to be, like a dilapidated Oz, a psychic territory as much as anything else). Or because I've not yet found any way to acknowledge (unironically) how raw and actual these films are in their representation of the American suburbs, of the lower- to middle-classes and their specific traumas. And yet no matter how bleak they show things were, things for a teenager now – not that there should ever be a competition for grief, disaffection or malaise – are so much bleaker.

↓

MATT DILLON

Two responses to the vastness called America are ceaseless sound and silence, and all of American culture fluctuates between them. Examples of the former include the gorgeous logorrhoea of Gertrude Stein, big cities, and television; of the latter, the complicated muteness of Andy Warhol's persona, desert plains, and photography. While replicating America's horizontality, movies depict this fluctuation with a hypnotic thoroughness, and one of the movie stars who understands intuitively (innately?) that the power of such hypnotism comes as much from silence as sound is Matt Dillon. Despite his seemingly simple portrayals of bravado and aggression, his slow speech always moves toward inarticulateness, wonder, and doubt. A boy's boy, a guy's guy, despite his rebel, teenage effect, Dillon has always revealed – disarmingly, hauntingly – the sweet, indefinite tenderness of the pretty girl on masculinity's inside.

↓

In **Over the Edge** the bigger girls make Matt stammer as he reveals his killer junior abs to the world from beneath his cut-off T-shirt. His girlish grace intensifies **Little Darlings**, in which he plays Kristy McNichol's sweetheart just by twinning her - never has the mirror stage of teenbeat love been so winsome. (While he was working his rebel magic in those performances Dillons' intractable punk twin, Linda Manz, strutted much of the same androgynous stuff, the stuff which makes Matt a man and Manz a Matt.) **My Bodyguard** and **Tex** (about which Pauline Kael wrote: 'Actors who have laboured to learn the rudiments of their profession must want to kill the potential teen idol Matt Dillon... He's a

natural, who takes to the camera with the baffling ease of a puppy... What [he] does works better on camera than most trained acting does.'); then **The Outsiders**, **Rumble Fish**, and the surprisingly good **Flamingo Kid**. Then it would be years before Gus Van Sant reminded Dillon of who he was; the embodiment of America's zoned-out, complicated, aphasic dreams and its ambiguous future. His natural charisma (which Kael pinpointed as one of reasons some may wish to kill him), his dopey sexiness, explains his appearance – or the appearance of his 'type' – in the work of Bruce Weber, Larry Clark and Dennis Cooper.

↓

Nothing like this is discussed in either **The Matt Dillon Quiz Book** by Gina Lo Duglio or **The Matt Dillon Scrapbook** by Cheryl L. Mead, but these two important examples of Dilloniana from the early eighties remain ravishing studies in the eroticism of innocence. An innocence which never really existed outside of myth and which was certainly almost gone for good – like much else – when whatever was the seventies became the eighties. The **Scrapbook** has photographs of Matt with his arm around Linda Manz at his sweet-sixteen birthday party, and at other parties coupled with blond Christopher Atkins and blonder Andy Warhol. By page three of the **Quiz Book**, the answers to many crucial questions ('Is Matt Left- or Right-Handed?' and 'What Turns Matt On?') are found. Among the most crucial would be the question 'Are Most of Matt Dillon's Fans Young Girls?' to which the answer, according to Gina Lo Buhlio, is 'No'.

space

$2.95
ISSUE SIX

spring storage

OUTDOOR PURSUITS
RELAXATION THERAPIES
EARTH DWELLERS
CHINESE TREASURES

IKEA® **space**

katy siegel.
DO IT YOURSELF!

IKEA's magazine, Space.

In Paris, **Pure Beauty** was the inaugural show for this new building, and we were framed by Frank Gehry, framed by the expectations of his architecture… It seemed to expect artists like Donald Judd and Carl Andre, and then we come in with our Scotch tape, Post-its, and thumbtacks.
Pae White (1)

↓

I'd like to make films, but I get the feeling I wouldn't be able to communicate well with a big crew. But maybe you could get sort of lost and not be such a big voice –just leave Post-its all over the set with instructions.
Rob Pruitt (2)

↓

To begin with a generalisation: there are two kinds of art made by young artists today. No, not New York art v LA art (the professionals v the students, suits and skins). My generalisations here are not geographic, but have to do with two different ways in which young Americans react to the world – I mean the art world, the immediate environment of school and their teachers, not the world at large. Firstly, many artists of the past decade have retreated into the local and immediate, modelling and remodelling their immediate surroundings, their physical and material proximity. They live in their studios the way an eight-year-old might live in a tree house. Secondly, many other artists have moved into deeper confinement, inward into their interior selves, probing their feelings and sensations, their immediate past and current conditions, with a tender self-regard verging on the romantic. These two tendencies are those I have plucked – speculatively, perhaps somewhat arbitrarily – from the field.

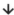

Young artists now enter an art world not only dominated by dealers and auction houses, but also configured in reaction to those forces of the marketplace. The reaction to the market and its money assumes the form of 'theory' – overarching theories and difficult, large ideas. Even these can be sold. Today's young artist is likely to regard both the dealers and the theorists as symptoms of global capitalism – the complications of the outside world, with its overwhelming mix of politics and ideas and economics and history. If this work were to find its own theory, it would be the theory made by an artist, a Robert Smithson or a Dan Graham. Theory resonant with big ideas, but resistant in its recalcitrance, and in the end largely incoherent. Big theory that becomes small when you ask what it's really doing for you or anyone else. It's not surprising that Smithson and Graham have become fashionable once again, as our culture turns to do-it-yourself strategies. Our culture even has a do-it-yourself method for studying itself: we call it cultural studies. It's a lot simpler than Adorno's negative critique of the culture industry or Habermas on public discourse. Why can't art be positive, something as real as the wall or my shoe? Why not settle for a private, subjective view of culture or reality, read 'against the grain', as eccentrically as need be? That is, as eccentrically as an artist feels. Is this bad? Bad for whom? The artists? Our society? It may seem so, but I don't think so. This art, like other arts, has its own intelligence.

↓

ANTI-THEORY

Yet for all the intelligence of their work, they wear their learning lightly. In fact, one

of the group's more distinctive qualities, as a friend put it, is the degree to which these efforts are 'language-proofed'.
Bruce Hainley (3)

↓

We don't get our ideas from other art, and that makes a difference. I think we sense that all that codified, secret-society art you see in most galleries is over.
Tim Rogeberg (4)

↓

Much has been stated during the past ten years or so about the opposition between theory and beauty (two vague terms). Beauty or aesthetic experience has frequently been held up as a suppressed value in the contemporary art world, and many critics and authors – from Arthur Danto to Wendy Steiner to Dave Hickey and Peter Schjeldahl – have been at pains to restore it to its rightful position, in a backlash against the theorists' emphasis on the power and politics of discourse and textuality in art. The most visible art attached to the new critical momentum has been the California painting of the nineties that drew on sixties colourfield painters such as Kenneth Noland and Morris Louis. These 'Californians' – Monique Prieto, Kevin Appel, Ingrid Calame, Laura Owens – make paintings that are opaque, non-referential, often dumb or mute in their refusal to mean, their insistence on being.

↓

There is another kind of 'dumb' art – often goofy, vulgar or rudely simple-minded – that seems to resist intellectual art-making. Tony Matelli, Rachel Feinstein, Martin Kersels, Brian Calvin, Rob Pruitt, Elizabeth Peyton and Jonathan Horowitz all make art that, while referential, refers to the apparently dopey,

deadpan and adolescent. The irony may not be worth much in the current climate; perhaps they fantasise that they probably couldn't do much better anyway, so they might as well be dumb. When a genius makes something dumb, like Pablo Picasso making a beach sculpture, it's amusing to contrast it with the same artist's deeply intelligent paintings and collages. If Picasso and everyone else alive in 1910 had painted like Rousseau, would Rousseau now be in MoMA? Wouldn't Picasso have been smarter about playing dumb? Imagine a folk tradition without an elite tradition – doesn't the tension between the two help both of them? What is this dumb art in tension with? Is it the 'theory' from the earlier generation? Is it the students against the teachers – the teachers, at schools like Cal Arts, with their interest in theoretical issues?

↓

HOMEMADE MODERNISM

The piece I showed at Richard's gallery started with me laying in bed every day and staring at the walls and the closet and then I started to fantasize about what was on the other side of the closet wall… And then I started to think, I'm gonna make that closet. Liz Craft (5)

↓

I like [my work] to have a sense of being at home… I like the connection to everyday materials, things just sitting around the house. For me, home just means 'being yourself'. You don't have to go outside to know more; you already have everything you need. Tom Friedman (6)

↓

Modernism has long looked like a monolithic, intellectual subject for young artists, but

today it appears most often in its domestic version, in art that depicts either architecture or design objects. The revival in mid-century modern furniture and design – from the LAMoCA exhibition on Case Study houses to Calvin Klein's version of household minimalism to Ikea's good design for the masses – has dominated the popular culture of the mid to late 90s. So-called 'shelter' magazines, such as **Wallpaper**, **Nest**, and **Dwell**, both reflected and promoted this interest. It was also developed by artists like Andrea Zittel, Jorge Pardo, Kevin Appel, Sam Durant, Inigo Manglano-Ovalle, Jennifer Bolande, Liam Gillick, Torborn Vevji and Clay Ketter. In a 1993 show at Shoshana Wayne, Pae White opened the exhibition with a quote taken from an Ikea catalogue ('IMPOSSIBLE!') on the gallery wall. (7) Many other artists incorporated objects from Home Depot into their work, not as found objects per se, but as material. Of these artists, Sarah Sze is certainly the most successful at incorporating quotidian odds and ends (Q-tips, clip lamps, dowels), overlooked as much for their relatively low social value as well as their small scale. One of the most spectacular projects in the domestic vein is Paul Sietsema's **Empire**, which recreates Clement Greenberg's apartment as pictured in a 1964 **Vogue** photograph, blending the Frankenthaler and Noland pictures with the modern couch and lighting, eliding art, taste, and design. Sietsema built a model from this image and then filmed the model, combining it with shots of its spatial opposite, a landmark room of the French Rococo.

↓

The subject of this work evokes the home, but no more than how it is made. While the last of the American avant-garde movements (Pop and Minimalism) adopted the look of the industrial, consumer culture, earlier avant-garde artists often resisted it by purposefully displaying their expressive mark. Palpably material painting, like that of Monet, often depicted the experience of the industrial world – but in a material, painterly style that emphasised its own handmade nature, the fact that it was irregular and awkward, not mass-produced. Artists of the early nineties, including Charles Ray, Robert Gober and Felix Gonzalez-Torres, were sympathetic to the Minimalist strategy, infusing its smooth forms with personal content. However, their successors, the generation of artists featured in **the americans. new art.**, seem more sympathetic to the strategy of the earlier avant-garde – with a twist.

↓

We seem to have moved from the nineteenth-century handmade to 'homemade'. Many critics use this term to describe the art by today's young artists, most of whom, after all, are professionally trained. (8) 'Home' implies common materials (Feinstein's felt) and techniques (Sze's glue gun); not only a resistance to the mass-produced, but a positive valuation of the amateur, the cottage industry. Sometimes this means making usually mass-produced articles by hand: Friedman, Muniz, and Sietsema have all made fake flowers – which Muniz then photo-graphed, and Sietsema filmed for **Untitled (Beautiful World)**, 1998. At Tate Modern, Swiss artists Fischli and Weiss made a three-dimensional trompe l'oeil version of a room under construction – including sawhorses, cigarette boxes and rubber gloves.

↓

While some craft-based work, such as Kara

Walker's silhouettes and Josiah McElheny's glass vases, are meticulously finished (and based on historical forms of craft), much of this art shows its rough edges. Critics also repeatedly invoke related terms such as 'obsessive' and 'labour-intensive' to describe the pipe-cleaner sculptures of Lucky de Bellevue, the Play-doh and Styrofoam creations of Tom Friedman, and the cut, sewn and hammered pastoral scenes of Liz Craft and Rachel Feinstein. This current use of craft carries neither the feminist spin of seventies artists such as Miriam Shapiro and Judy Chicago, nor precisely the abjection of Mike Kelley. In many ways, this work more seriously appraises the values of the middle class, consumer world to which the artists belong, and whose values the art carries. What are they trying to understand? Or what are they trying to make us understand?

↓

In an interview with Rob Pruitt, Jonathan Horowitz mused, 'Sometimes I wonder if that whole craft, DIY thing is maybe a desperate way for people to get back in touch with the world nowadays, to get involved again by putting your hands on it…' (9) This is certainly possible. We can understand how cakes and doilies are made, and, when we read Martha Stewart's magazine, at least imagine ourselves doing it. DIY has slightly different implications in the realm of fashion, where the clothing line Imitation of Christ recuts and restyles old clothes; and various small boutiques perform the service of personalising jeans and t-shirts (the most mass-produced of clothing items) with rips and embroidery. These clothes indicate individuality by being quirky and offbeat, rather than avant-garde in the strict sense

of forward-looking; the amateur designer doesn't create something radically different, but instead remakes the status quo. Similarly, a new magazine, ironically titled **ReadyMade**, caters to the young, groovy do-it-yourself'er. Cooler than the Martha Stewart fan, this young knitter, strummer, baker, or ashtray-maker isn't after perfection so much as individualistic expression, or at least the look of expressiveness.

↓

IN MY ROOM

Size determines an object, but scale determines the art. In terms of scale, not size, a room could be made to take on the immensity of a solar system. **Sarah Sze (after Robert Smithson)** (10)

↓

I imagine that most of us have some kind of fictive world that we can retire to during our day. An imaginary self or an imaginary location. I found that in textured and multilayered ways I was retreating into the lore of the South **Kara Walker** (11)

↓

The legend suggests that the emperor tried to re-create his own universe, as he understood it, inside his tomb so that he would be able to eternally fix the world and his place in it. **T. J. Wilcox** (12)

↓

Along with domestic and craft-oriented art, another related form of artistic escapism is making the world – or a world – at a scale that the artist controls herself. This can take many forms, one of which is the model: as in Rob de Mar's oases and landscapes; Clara Williams's quiet pastoral installations; Michael Ashkin's dioramas; and Mick O'Shea's **Artworld**, 1999, a model train set. Models evoke the obsessive

to have such great ideas.

↓

Or to tell you anything at all. Almost all of the artists in this show insist that their work is not ironic, a quality perceived as having dominated the art of the recent past. Irony is smart; the new art is dumb. Although they would certainly cringe at the comparison, in this (ironically) they are certainly in tune with the larger culture; we've seen many recent articles on post-ironic literature and media. Irony and critique have both been replaced by a variety of gambits in tone and audience address, including generosity, optimism, ambiguity and blankness.

↓

Much of the work in **the americans. new art.** appears sweet or quirky, but it can also be pouty and withdrawn, riddled with the particular, personal in demeanour yet not particularly open: girl with arms crossed, not akimbo. Statements by the artists project reticence, romance and seduction; recall Pae White and Rob Pruitt at the beginning of this essay, speaking softly and elliptically with their Post-it notes. These utterances seem to implicate the viewer, echoing the theoretical conceit that emphasises the role of the interpreter over that of the artist in the formation of meaning (death of the author / birth of the reader).

↓

So what are we to make of this new art? Perhaps, in post-medium and non-ideological art, the material – to paraphrase Marshall McLuhan – is the medium. Photographs are often layered (as in the case of Amy Adler, Vic Muniz and Thomas Demand), the image only the final step in a process of intensive labour, rather than the direct result of a snapping shutter. Film and video are also often blurred and scarred by generations of copying (Wilcox and Horowitz). Even Paul Pfeiffer's digital videos have a palpable presence, achieved through the concentration and repetition of the image. Images that once (before computers) appeared immaterial become handled, physical objects. Looking at recent painting and sculpture, the material itself also takes a central, even genetic role, often figuring in a synecdochic relation to the whole, like the little bits of Sze, Friedman, Gallagher, Hawkinson and Tomaselli, of Nina Bovasso, Diana Cooper, Erik Parker and Matthew Ritchie.

↓

All this busy work could be read as anti-intellectual. If you do something that you can totally immerse yourself in, like craft, and it takes a year to execute (or five years, as in the piece of paper Friedman titled **1000 Hours of Staring**), then you only need one idea. But there are other values inherent to an intense process of making, ones that come not through creating a labour-intensive object worth its commercial price, but from a positive experience for the artist. These values – the handmade, the original, the personal, the investment of the individual – and this kind of attention are the opposite of those espoused by Minimalist artists such as Stella, who asserted that he didn't want to spend much time absorbed in looking at (or making) paintings. As Sietsema has said about his own work, 'The films are supposed to be a little bit about becoming immersed in something – partially me doing it, and then somebody watching it.' (20) Just 'a little bit'.

01 Pae White, in Jan Tumlir, 'A Conversation with Pae White, Artist', **Artweek**, San Francisco, 17 November 1994, p 11.

02 In Rob Pruitt and Steve Lafreniere, 'Elizabeth Peyton', **Index**, New York, July 2000, p 61.

03 Bruce Hainley, 'Towards a Funner Laocoön', **Artforum**, New York, Summer 2000, p 167.

04 In Dennis Cooper, 'Too Cool for School', **Spin**, New York, July, pp 86–94.

05 In Christopher Miles, 'Art and Craft', **Detour**, New York, November 1997, p 150.

06 In John Miller, 'Interview', **Index**, New York, January 1997, p 30.

07 Ikea's magazine, **Space**, has the dimensions of **Artforum**, and a very similar design.

08 For example, Los Angeles Times critic Christopher Knight used 'homemade' three times in a brief review of a Martin Kersels show. See Christopher Knight, 'That's Show Biz', **The Los Angeles Times**, Los Angeles, 16 September 1999, p 24.

09 Rob Pruitt, in 'Tea No.2: Rob Pruitt and Jonathan Horowitz', **Made in USA**, New York, Autumn–Winter 1999-2000, p 59.

10 Sarah Sze, quoting Smithson, as cited in Jeffrey Kastner, 'Sara Sze: Tipping the Scale', **Art/Text**, Los Angeles, May–July 1999, p 73.

11 Lawrence Rinder, 'An Interview with Kara Walker', **Capp Street Project: Kara Walker** (exhibition catalogue), California College of Arts and Crafts Institute, Oakland, CA, 1999, np.

12 In Douglas Fogle, 'Interview', **Dialogues: Sam Easterman / T. J. Wilcox** (exhibition catalogue), Walker Art Center, Minneapolis, 1998, np.

13 Jeff Burton, in Steve Slocombe, 'Eyeing Up Los Angeles', **Sleazenation**, London, March 1999, p 83.

14 Elizabeth Peyton, in Linda Pilgrim, 'An Interview with a Painter', **Parkett**, New York / Zurich, 1998, p 59.

15 Rob Pruitt, in 'Tea No.2', op cit, p 58.

16 Dennis Cooper, op cit, p 90.

17 In Tim Griffin, 'A Man, A Plan, A Panda', **Time Out New York**, New York, 1 March 2000, p 51.

18 Rob Pruitt, 'Tea No.2', op cit, p 58.

19 Dale McFarland, 'Pae White', **Frieze**, London, March–April 1999, np.

20 Sietsema, in Raymond Pettibon, 'Paul Sietsema by Raymond Pettibon', **Issue**, New York, 2000, p 147.

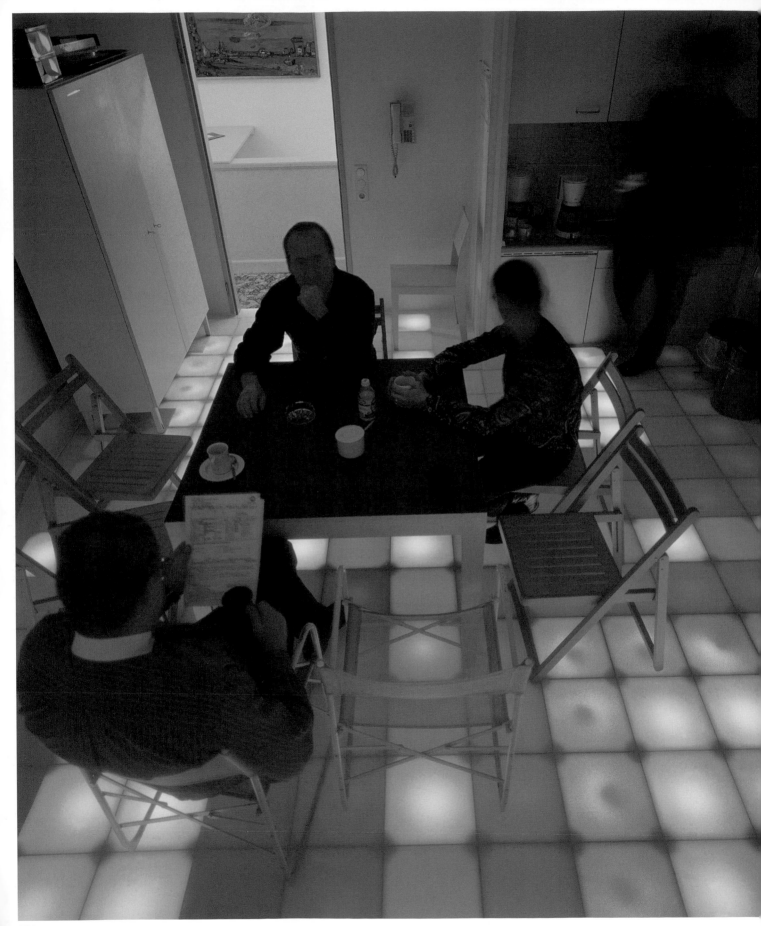

bennett simpson.
PUSHING AN OPEN DOOR: THE ARTIST AS CULTURE BROKER.

Piotr Uklanski.
Untitled (Dancefloor), 1998.
Installation at Neues Weserburg, Bremen.

295

In the first half of the 1990s – a recessionary period when galleries, art magazines, and funding agencies were closing by the hundreds – it is estimated that American universities produced ten thousand Master of Fine Arts graduates. (1) Such a statistic raises numerous questions, not only about the economic and cultural field into which this surplus of artists would enter, but about the graduates themselves. Precisely, what kind of 'professionals' were they trained to be? What were their specific skills and disciplines? And by what standards would their work be valued?

↓

Vying for attention in the forcibly down-sized 'free market' art economy of the nineties, artists had to be nimble, enterprising – if not outright careerist – and adept at de-specialising their practices to fit a plurality of media and contexts. Ironically, many MFA programmes had readied young artists for exactly this role. Employing conceptual, post-minimal, video and performance artists from the sixties and seventies, schools such as Cal Arts, UCLA, Art Center, Yale and the Whitney Museum's Independent Study Programme tended to privilege intellectual and critical study over the more traditional training in manual skills like drawing, figure painting and sculpture. 'Knowledge work' became detached from its antecedent, technical work. 'The language one learns to speak in graduate school,' writes Howard Singerman in his book about the MFA, **Art Subjects: Making Artists in the American University** (1999), 'provides a crucial internal tie that links artists, dealers, curators, critics, and departments as they address common issues and concerns.' (2) Such language might have to do with the practical necessities of being an artist – how to get a gallery show or the curatorial histories of specific institutions. More often than not it involved the acquisition of the theoretical knowledge particular to contemporary art's critical self-understanding: the importance of Lacan to identity politics, for instance, or the legacy of the Frankfurt School in debates about post-modernism. Successful participation or 'competence' in the field of art increasingly demanded that young artists know how to sound professional, not just as potential collaborators in the business of the art world, but as navigators of cultural and intellectual capital. In this way, artists were valued largely for their displayed ability to become flexible and fluent practitioners of mental labour – even if it had nothing apparently to do with the kind of production they commenced.

↓

It is not my concern, however, to dwell here on the instrumentalisation of theory in arts education. The aspects of nineties art that seems most relevant now is the transformation of the field of art production and the position occupied by young artists in a culturally diffuse and globalised art world. Art has become more and more a kind of ancillary service industry to entertainment and commercial culture. Museums now speak of 'box-office' take and stage multi-media and heavily marketed spectacles that often have to compete for the same 'mindshare' – if not direct funding – as the performing arts, sports and film. Needless to say, artists have had to adapt to these changes. In some respects they have been able to capitalise on the essentially communication-based, analytical and interpretative skills taught to

them in the academy. Such skills have made artists more strategic, more diversified, more self-conscious of themselves as agents or providers of service, the value of which might differ across public and private contexts. The implicit critique of the art object and of the art apparatus (artist, studio, dealer and patron, criticism, gallery and museum), a critique that was a legacy of the conceptual and political art of the sixties and seventies and that might ostensibly have been instilled in artist's education, has been all but evacuated from contemporary practice even as the strategies of display and production of this earlier period have been widely assimilated. Artists are no longer valued merely for their ability to read or comment upon culture. In a free market, the role of the artist has increasingly become that of the professionalised knowledge worker: creating, administering and managing a huge array of information, styles, materials and images, ersatz experience, sociological data and pop culture.

↓

Over the course of the nineties, art as knowledge work itself underwent a profound and market-influenced transformation. If, in the early years of the decade, Andrea Fraser could speak of her practice as a kind of critical 'service provision', wherein she performed 'the interpretation or analysis of sites and situations', offered herself as a 'public educator', or otherwise engaged in collaborative, community-oriented work, by mid-decade the art aparatus and market had found ways to 'aestheticize' or 're-materialize' art practice as social work, despite its original claims to criticality. [3] From information theory, Metcalf's Law states that a network is only as powerful as the number of users or points it comprises. The most successful artists in the nineties – Matthew Barney, for instance – were those whose production was the most flexible in its ability to unite the largest number of points in the network. In this 'labour theory of value', the art that will continue to receive institutional and corporate support will be that which has meaning and currency that can be shared among the largest number of network participants, allowing for the broadest alliance of cultural and real capital, and creating the widest cross-cultural demand.

↓

Accordingly, mid-nineties art witnessed an explosion of seemingly new production models that signified collectivity, networks and diversified social function, while remaining bound to the trajectory of craft-based studio production (from individual artist, to individual dealer, to private collection, to museum). [4] Rirkrit Tiravanija cooked communal Thai dinners in far-flung galleries and museums; Piotr Uklanski installed his custom-built disco dance floors as gallery pieces, as museum shows, and as decoration in bars; Vanessa Beecroft staged high-style fashion spectacles; Jorge Pardo convinced the Los Angeles Museum of Contemporary Art to partially invest in the building of a faux-moderne ranch house which he then lived in and exhibited. Some artists or art groups made themselves into quasi-functional corporations, complete with client lists and logos (ChanSchatz, the Bernadette Corporation, R™ark). Others entered into the production domain of film and music (Barney, Doug Aitken, Fischerspooner) or began to explore the possibilities of digital media – used

both as a tool to renovate media like painting and photography and as a technology and cultural field in and of itself.

↓

The facility of nineties artists' with diverse fields of production and knowledge was not simply a product of up-to-the-minute art school education where appropriation and pastiche were taught as a lingua franca. It was also a response to the demands of an art market trying to keep up with global entertainment and culture markets. Ironically, the proliferation of biennials, art fairs, international residencies, regional art centres, and franchise museums did not mean that artists had to make their productions smaller or more portable (although many did, creating the momentary vogue for 'nomadism'). It meant that more places had more money more often. Big production or big-ticket art was increasingly seen as a way of bringing prestige from cultural hubs like New York, Los Angeles and London to places with less currency on the international art market – places which, in turn, might be struggling to make themselves into 'arts destinations' as a way of boosting tourism and international corporate investment. The image of the successful nineties artist as a multi-tasking jet-setter, shuttling between Williamsburg studio, Chelsea Gallery, Korean biennial and London fashion shoot may be a gross cliché, but it testifies to the degree which artists were called upon to lend their production to as many global service outlets as possible.

↓

London critics Anthony Davies and Simon Ford have written presciently about the economic shifts in the culture of art, primarily within the British art scene of the nineties, and primarily as a way of underscoring the inter-relationship between the 'young British artist' (yBa) phenomenon, state cultural policy and corporate investment. (5) In 'Culture Clubs' they write, 'the realisation that a company or an individual could be valued principally on "intangible assets" (e.g. intellectual capital and access to networks)' has produced the 'emergence of a hybrid professional, the "culturepreneur", to exploit the new cross and inter-sectoral economies.' (6) This figure of the culturepreneur (also variously called a 'culture-broker' or a 'pro-sumer') is a kind of ancillary or post-yBa, who has left behind the relatively circumscribed economy of simply making artwork and entered more literally the realm of cultural-economic mediation. As part of a new business avant-garde – including media consultants, producers from the film and dot.com industries and fast-lane movers in the world of fashion, magazines, music and cultural policy (think tanks, techno-policy gurus, etc.) – the artist turned culturepreneur is able:

↓

to follow capital wherever it goes, tapping into local networks, setting up partner-ships, and identifying trends for a variety of clients. Their bridging role, between business and communities that work on the cutting edge of culture, provides the knowledge, information, and 'association' that is vital to companies requiring local association for competitive global strategies.' (7)

↓

The cultural and economic co-dependencies – variously called alliances, associations, affiliations, sponsorships, co-productions and

partnerships – navigated by the culturepreneur are widely apparent in the United States, though they are, as yet, not as glaring as they are have been in London, a city whose nineties culture and art market was predicated almost exclusively on spectacle. One sees the influence of 'alliance culture' in the corporate sponsorship of museum exhibitions (Intel for SFMoMA's **0101: Art in Technological Times**, Instinet for the Whitey's **Bitstreams**) and in the Museum of Modern Art's 'Junior Associates' programme, which gives prominent and wealthy young people access to MoMA's curators, trustees and programming, and allows them private views of exhibitions and opportunities to mingle among the cultural and business elite. Other, more radically objectified instances of culture brokering can be seen in organisations like Yvonne Force's Art Production Fund, a kind of public relations firm-cum-venture capital search agency, which has co-produced, among other things, Vanessa Beecroft's art-fashion spectacles at the Guggenheim, the staging of Jeff Koons' **Puppy** at the Rockefeller Center, and – in association with Gavin Brown's Enterprize, Levi's and the new media services company Razorfish – the Los Angeles and Berlin performances of the art/music group Fischerspooner. The Art Production Fund is probably the closest any American venture has come to the culturepreneurialism described by Davies and Ford. This model of mediation between artists, institutions, and public and corporate funding will only become more prevalent in the future.

↓

Interestingly, the instances of literal culture brokering described already have been nascent metaphorically in the practice and discourse of much nineties art. French critic and curator Nicolas Bourriaud (now co-director, with Jerome Sans, of the Palais de Tokyo art centre in Paris) was not the first commentator to point out the 'relational' or 'participatory' aspects of certain contemporary practices – indeed, the activation of audience has been taken for granted since Minimalism – but he was the first to recognise this phenomenon as a cultural symptom linked to the emergence of new technology and information culture. Artists as wide-ranging as Robert Smithson, Hans Haacke, Peter Fend, Andrea Fraser and Christian Phillip-Müller had taken a stand against what Smithson called the 'cultural containment' of the institutional museum, positioning their work in site-specific locations in order to point out the aesthetic and political dysfunctionalities of art's relationship to the social field. Bourriaud, however, recognised and promoted a more post-political, or apolitical, art of social navigation – Rirkrit Tiravanija's cooking and eating performances, for instance – that could be and was easily assimilated first into traditional museum settings and ultimately into the commercial art market.

↓

With this art of 'relational aesthetics', the artist becomes a kind of agent or host throwing parties, creating spontaneous communal situations, introducing non-art domains into the art experience, but, crucially, without the political or self-regulating intention of earlier service-oriented art.. Seemingly no longer a producer of discrete objects – paintings, sculpture, photographs, even gallery installations – the 'relational aesthetics' artist poses as a culturepreneur,

programming and mediating hitherto distinct fields of cultural information. This kind of artist, as an agent provocateur, does not directly manoeuvre the real capital of the culturepreneur, but he does play with a symbolic currency of diversified – and diversional – enticement, itself easily functional within the market domain of the gallery or museum. This 'play' is fast becoming real, less of a posture, for artists like Doug Aitken or Roe Ethridge, whose art production is often indistinguishable from their 'other' commercial work (Aitken as a director of music videos, Ethridge as a commercial photographer). The webs of models, actors, production crews, commercial techniques, budgets, clients and agents that comprise their productions – more literally relational than 'relational aesthetics' – leave them just shy of the real-world instrumentality embodied by the culturepreneur.

↓

The increasing transparency of art's embrace of 'alliance' and commercial culture might suggest a forthcoming boom in art production adapted specifically to the links and networks that connect the different realms. For their part, Davies and Ford have speculated that the distinct roles of artist, curator, critic, and dealer will, eventually, cease to hold any value and be subsumed into the culturepreneur or culture-broker. This is a bold notion, especially in light of the fact we are witnessing – or rather, we imagine we are witnessing – a widespread 'return to artistic craft', to the traditional studio model of idiosyncratic material production: 'the new sculpture from Los Angeles', for instance, or 'the new abstract painting'. Far from disappearing, the artist, in some popular,

mythological sense, seems always to be re-emerging, asserting herself despite the increasing noise of a diversified art culture. I would suggest, however, that this re-assertion of traditional studio production is largely a red herring, not quite the point in and of itself. 'What artists do' has changed irrevocably since the time of the heroic, individual artist-subject. The category Artist, no matter how much a given practitioner hews herself to traditional media, is just one category among many, indistinct in some intangible way from other categories of cultural labour like writers, curators and website content providers. Artists are now 'people who do many things', who work in and with culture. To say that a given artist is a painter does not, and perhaps cannot, mean the same thing in 2001 it did in 1951. To say that art is 'returning' to craft or, conversely, to say that art is increasingly engaged with sociability, relationality and interactivity, is to speak in the highly imprecise language of mythology and popular imagination – not the best tools for making distinctions about practice and the economic or cultural factors that inform it.

↓

Have we, as artists, critics, and participants in culture, forfeited our ability to make such distinctions? What would the making of such distinctions require now? The new metaphors of production nascent in nineties art have, indeed, helped transform art's mythologies (the reverse is also true), but it is far less certain that they have produced any meaningful alteration of the age old economic models circumscribing art. Nor have they necessarily 'prepared' us to alter the future. Such an alteration would seem to require a

more thorough understanding of art's evolving sociological and industrial spheres — the increasingly contentious spheres of audience, distribution, and artistic labour — and the 'alliance cultures' in which art will be produced in years to come.

01 Howard Singerman, **Art Subjects: Making Artists in the American University**. University of California Press, Berkeley, CA, 1999, p 6.
02 Singerman op cit, p 202.
03 Andrea Fraser, 'What's Intangible, Transitory, Mediating, Participatory, and Rendered in the Public Sphere?', **October**, New York, Spring 1997, pp 111 116.
04 This incongruency was perhaps most visible in the confusion over how to value and distribute film and video work and has recently become even more apparent with the frustrated introduction of digital media into the art market and museum archive.
05 See Anthony Davies and Simon Ford's three recent essays: 'Art Capital', **Art Monthly**, London, February 1998; 'Art Futures' **Art Monthly**, London, February 1999; and 'Culture Clubs', **Mute**, London, Autumn 2000.
06 Davies and Ford, 'Culture Clubs', op cit, np.
07 Davies and Ford. 'Art Futures', op cit, np.

AUTHOR'S ACKNOWLEDGEMENTS

Mark Sladen would like to thank the following for their help.

Principally: the artists and writers.

Not forgetting: the owners of works reproduced in the book and the lenders of works included in the exhibition (please note that at time of publication a full list of lenders was not available).

For advice: Laura Hoptman (Museum of Modern Art), Larry Rinder (Whitney Museum of American Art), James Rondeaux (Art Institute of Chicago), Connie Butler (Los Angeles Museum of Contemporary Art), Russel Fergusen (UCLA Armand Hammer Museum), Lauren Wittels (Citigroup Private Bank Art Advisory Service), Amanda Sharp (Frieze), Paul Foss (Art/Text) and Stuart Comer.

Artists' representatives: Douglas Christmas (ACE Gallery), Bob Gunderman, Randy Sommer and Bettina Hubby (ACME), Andrew Kreps and Jamie Isenstein (Andrew Kreps Gallery), Susanna Greeves (Anthony d'Offay Gallery), Brent Sikkema and Michael Jenins (Brent Sikkema), Casey Kaplan and Muriel Quancard (Casey Kaplan Gallery), Giovanni Intra (China Art Objects), Tommaso Corvi-Mora (Corvi-Mora), Elizabeth Schwartz (Deitch Projects), Hudson and Jimi Dams (Feature Inc), Blaire Dessent (Friedrich Petzel Gallery), Zach Miner (Gagosian), Kirsty Bell and Corinna Durland (Gavin Brown's Enterprize), Ulrich Gebauer (Galerie Gebauer), Carol Greene (Greene Naftali Gallery), Julia Sprinkel (James Cohan Gallery), Lothar Albrecht (LA Galerie Lothar Albrecht), Leo Koenig and Elizabeth Balogh (Leo Koenig Inc), Marc Foxx and Khara Perkins (Marc Foxx), Margo Leavin and Wendy Brandow (Margo Leavin Gallery), Marianne Boesky and Elisabeth Ivers (Marianne Boesky Gallery), Haan Chau (Metro Pictures), Tim Neuger (Neugerriemschneider), Bruce Hackney (Nicole Klagsbrun), Paolo Curti (Paolo Curti & Co), Shaun Kaley Regen and Lisa Overduin (Regen Projects), Richard Telles (Richard Telles Fine Art), Sadie Coles and Pauline Daly (Sadie Coles HQ), Christian Haye, Jenny Liu and Cathy Blanchflower (The Project).

At the Barbican: Carol Brown for her encouragement and Philippa Alden, Julia Bunnage and Sophie Persson for their diligent assistance.

For the book: Edward Booth-Clibborn (Booth-Clibborn Editions), Joseph Burrin (BCD) and Rick Kemp (Tamarind).

Plus: Garrick.

BARBICAN ARTS PARTNERS

Linklaters
Clifford Chance
Merrill Lynch
BP
Bloomberg
Slaughter and May
Richards Butler

the americans. new art. the americans. new art. the americans. new art. the americans. new art. the americans. new art. the americans. new art. the americans. new ar
the americans. new art. the americans. new art. the americans. new art. the americans. new art. the americans. new art. the americans. new art. the americans. new ar
the americans. new art. the americans. new art. the americans. new art. the americans. new art. the americans. new art. the americans. new art. the americans. new ar
the americans. new art. the americans. new art. the americans. new art. the americans. new art. the americans. new art. the americans. new art. the americans. new ar
the americans. new art. the americans. new art. the americans. new art. the americans. new art. the americans. new art. the americans. new art. the americans. new ar
the americans. new art. the americans. new art. the americans. new art. the americans. new art. the americans. new art. the americans. new art. the americans. new ar
the americans. new art. the americans. new art. the americans. new art. the americans. new art. the americans. new art. the americans. new art. the americans. new ar
the americans. new art. the americans. new art. the americans. new art. the americans. new art. the americans. new art. the americans. new art. the americans. new ar
the americans. new art. the americans. new art. the americans. new art. the americans. new art. the americans. new art. the americans. new art. the americans. new ar
the americans. new art. the americans. new art. the americans. new art. the americans. new art. the americans. new art. the americans. new art. the americans. new ar
the americans. new art. the americans. new art. the americans. new art. the americans. new art. the americans. new art. the americans. new art. the americans. new ar
the americans. new art. the americans. new art. the americans. new art. the americans. new art. the americans. new art. the americans. new art. the americans. new ar
the americans. new art. the americans. new art. the americans. new art. the americans. new art. the americans. new art. the americans. new art. the americans. new ar
the americans. new art. the americans. new art. the americans. new art. the americans. new art. the americans. new art. the americans. new art. the americans. new ar
the americans. new art. the americans. new art. the americans. new art. the americans. new art. the americans. new art. the americans. new art. the americans. new ar
the americans. new art. the americans. new art. the americans. new art. the americans. new art. the americans. new art. the americans. new art. the americans. new ar
the americans. new art. the americans. new art. the americans. new art. the americans. new art. the americans. new art. the americans. new art. the americans. new ar
the americans. new art. the americans. new art. the americans. new art. the americans. new art. the americans. new art. the americans. new art. the americans. new ar
the americans. new art. the americans. new art. the americans. new art. the americans. new art. the americans. new art. the americans. new art. the americans. new ar
the americans. new art. the americans. new art. the americans. new art. the americans. new art. the americans. new art. the americans. new art. the americans. new ar
the americans. new art. the americans. new art. the americans. new art. the americans. new art. the americans. new art. the americans. new art. the americans. new ar
the americans. new art. the americans. new art. the americans. new art. the americans. new art. the americans. new art. the americans. new art. the americans. new ar
the americans. new art. the americans. new art. the americans. new art. the americans. new art. the americans. new art. the americans. new art. the americans. new ar
the americans. new art. the americans. new art. the americans. new art. the americans. new art. the americans. new art. the americans. new art. the americans. new ar
the americans. new art. the americans. new art. the americans. new art. the americans. new art. the americans. new art. the americans. new art. the americans. new ar
the americans. new art. the americans. new art. the americans. new art. the americans. new art. the americans. new art. the americans. new art. the americans. new ar
the americans. new art. the americans. new art. the americans. new art. the americans. new art. the americans. new art. the americans. new art. the americans. new ar
the americans. new art. the americans. new art. the americans. new art. the americans. new art. the americans. new art. the americans. new art. the americans. new ar
the americans. new art. the americans. new art. the americans. new art. the americans. new art. the americans. new art. the americans. new art. the americans. new ar
the americans. new art. the americans. new art. the americans. new art. the americans. new art. the americans. new art. the americans. new art. the americans. new ar
the americans. new art. the americans. new art. the americans. new art. the americans. new art. the americans. new art. the americans. new art. the americans. new ar
the americans. new art. the americans. new art. the americans. new art. the americans. new art. the americans. new art. the americans. new art. the americans. new ar
the americans. new art. the americans. new art. the americans. new art. the americans. new art. the americans. new art. the americans. new art. the americans. new ar
the americans. new art. the americans. new art. the americans. new art. the americans. new art. the americans. new art. the americans. new art. the americans. new ar
the americans. new art. the americans. new art. the americans. new art. the americans. new art. the americans. new art. the americans. new art. the americans. new ar
the americans. new art. the americans. new art. the americans. new art. the americans. new art. the americans. new art. the americans. new art. the americans. new ar
the americans. new art. the americans. new art. the americans. new art. the americans. new art. the americans. new art. the americans. new art. the americans. new ar
the americans. new art. the americans. new art. the americans. new art. the americans. new art. the americans. new art. the americans. new art. the americans. new ar
the americans. new art. the americans. new art. the americans. new art. the americans. new art. the americans. new art. the americans. new art. the americans. new ar
the americans. new art. the americans. new art. the americans. new art. the americans. new art. the americans. new art. the americans. new art. the americans. new a
the americans. new art. the americans. new art. the americans. new art. the americans. new art. the americans. new art. the americans. new art. the americans. new a
the americans. new art. the americans. new art. the americans. new art. the americans. new art. the americans. new art. the americans. new art. the americans. new a
the americans. new art. the americans. new art. the americans. new art. the americans. new art. the americans. new art. the americans. new art. the americans. new a
the americans. new art. the americans. new art. the americans. new art. the americans. new art. the americans. new art. the americans. new art. the americans. new a
the americans. new art. the americans. new art. the americans. new art. the americans. new art. the americans. new art. the americans. new art. the americans. new a
the americans. new art. the americans. new art. the americans. new art. the americans. new art. the americans. new art. the americans. new art. the americans. new a
the americans. new art. the americans. new art. the americans. new art. the americans. new art. the americans. new art. the americans. new art. the americans. new a
the americans. new art. the americans. new art. the americans. new art. the americans. new art. the americans. new art. the americans. new art. the americans. new a
the americans. new art. the americans. new art. the americans. new art. the americans. new art. the americans. new art. the americans. new art. the americans. new a
the americans. new art. the americans. new art. the americans. new art. the americans. new art. the americans. new art. the americans. new art. the americans. new a
the americans. new art. the americans. new art. the americans. new art. the americans. new art. the americans. new art. the americans. new art. the americans. new a
the americans. new art. the americans. new art. the americans. new art. the americans. new art. the americans. new art. the americans. new art. the americans. new a
the americans. new art. the americans. new art. the americans. new art. the americans. new art. the americans. new art. the americans. new art. the americans. new a
the americans. new art. the americans. new art. the americans. new art. the americans. new art. the americans. new art. the americans. new art. the americans. new a
the americans. new art. the americans. new art. the americans. new art. the americans. new art. the americans. new art. the americans. new art. the americans. new a
the americans. new art. the americans. new art. the americans. new art. the americans. new art. the americans. new art. the americans. new art. the americans. new a
the americans. new art. the americans. new art. the americans. new art. the americans. new art. the americans. new art. the americans. new art. the americans. new a
the americans. new art. the americans. new art. the americans. new art. the americans. new art. the americans. new art. the americans. new art. the americans. new a
the americans. new art. the americans. new art. the americans. new art. the americans. new art. the americans. new art. the americans. new art. the americans. new a
the americans. new art. the americans. new art. the americans. new art. the americans. new art. the americans. new art. the americans. new art. the americans. new a
the americans. new art. the americans. new art. the americans. new art. the americans. new art. the americans. new art. the americans. new art. the americans. new a